Mexican American Artists

NUMBER TWO
The John Fielding and Lois Lasater Maher Series

Mexican
American Artists

by Jacinto Quirarte

UNIVERSITY OF TEXAS PRESS, AUSTIN AND LONDON

Library of Congress Cataloging in Publication Data

Quirarte, Jacinto, 1931–
 Mexican American artists.

 (John Fielding and Lois Lasater Maher series, no. 2)
 Bibliography: p.
 1. Art, Mexican American. 2. Art, Modern — 20th
century — Southwest, New. 3. Artists, Mexican American.
I. Title. II. Series.
N6538.M4Q57 709'.79 72-10925
ISBN 0-292-75006-4

To the memory of my father
FRANCISCO QUIRARTE

CONTENTS

ILLUSTRATIONS

COLOR PLATES

BLACK-AND-WHITE PLATES

PREFACE

This study began in May 1969 when Downs Matthews, editor of *The Humble Way*, invited me to write an article on American artists of Mexican descent and their contributions to U.S. culture. When he first suggested the topic, I was not at all sure that such a study was feasible. Like most art historians I was not overly concerned with nationality and even less with ethnicity in my studies of art and artists. These matters were simply not important in the assessment of works of art. After all, I reasoned, all twentieth-century artists were part of an international community. Granted, national origins could on occasion be used to explain certain tendencies in the production of works of art, such as the use of large canvases by the American Abstract Expressionists during the forties and fifties, which has been identified as a specifically American trait. Further, the identification of an artist by national origin or by his adopted country has been used primarily for the sake of convenience, even when these designations have become blurred in the twentieth century. Picasso has lived in France for at least seventy of his ninety years but is considered Spanish. Willem de Kooning arrived in this country as a young man in the twenties from Holland, yet he is considered an American artist. Obviously, there are many factors that determine the ultimate identification of an artist within a national framework. The point is that the work of both artists has been considered within the context of twentieth-century art, that is, within an international art.

So why this study? First of all, I realized that here was a largely untapped body of material, precisely because attitudes governing the selection of material for art historical study had led to its exclusion. It simply did not conform to this view. Ironically, while nationalism has been downplayed in matters of artistic production, it has nonetheless determined the way we perceive the art of the past and the present. Certain examples of art and architecture in the American Southwest have been ignored because they do not fit into our preconceived notions of what constitutes American and Mexican art. In fact, we have unwittingly misled ourselves by thinking along national rather than artistic boundaries in dealing with these works of art. Thus, the missions of Texas, New Mexico, Arizona, and California have been considered as an isolated phenomenon—interesting but rather curious relics of the colonial past of the area. American historians, with few exceptions, have ignored them. They have fared no better under Mexican historians, who have insisted on identifying Mexico and, by extension, Mexican art with the central part of that nation. The northern tier of states has rarely been treated, and Yucatán is usually considered outside the realm of these studies. This view places Mexico within the northern extension of Mesoamerica, which encompasses all of central and southern Mexico, Guatemala, British Honduras, parts of Honduras, and El Salvador.

Thus, the American Southwest is left without moorings. It is rarely included in general histories of Mexi-

can colonial art. In this country it has not received the attention it deserves—a lack that is partially offset in this study. The art of the American Southwest is treated as an integral part of New Spanish and Mexican art. Cultural and artistic rather than present political boundaries are used as a basis for a spatial definition in this unit of study. Thus, the missions, the *santos,* and the work of twentieth-century Mexican muralists in the United States are considered along with the work of the contemporary Mexican American artist.

I wish to thank Downs Matthews for his continued

enthusiastic support of my work in this area. Support was received from the Institute of Latin American Studies (a Summer Research Grant) for a trip to New York and to cities in Texas, New Mexico, Arizona, and California during the summer of 1970 to interview artists and to see their works. The Center for Mexican American Studies supplied further research grant funds in the summer of 1971 for the completion of this project.

Jacinto Quirarte
San Antonio

INTRODUCTION

I

In some respects this is a most unfortunate time for us to be concerned with the art of Mexican Americans, or Chicanos. Artists have rarely, if ever, been involved with problems of ethnic identity. And in recent years artists have been quite concerned with the production of art works that are divorced from almost everything that has to do with our everyday lives. What the artist is, who he is, is peripheral to this enterprise.[1] In short, artists have been breaking down national and ethnic boundaries rather than setting them up. This procedure is not new, of course. Artists have been doing this since the last half of the nineteenth century, when their positions, their roles in their respective societies, became blurred or non-existent.[2] The reasons are extremely complex: the change in patronage, which merely reflected the change in governments, changes in economic systems, the shifting of power structures. No longer were monarchs, the church, or wealthy individuals in a position to designate, to commission, the work of artists. Artists were affected not only by these practical considerations but also by the scientific knowledge of the day.[3]

Stripped of the usual roles as portrait or history painters, that is, involvement with narrative subjects or with the usual types of work that were assigned them, artists began to go their own way by the 1860's, particularly in France. They began to experiment with new ways of representing the world. No longer confined by the patronage that had restricted them in the past, artists sought and began to create new ways of representing the world. In so doing, they began their alienation from society that we find so pronounced today. For over one hundred years, artists in Western societies have ceased to perform services that could be characterized as indispensable. These services are neither solicited nor required and, as far as many influential members of these societies are concerned, are totally unnecessary. Artists no longer fulfill any specific practical function.[4]

[1]Francis V. O'Connor, *Jackson Pollock*, p. 33. In an interview published in *Arts & Architecture*, Pollock said: "The idea of an isolated American painting, so popular in this country during the thirties, seems absurd to me, just as the idea of creating a purely American mathematics or physics would seem absurd.... And in another sense, the problem doesn't exist at all; or if it did, would solve itself: An American is an American and his painting would naturally be qualified by that fact, whether he wills or not. But the basic problems of contemporary painting are independent of any one country" (16 [1944]: 14).

[2]The first artists to break away from these societal bonds were the Impressionists, although individuals who immediately preceded them had already begun the process.

[3]The widespread use of photography in the early 1840's and later the scientific discoveries in the perception of color and light had an impact on late nineteenth-century artists like Georges Seurat.

[4]The question here of course revolves around the word *function*. Here the meaning is restricted to the specific positions accorded artists in the past as far as the commissioning of specific works is concerned: paintings or sculptures of religious subjects destined for ecclesiastic use in altars, etc. Works commissioned by monarchs and other important persons fall under the same category.

What has actually happened is that an *approach to the making of art objects has been formulated that knows no national or ethnic boundaries.*[5] And yet we are at present confronted, on the one hand, with a demand that a specific Mexican American identity be found, one that can be readily pointed to when looking at art works produced by members of this group. On the other hand, these works must be judged on merits that have nothing to do with a Mexican American identity. At least, we profess to have ideas regarding these matters.[6] We subscribe to them when we look at works of art. We say that works of art represent an involvement either with subject, with object, by the artist, or with spiritual values. In one way or another the individual comes to grips with these things, in ways that touch him deeply rather than superficially. How he comes out of it depends upon him as an artist.

The Problem: To be a Mexican American; to be an artist. What do we do with this dilemma? What specifically does the Mexican American do that identifies him as such? Is this apparent in his work? Does he consciously go about establishing a particular way of seeing and, by extension, reflecting this in the way he paints? Is there a specific Mexican American quality to the use of color? the use of line? the use of space? We can say that this is not the central problem, of course. What is important is that the artist knows, or he may feel to some extent, that what he is, is reflected in his work—the indefinable quality that

makes him what he is. Certainly, we can look at works in retrospect and say that this is good, this is bad; that this part reflects the individual's personality, his personality in turn is linked to his background, his background is one in which such and such elements were paramount, and these we can identify as being part of a Chicano world view. But some of the Chicano painters are not satisfied with this indirect identification of their work with a Chicano background. They want more.[7]

The Mexican American has been touched by Mexico's efforts to establish a Mexican identity, which has by no means been entirely resolved. The Mexican is still searching for his roots in the pre-Columbian past while he is firmly anchored in a European frame of mind. All cultural frames of reference are European. These have been affected but not appreciably altered by pre-Columbian survivals. Elements like Náhuatl words enrich Spanish as spoken by Mexicans. Artists may take pre-Columbian motifs, as Diego Rivera has done in many of his murals,[8] but the pictorial language and conventions remain European.

The pre-Columbian past is everywhere evident in Mexico. Material remains are abundant. Indigenous peoples comprise a great majority of the population. Twentieth-century artists have been cognizant of this past, with Rivera at the forefront of those who champion it and José Clemente Orozco equally forceful in denouncing it.[9] But, regardless of their attitudes toward this past, Mexican artists have not been able to ignore it. All muralists used various aspects of the pre-Columbian world in their mural programs. Rivera presented it as an ideal world in his National Palace murals, and the conquest as a heroic struggle against all odds. David Alfaro Siqueiros developed a thematic program in his murals at Chillán, Chile, and in Mexico City, in which Cuauhtemoc personifies the successful fight against the oppressor, symbolized by the centaur—half man, half beast.[10] To Orozco, this world was inhabited by inhospitable gods, who appear to have more in common with the vengeful god in the Judaic tradition than with the pre-Columbian world. He, of course, overwhelms the opposition with a massive satyrical brush, as he on occasion did in his murals. In fact, it is when this part

[5]The context for this generalization is Western art.

[6]First person plural refers to artists, art critics, art historians, and other persons involved in the art business.

[7]A number of Mexican American artists have identified themselves as Chicano artists. These are the Pintores de la Nueva Raza in San Antonio, and the Mexican American Liberation Art Front in Sacramento, California.

[8]See Stanton L. Catlin, "Some Sources and Uses of Pre-Columbian Art in the Cuernavaca Frescoes of Diego Rivera," in *XXXV Congreso Internacional de Americanistas: Actas y memorias,* III, 439–449. Catlin deals with only one of Rivera's murals. However, it is easy to trace the use of pre-Columbian motifs by the artist much earlier in his paintings at the Ministry of Education Building. Closely linked to the Cuernavaca murals are those in the National Palace stairway.

[9]José Clemente Orozco, *Autobiography,* pp. 109–110.

[10]Bernard S. Myers, *Mexican Painting in Our Time,* pp. 211–234.

of his personality was allowed to go unchecked that we have caricature rather than painting.

At any rate, whatever the attitudes toward their pre-Columbian past—*negative* or *positive*—all used a European pictorial language. Even the techniques are European. The muralists' use of fresco and the thematic and formal programs fit into a European frame of reference. It is the final development of a tradition that was initiated in Florence during the fifteenth century by Masaccio and others.[11] The content is Mexican, the expression is Mexican, the language is European.

Beyond its connections with European culture in general, Mexican art is imbued in particular with Spanish attitudes. José Guadalupe Posada has more in common with Francisco Goya than he does with pre-Columbian Mexico.[12] Posada's use of *calaveras* is sometimes associated with that world. However, this motif and others, like his Chepito Marihuano, are designed to give him a forum that will enable him to launch his attacks upon man and his imperfect world. His biting satire, his constant references to the political world, as well as to the lowest rungs of society, are European rather than pre-Columbian attitudes. There is no doubt that these attitudes have been tempered by the Mexican experience, but the European elements and their configuration must be recognized.

The pre-Columbian artist was rarely, if ever, truly involved in recording his sensations of visual reality.[13] His was a world in which natural phenomena played a negligible role in the creation of images. These images were of deities and men whose attributes, which identified them, were more important than their godliness or humanity. Thus, the persistence of certain

visual conventions that served the artists' purposes very well. Since a figure's relationship to the space surrounding it was of little import, the artists ignored most of the space indicators developed so assiduously by Western artists. The placement of a figure in space, a definition of its mass and volume, is achieved by a variety of perspectival devices—diminution in size, overlapping, placement in the visual plane, modeling. This technique was central to European painting, at least until prior to the present century. The pre-Columbian artist was more involved in defining the deity or the human figure with a number of signs and other elements that would instruct the observer as to the figure's place in the pantheon or the society, its power rather than its physical attributes. Whether a figure was within a legible spatial frame was of no consequence. Thus, all figures are presented within a single frontal plane. Diminution in size reflects the figure's relative importance within a specific context rather than its placement in space relative to the observer. The pre-Columbian artist was equally unconcerned with a figure's displacement of space—its volumetric definition. Thus, all figures are basically two-dimensional forms. Only the contours of the forms give a sense of the figure's volume. Yet, this is basically nullified by the artist's use of unmodulated color. Color is applied in flat tones and then outlined in black.

With the arrival of the Spaniards in the sixteenth century, the Indian painters took the alien formal programs, if not the thematic ones, all at once. Thus, there is a strange amalgamation in the sixteenth-century codices of European pictorial convention and pre-Columbian motifs—deities and historical personages.[14] The Indian painters began to use modeling and chiaroscuro. These and other techniques had been important for at least one hundred years in Europe. Artists were interested in defining, with as much accuracy as possible, not only the configuration of an object as it is affected by light, its placement within its proper spatial context, but also its relationship to other objects—a definition of spatial intervals.

In discussing art and in particular their own art

[11]Values first expounded by early fifteenth-century Italian artists are retained by the Mexican muralists: definition of forms in terms of light and dark, single perspectival devices, etc.

[12]*100 Original Woodcuts by Posada*, foreword by Jean Charlot. The views expressed in regard to Posada's work are mine. The reference here is to the woodcuts rather than to Charlot's comments.

[13]Jacinto Quirarte, *Maya Vase and Mural Painting.*

[14]Donald Robertson, *Mexican Manuscript Painting of the Early Colonial Period.*

with Mexican American artists over the past two years from New York to California and places in between, I found great diversity in approach, attitudes, and types of work.[15] Some artists were more concerned with a personal approach to their work, while others preferred to align themselves with groups. There are the Pintores de la Nueva Raza from San Antonio, who exhibit under the heading TLACUILO, numbering some twenty-two artists.[16] There are those identified with the northern California group formed a few years ago, called MALAF (Mexican American Liberation Art Front).[17] And there are still others in New York comprised of American Indians, Mexican Americans, Puerto Ricans, blacks, and hillbillies under the heading of the Rainbow Culture, with headquarters in the Museo del Barrio.[18]

The Pintores de la Nueva Raza have aims similar to those espoused by MALAF, although they stress the teaching aspects of their program more emphatically. In some respects these points of view have parallels with the great manifestoes written by David Alfaro Siqueiros in the twenties and subscribed to by the other muralists—that is, a very specific program in which painting or muralism was subjected to a programmatic purpose.[19] It was to be used to reach the people; these murals were to teach the people what they had to know about themselves, about their past, present, and future. That is why there was such a tremendous emphasis on history— pre-Columbian, the conquest, the wars of independence, and the revolution.[20]

Coming back to the Mexican American situation, we see that there is a desire to move away from the so-called European (*gabacho* or Anglo) approach to the creation of a work of art. Coupled with this search for new approaches is another, which is related to what can only be described as a longing for, a feeling of, nostalgia for the ancient past. A search for original sources. And by this is meant the indigenous, or pre-Columbian, sources. This very idealistic point of view is stronger, if not exclusive, with the San Antonio group. These artists have some idea regarding the attitudes that the pre-Columbian peoples had toward life and by extension how these were reflected in their works.

Attitudes regarding how this search for roots is to be expressed differ. Some artists seem to be bogged down in the use of language as it relates to painting. There has to be some differentiation between the pictorial language, that is, the grammar, the constituents of a work of art, whether it is a sculpture or a painting. How these elements are put together— line, color, shape, texture, volume, light, mass, weight —and the forces that determine their articulation are, of course, the central problem.

Ralph Ortiz recognizes this very clearly, when he refers to the Mexican muralists: "They used Western devices to convey the content. Rather than use Western devices I feel that it is important that we discard them."

Esteban Villa has recognized the problem also. What he is trying to do is get away from the essence, the determinants, in Western-oriented painting that has absolutely no meaning for him and other Chicano artists.

When José [Montoya] and I and other painters attended Arts and Crafts in Oakland we were completely trained

[15]A trip was made during the summer of 1970 to New York, Texas, New Mexico, Arizona, and California to interview artists and to see their works. This was part of the research conducted for this book.

[16]Taped conversation with Felipe Reyes and other members of this group in San Antonio on November 13, 1971.

[17]Taped conversation with Esteban Villa and José Montoya in Sacramento, California, on June 24, 1970.

[18]Taped conversation with Ralph Ortiz, director of the Museo del Barrio, in New York City on June 5, 1970.

[19]Jean Charlot, *The Mexican Mural Renaissance, 1920– 1925.*

[20]When we look back at the work of the muralists we see that it was good, not because the professed aims of the artists were accomplished, although these had a great deal to do with what they were about, but because they were able to transcend these stated purposes and programs. Those things we admire on an artistic level go way beyond what Rivera and the others said they were trying to do. Unfortunately, once many of the programs were worked out—the history of Mexico: the protagonists, heroes, and villains—much of the work became repetitive. These thematic programs obviously no longer were of the most vital concern to the artists; they no longer felt as close to these things, so that later works are not comparable to those produced during the twenties and the thirties. These actions no longer fulfilled the needs, nor did they reflect exactly how the artists felt; Mexico itself had changed.

in the European tradition of painting. We tried to imitate the French Impressionists, the German Expressionists, the Surrealists, the Japanese artists, and we found it very hard to relate. We went through four years of art and not really had our soul in it. There was no heart in it that we felt. This is where we are. On the one hand, the teachers would tell us be yourself, express your intimate feelings and then, on the other hand, well, paint like we are teaching you here—the European tradition. So it was tearing us apart. We would go home to a Mexican setting, a situation "y alli está uno hablando Español, y hablando de la comida Mexicana." So that was really much a part of our life, and then go to school and have to change our role and our image; then we became Anglos while in that school.

Esteban's view in no way leads to a separatist movement, although he has been accused of this by his detractors. In fact, the San Antonio group is far more concerned with cultural autonomy than is the Oakland-Sacramento group. The San Antonians seek to emphasize the roots aspect of their work—pre-Columbian and Mexican—rather than their involvement with American culture. Esteban makes this very clear when he speaks of the Chicano and Chicano art as a merging of two cultures: "... a merging of that 'de lo que viene de Mexico' and contemporary American society—a kind of marriage of the two. And from this you're going to come out with biculturalism. And this is where Chicano art is right now. It's just beginning. There are some art forms that are starting to come out." Esteban Villa and the other MALAF artists are trying to reflect the Chicano existence in their work—those things that we have all experienced throughout the Southwest (Texas, New Mexico, Arizona, and California)—remembrances, echoes of Mexican views of the world reinforced by our parents, our grandparents, our family, and our friends.

To the San Antonio artists a call for cultural autonomy is seen as a movement that would be a reversal of what actually took place in Mexico in the sixteenth century. They see themselves as subject peoples (artists). They have been trained to follow European value systems with no reference whatever to the Chicano experience.

In effect what is happening here is an attempt to reverse the role that the artist has had in relationship to a dominant culture. A case in point: A parallel can be drawn with the events that took place in sixteenth-century Mexico when the Spaniards arrived. Not only did the vanquished take up many of the new tools brought by the Spaniards (arch and vault construction), but the Indian craftsmen also began to deal with some of the European pictorial languages, such as the use of perspective, the use of modeling or chiaroscuro, the application of effects of dark and light. All of these were alien to the pre-Columbian mind, as has already been shown.

It is this taking of alien formal and thematic programs that these Chicano artists are trying to change. But before they can accomplish this, they must be aware of the various levels at which they must operate as artists. It is not enough to say, "we are not going to paint like the Western-oriented artists," but one must zero in on what is Chicano and how this relates to making art.

Our problem then is to define what a Chicano is before we can define what Chicano art is. I am not presumptuous enough to say that I know what it is. The Chicano is not one kind of person. He is not a generalized entity. I think that if we operate in this fashion we end up echoing all those who categorize us, group us into the stereotypes we all know so well.

The Chicano community is extremely complex. There is no one person who represents a typical Chicano. Chicanos, or Mexican Americans, live in those areas of Texas, Arizona, New Mexico, California, Nevada, and Colorado that were at one time part of Mexico. The peoples in these areas were technically Mexicans; but before that they were New Spaniards, or part of "Nueva España"; it was after this that the area became part of the Mexican republic. But this affiliation only lasted, in the case of Texas, for fifteen years, and for the rest of the Southwest for another ten. So, we have been New Spaniards for over 200 years, Mexicans for 15 to 25 years, and Americans for over 120 years. This is a technicality, of course, and does not alter the fact that we are very much a part of Mexico, while at the same time a part of this country. The search for identity is then our paramount concern.

There is first of all the Chicano as artist. The language he uses is tempered by European culture, specifically the Spanish as it has come through and been redefined in Mexico. This background, coupled with an American approach or experience, has created the Mexican American. Esteban Villa expressed it this way:

Primero, I want to say that I paint and draw as a Chicano. Not too long ago I was asked by a group of college students, "Is there such a thing as Chicano Art?" I say there is. All my observations on life are definitely seen and felt as a Chicano.
I still believe in "el día de los santos," "el bautismo," "la boda," and "la llorona." I still believe in using "español" and eating "menudo." I still believe in playing the guitar, and, most of all, I still believe in all the ceremony and folklore that is part of being Chicano.[21]

When asked about his background and what effect this might have on his work, Melesio Casas of San Antonio answered that Mexican Americans are outsiders:

To me, being an outsider is the next thing to being an artist. I think we are lucky to be born outsiders. The other thing, however, is this. You think that, because you eat tortillas and you think in Spanish or in the Mexican tradition, you can identify yourself. I don't think it's quite true. First of all, because we use liquitex, and we use canvas, and we use stretcher boards. "No usamos bastidores o manta." So we are a mixture. So there is no sense in trying to say that we have that kind of purity. We are entirely different. We are neither Mexican nor Anglos. We are in between.[22]

The groups, the loners, are all in their way creating works of art that define their Mexican American identity. Some go about this consciously working out programs they hope to follow. Others are far more concerned with their voices.

I would like to make one more comment regarding nationality or ethnicity: the Aztecs, like the Italians of the Renaissance and the Romans before them, thought of those who had preceded them as perfect in every respect—a group of people with whom, obviously, some kind of bond had to be established. The Romans had this feeling for the Greeks, the Italians for the Romans, and the Aztecs for the Tol-

tecs. And, as we all know, the Toltecs were synonymous with artists. The Aztecs revered the Toltecs. This feeling is reflected in the following sixteenth-century text translated from the Náhautl:

Toltécatl: el artista, discípulo, abundante, multiple, inquieto
El Verdadero artista: capaz, se adiestra, es hábil; dialoga con su corazón, encuentra las cosas con su mente.

El verdadero artista todo lo saca de su corazón; obra con deleite, hace las cosas con calma, con tiento, obra como tolteca, compone las cosas, obra hábilmente, crea; arregla las cosas, las hace atiladas, hace que se ajusten.[23]

This reverence for forebearers illustrates the plight of all peoples. In their efforts to achieve a certain legitimacy firmly anchored to the past, they will take or establish kinship, bonds with others who have preceded them. To whom shall we look for this? Yes, we have our own sources to which we can go. There is the Spanish, Moorish, and Indian. Which of these is the strongest? In what doses were the mixtures established? The Spaniard was a composite himself when he arrived on these shores. Culturally, he was late Gothic, part Renaissance, and extensively Moorish, since many of the conquistadores were from the southern part of Spain. The Spaniards are a people whose beginnings (historically) can be linked to the Iberians, Phoenicians, Carthaginians, Romans, Greeks, Visigoths, and Moors. And what of the Aztecs? They were heirs to an even longer tradition.

[21]*El Grito: A Journal of Contemporary Mexican-American Thought* 2, no. 3 (Spring 1969), n.p.
[22]Taped interview with Mel Casas, Rudy Treviño, and Emilio Aguirre, all of San Antonio, on August 1, 1970.
[23]Miguel León-Portilla, *La filosofía Náhuatl*, p. 261. English translation taken from Miguel León-Portilla, *Aztec Thought and Culture*, p. 168:

The artist: disciple, abundant, multiple, restless.
The true artist, capable, practicing, skillful, maintains dialogue with his heart, meets things with his mind.

The true artist draws out all from his heart; works with delight; makes things with calm, with sagacity; works like a true Toltec; composes his objects; works dexterously; invents; arranges materials; adorns them; makes them adjust.

They were but the latest in a long list of cultures that had their beginnings three thousand years ago—the Olmecas, Teotihuacanos, Mayas, Zapotecas, Totonacas, Toltecas, Mixtecas, Mayas - Toltecas—and then finally Aztecas.

Thus, we have two very complex strains that have gone into our make-up. The Aztecs are but a small part of it. They just happened to be the dominant group when the Spaniards arrived. And because of this, their presence throughout Mexico and Guatemala is easily discerned today—primarily through language, the Náhuatl place names. We ourselves have been touched by these *nahuatlismos*: we use *esquite, helote, guajolote, tecolote, aguacate, tomate, chocolate, mitote, tepalcate.* This usage has enriched our lives, but it is peripheral to our main use of langauge: English and Spanish, a bilingualism that makes us very special. We have a rich heritage; we have our roots in pre-Columbian times; we are related to three centuries of Spanish rule; we are related to a century and a half of American rule. So that we are all of these and none of them. It isn't just a duality. It is far more than that. And of course it is our role to define exactly what that is.

II

Antecedents for the art and the architecture of Mexican America will be discussed in Part One, which is comprised of three chapters. The extent and nature of the New Spanish and the Mexican presence in the Southwest will be demonstrated in Chapter 1. This will be a survey presented in briefest outline. More extensive treatment can be found elsewhere.[24] The purpose here is to emphasize precedence in the discovery, exploration, and settlement of these lands, and to define in cultural, political, and economic terms the Mexican American presence in this area. These antecedents are no more Spanish than the American settlement of the lands west of the original thirteen colonies is English. Although the record is perfectly clear, it has to be underlined over and over again. First of all, so strong is the general view that the growth of the United States corresponds to an exclusively westward movement that the role played by these first arrivals and their descendants

in the development of the Southwest is underplayed.[25] Second, the settlers in northern New Spain, now the Southwest, represent the northern reaches of a transplanted European culture wedded to a strong local one—the Indian—whose development antedates by several centuries American domination of the area. By the time New Spaniards had settled New Mexico in the late sixteenth century, and resettled it a century later after the Indian rebellion of 1680,[26] they were no longer strictly peninsular types, but rather representatives of the colony of New Spain itself. This was even truer of the late-eighteenth-century settlers from Sinaloa to San Francisco.[27] They

[24]See John Francis Bannon, *The Spanish Borderlands Frontier, 1513–1821.*

[25]Herbert Eugene Bolton, *The Spanish Borderlands: A Chronicle of Old Florida and the Southwest.* The word *borderland* first appeared in this study, published in 1921. Herbert Eugene Bolton, "The West Coast Corridor," in *Bolton and the Spanish Borderlands,* ed. John Francis Bannon, pp. 123–130. Bolton's description of the northward extension of New Spain along three major corridors is followed in this study. (1) The East coast, a "wide plain lying between the Eastern Sierra and the Gulf of Mexico"; (2) the West coast, "a narrow plain between the Sierra Madre Occidental and the Pacific Ocean"; and (3) the Great Central Plateau, or "Mesa Central, between the Eastern and Western Sierras."

[26]The Pueblo Revolt of 1680 came as a result of the usual clashes between the first Europeans and the Indians. The New Spaniards, driven out of northern New Mexico in that year, retreated to El Paso. After unsuccessful attempts to regain the province—by Governor Antonio de Otermín in 1681 and by General Domingo Jironza Petriz Cruzate in 1688—Don Diego de Vargas, the newly appointed governor and captain-general of New Mexico, reconquered New Mexico in 1692. Some of the old settlers returned to their homes, but new recruits from central Mexico came in as well. Concerted efforts were made to have a greater concentration of New Spaniards in the province so as to make any further Indian outbreaks less hazardous. Among the new arrivals were over two hundred people from Mexico sent by the viceroy under the leadership of Fray Francisco Farfán in 1694. They founded Villa Nueva de Santa Cruz de Españoles Mexicanos del Rey Nuestro Carlos Segundo. This was later shortened to Santa Cruz. Juan Páez Hurtado, Vargas's agent, recruited forty-four new families from Mexico; these were the founders of Bernalillo, near Albuquerque. See Bannon, *Spanish Borderlands Frontier,* pp. 80–86, 88, 90.

[27]Herbert Eugene Bolton, *Outpost of Empire,* pp. 133–154. Colonists for the town of San Francisco were recruited from the districts of Culiacán, Sinaloa, and Fuerte, in the province of Sonora, now Sinaloa. Culiacán was already 250 years old, having been founded in 1531. Fuerte was founded in the

already represented several generations born and bred in the Sinaloa settlements.

Chapter 2 will deal with the art and the architecture of the seventeenth to the nineteenth centuries. It will not be the purpose here to deal with the historical development of architectural forms in the Southwest but to discuss a few outstanding examples in order to demonstrate that these are artistic manifestations of a culture to which all Mexican Americans belong, that of New Spain, or Mexico. What the new arrivals and the friars attempted to re-create once they settled in these areas was a society and an architecture that was already tempered by several centuries of development in the New World—the Mexican experience—and, therefore, several times removed from its original models in Spain. Central New Spain, itself, had already created an architectural tradition by the seventeenth and eighteenth centuries, which was echoed in the northern provinces.[28] So it is in this sense that these settlements in the Southwest will be viewed. Not as Spanish but New Spanish or, more precisely, Mexican. It is the Mexican model that is echoed in these far-flung northern provinces, a variation of Mexican colonial art and architecture. Some nineteenth-century *san-*

teros will be included in this chapter. This long-established tradition in New Mexico continued in spite of the American occupation, while in the other provinces changes were more rapid and decisive.

The third chapter, corresponding to a more universal influence within the United States, will deal with the work of the Mexican muralists in California, Michigan, New York, Massachusetts, New Hampshire, and Texas. While the earliest New Spanish tradition was retained and maintained in New Mexico in the nineteenth century, with the present *santeros* representing a faint echo, the second Mexican "intrusion" occurred in the twentieth century. This time the settlers, moved by political upheavals in Mexico, came as immigrants. Among the new arrivals were painters who later became internationally famous for their murals in Mexico and in the United States. It is not generally known that, although all four of the best-known muralists carried out commissions in this country, two of these came and stayed for years. And it was during those years that José Clemente Orozco and Rufino Tamayo matured as artists. Orozco first went to San Francisco in 1917 and then to New York, where he stayed for several years.[29] He was again in New York from 1926 to 1932 and in New Hampshire from 1932 to 1934. Rufino Tamayo arrived in New York in 1926 and stayed off and on until after World War II, when he returned to Mexico already internationally famous.[30] David Alfaro Siqueiros and Diego Rivera came only to carry out specific commissions.[31]

Part Two, comprised of five chapters, will deal with the work of Mexican American artists who were born in this country or came as children and developed as artists here. This discussion will bring us to the present. Since the sample is diverse, and dispersed in time and space, it is difficult to classify the material in the traditional ways. We are not dealing with a substantial body of work produced over a period of decades or centuries by a few artists. Thus, there is no need to break it down into the usual temporal units, with their appropriate headings based on specific characteristics that would distinguish one period from another. Rather, the main body of materials is by living artists still working; so in that sense

mid–sixteenth century. Mocorito and Sinaloa were founded a little later.

[28]For a thorough discussion of the colonial architecture of Mexico see Manuel Toussaint, *Colonial Art in Mexico*, trans. and ed. Elizabeth Wilder Weismann; Pablo C. Gante, *La arquitectura de México en el siglo XVI*; George Kubler, *Mexican Architecture of the Sixteenth Century*; John McAndrew, *The Open-Air Churches of Sixteenth-Century Mexico*; and Joseph A. Baird, Jr., and Hugo Rudinger, *The Churches of Mexico, 1530–1810*.

[29]Orozco describes his trips to this country and his experiences while here in his autobiography, first published in fifteen installments in the Mexican newspaper *Excelsior* between February 17 and April 8, 1942. These articles ʼere published in book form in 1945 by Ediciones Occidente under the title of *Aut ̣ ̣grafía*. The English version was published by the University of Texas Press under the title of *José Clemente Orozco: An Autobiography*, trans. Robert C. Stephenson, in 1962.

[30]Myers, *Mexican Painting in Our Time*, pp. 127–132, 257–262.

[31]Virginia and Jaime Plenn, *A Guide to Modern Mexican Murals*, pp. 139–149.

it is not a history but a record, a chronicle of a specific group of contemporary artists. Some have been working since the late twenties—men like Octavio Medellín and Antonio García—some for only a few years—Glynn Gómez and Amado Peña. The others fall in between.

The same holds true for movements. There is no coherence in that respect. Most of the artists selected for this study do not know one another. The artists could be classified according to media used or along traditional lines of painters, sculptors, and so on, but that arrangement would not be instructive. Obviously, the artists themselves are important, not the particular artistic language they may prefer to use. Thus, the most effective classification is one based along generational lines, since this would incorporate works dating from the thirties on up to the present.

Most of the artists selected were interviewed during the summer of 1970. Others were interviewed more recently. Thus, since much of the material was gathered and recorded on tapes, the presentation will be similar to the journalist's use of the interview, presented as "conversations with artists." This approach will be particularly true of Chapter 8, where various points of view are presented in regard to the use of Mexican American, or Chicano, art.

Part One. Antecedents

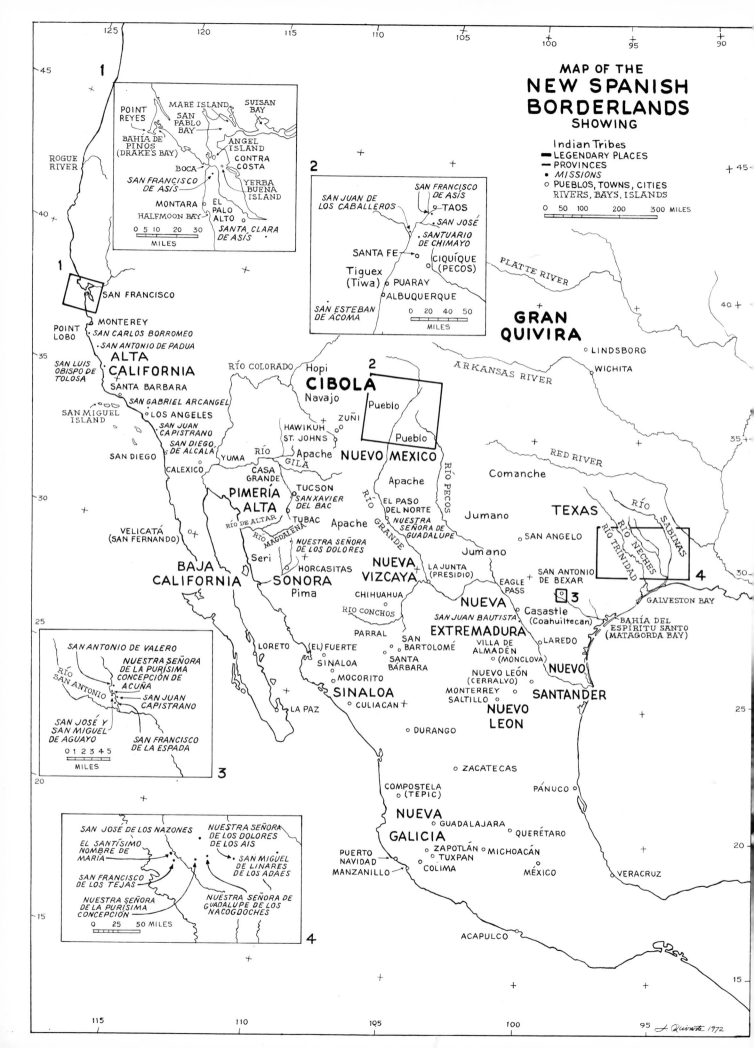

MAP OF THE
NEW SPANISH
BORDERLANDS
SHOWING

Indian Tribes
▬ LEGENDARY PLACES
▬ PROVINCES
• *MISSIONS*
○ PUEBLOS, TOWNS, CITIES
RIVERS, BAYS, ISLANDS

0 50 100 200 300 MILES

Inset 1 (San Francisco area):
POINT REYES
MARE ISLAND
SAN PABLO BAY
SUISAN BAY
BAHÍA DE PINOS (DRAKE'S BAY)
ANGEL ISLAND
CONTRA COSTA
BOCA
SAN FRANCISCO DE ASÍS
YERBA BUENA ISLAND
MONTARA
EL PALO ALTO
HALFMOON BAY
SANTA CLARA DE ASÍS
0 5 10 20 30 MILES

Inset 2 (New Mexico area):
SAN JUAN DE LOS CABALLEROS
SAN FRANCISCO DE ASÍS
○ TAOS
• *SAN JOSÉ*
• *SANTUARIO DE CHIMAYO*
SANTA FE ○
CIQUÍQUE (PECOS)
Tiguex (Tiwa)
• PUARAY
○ ALBUQUERQUE
SAN ESTEBAN DE ACOMA
0 20 40 50 MILES

ROGUE RIVER
PLATTE RIVER
GRAN QUIVIRA
○ LINDSBORG
ARKANSAS RIVER
○ WICHITA
POINT LOBO
MONTEREY
• *SAN CARLOS BORROMEO*
• *SAN ANTONIO DE PADUA*
ALTA CALIFORNIA
SAN LUIS OBISPO DE TOLOSA
SANTA BARBARA
RÍO COLORADO
Hopi
CIBOLA
Navajo
Pueblo
Pueblo
SAN GABRIEL ARCÁNGEL
SAN MIGUEL ISLAND
○ LOS ANGELES
ZUÑI
HAWIKUH
ST. JOHNS
NUEVO MEXICO
SAN JUAN CAPISTRANO
SAN DIEGO DE ALCALÁ
SAN DIEGO
YUMA
RÍO
GILA
Apache
Apache
RÍO PECOS
Comanche
RED RIVER
RÍO SABINAS
CALEXICO
CASA GRANDE
PIMERÍA ALTA
TUCSON
SAN XAVIER DEL BAC
EL PASO DEL NORTE
NUESTRA SEÑORA DE GUADALUPE
Jumano
TEXAS
SAN ANGELO ○
RÍO NECHES
RÍO TRINIDAD
VELICATÁ (SAN FERNANDO) ○
RÍO DE ALTAR
TUBAC
Apache
RÍO MAGDALENA
NUESTRA SEÑORA DE LOS DOLORES
RÍO GRANDE
NUEVA VIZCAYA
Jumano
LA JUNTA (PRESIDIO)
EAGLE PASS
SAN ANTONIO DE BEXAR
GALVESTON BAY
BAJA CALIFORNIA
Seri
SONORA
HORCASITAS ○
Pima
CHIHUAHUA ○
RÍO CONCHOS
NUEVA EXTREMADURA
SAN JUAN BAUTISTA
○ Casastle (Coahuiltecan)
BAHÍA DEL ESPÍRITU SANTO (MATAGORDA BAY)
LORETO
(EL) FUERTE
PARRAL
SAN BARTOLOMÉ
SANTA BÁRBARA
VILLA DE ALMADÉN (MONCLOVA)
LAREDO
NUEVO SANTANDER
SINALOA
MOCORITO
SINALOA
NUEVO LEÓN (CERRALVO)
MONTERREY
SALTILLO
NUEVO LEÓN
LA PAZ
CULIACAN ○
○ DURANGO
○ ZACATECAS
COMPOSTELA (TEPIC) ○
PÁNUCO ○
NUEVA GALICIA
○ GUADALAJARA
QUERÉTARO ○
PUERTO NAVIDAD
MANZANILLO
ZAPOTLÁN ○
TUXPAN ○
MICHOACÁN ○
COLIMA
MÉXICO ○
VERACRUZ ○
ACAPULCO ○

Inset 3 (San Antonio area):
SAN ANTONIO DE VALERO
NUESTRA SEÑORA DE LA PURÍSIMA CONCEPCIÓN DE ACUÑA
RÍO SAN ANTONIO
SAN JUAN CAPISTRANO
SAN JOSÉ Y SAN MIGUEL DE AGUAYO
SAN FRANCISCO DE LA ESPADA
0 1 2 3 4 5 MILES

Inset 4 (East Texas missions):
SAN JOSÉ DE LOS NAZONES
NUESTRA SEÑORA DE LOS DOLORES DE LOS AIS
EL SANTÍSIMO NOMBRE DE MARÍA
SAN MIGUEL DE LINARES DE LOS ADAES
SAN FRANCISCO DE LOS TEJAS
NUESTRA SEÑORA DE LA PURÍSIMA CONCEPCIÓN
NUESTRA SEÑORA DE GUADALUPE DE LOS NACOGDOCHES
0 25 50 MILES

J. Quirarte 1972

1. Lands and Peoples

Discovery, Exploration, and Settlement

THE EXPLORATION AND SETTLEMENT of the vast area defining the outer reaches, or northern frontiers, of New Spain, now the American Southwest, hinged on a number of factors and considerations—economic, political, and religious. Whether it was to expand the territorial dominions of Spain, to convert and "civilize" the Indians found in these lands, or to check the advance of the Russians and the English along the Pacific coast, the French along the Gulf coast, and then the encroachment of the Americans over the entire area, the Spanish, New Spanish, and Mexican presence in this vast territory was so pervasive that manifestations of it are still in evidence throughout the Southwest, through its people, language, place names, art, and architecture.

In order to better understand the art and the architecture of the Southwest, I plan to survey briefly the discovery, exploration, and settlement of this area from its first sightings in the early sixteenth century to the end of the New Spanish period in the early nineteenth (1519–1823).[1] This historical survey, with particular emphasis on the area of the United States where most Mexican Americans now live, will tell us about those who arrived from New Spain and those who met them—the numerous Indian tribes found in this vast area. A review of those events that are echoed but not explained by the place names with which we are all familiar will bring the area into sharper focus.[2]

[1]Although California and the rest of New Spain comprised, by 1823, the Republic of Mexico, a last mission—San Francisco Solano, intended as a replacement for San Francisco de Asís—was built in that year. The transfer was never made. See Cleve Hallenbeck, *Spanish Missions of the Old Southwest*, p. 76.

[2]It is interesting to note that, even though Mexican Americans have personally been touched by these events, with in some cases their immediate families coming northward as late as the twenties and thirties of this century, they have somehow failed to establish kinship with these early explorers and settlers. And beyond that, the dominant culture since the mid–nineteenth century has severed these ties so effectively that Mexican Americans have ended up feeling like intruders into the Anglo scheme of things instead of the other way around.

The region under consideration at one time comprised that portion of New Spain (1521–1821), later the Republic of Mexico (1822) and now the states of California, Nevada, most of Arizona, New Mexico, and part of Colorado, acquired from Mexico by the Treaty of Guadalupe Hidalgo on February 2, 1848.[3] Inextricably linked with this area is the entire northern part of Mexico, which in its turn had been the outer reaches of the frontier of New Spain, itself the staging area for further explorations northward. The central corridor along the plateau included Nueva Vizcaya (Chihuahua) and Nuevo México (New Mexico, part of eastern Arizona, part of western Texas). Along the Pacific coast were Nueva Galicia (Jalisco), Sinaloa, Pimería Alta (Sonora and southern Arizona), Baja California, and Alta California (California). To the east along the Gulf coast were Nuevo León, Nueva Extremadura (Coahuila), Nuevo Santander (Tamaulipas), and Texas (southeastern, central, and eastern Texas).

Spaniards from the Caribbean islands and New Spain explored the area now known as Texas and New Mexico as early as the sixteenth century. The first sighting of the Texas coast near the mouth of the Río Grande was made by Alonso Alvarez de Pineda in 1519.[4] Alvarez de Pineda, sailing out of Jamaica with four ships and running the coast from Florida to Pánuco (Tampico), was actually looking for the strait to Cathay. Two other expeditions followed, one headed by Diego de Camargo in 1520 and the other by Francisco de Garay, the *adelantado* (governor) of Jamaica, in 1523.

In 1528 Pánfilo de Narváez,[5] the governor of Florida, set out from Cuba with four hundred men, eighty-two horses, four ships, and a brigantine to explore the territory under his jurisdiction. This comprised the area along the Gulf coast from the Atlantic to Texas. The ships were driven off course by a wild south wind in April 1528 and cast ashore on the south coast of Florida. From there Narváez decided to send part of his men in ships to follow along the coast while he and the others went overland. The two groups were never reunited, although the ships tried to establish contact along the coast for a year.

Eventually, somewhere along the Louisiana coast, Narváez and his men were able to build a number of ships, which they hoped to sail westward to New Spain. Some two hundred survivors landed on the southeastern shore of Texas (at or near present Galveston). Only Alvar Núñez Cabeza de Vaca, Alonso del Castillo Maldonado, Andrés Dorantes, and his black Moorish slave, Estebanico, survived the elements, starvation, and hostile Indians. All four, enslaved by various Indian tribes for the next six years, finally managed to escape from their captors and began the trek for which they are famous. They crossed Texas and Mexico from the Gulf coast to the Pacific Ocean through northern Chihuahua and down to Culiacán, finally arriving in Mexico City on July 25, 1536.

Cabeza de Vaca reported hearing about great cities with many-storied houses on the river to the north. The great riches to be found there created quite a stir in Mexico City. As a result of these reports, Antonio de Mendoza, the first viceroy of New Spain (1535–1550), soon sponsored a number of expeditions to these new lands. This marks the first major stage in the exploration of the lands to the north of New Spain.

[3]The Texas rebellion against the central Mexican government in 1836 had become, by the mid-forties, a major problem between Mexico and the United States. Mexico had never recognized Texas independence. Its entry into the Union ten years later led to the war between the two countries (1846–1848) and the loss of this vast territory. This conflict was the culmination of the political changes in that area, which had been set in motion forty years earlier with Mexico's declaration of independence from Spain in 1810.

[4]Cortés was only then making his way to Mexico. However, Spain continued to control Florida (1565–1821) and the area from the Mississippi to the Rockies (1762–1800) from bases in the Caribbean, while the area from Texas to California eventually became part of New Spain. Spain's control of Florida was broken by an English takeover from 1763 to 1783 and by a seizure of its western part by the United States in 1810. See Paul Horgan, *Great River: The Río Grande in North American History.*

[5]"The Narrative of Alvar Núñez Cabeza de Vaca," in *Spanish Explorers in the Southern United States, 1528–1543,* ed. Frederick W. Hodge and Theodore H. Lewis, pp. 1–123; also Thomas F. McGann, "The Ordeal of Cabeza de Vaca," *American Heritage* 12, no. 1 (December 1960): 32–37, 78–82.

Fray Marcos de Niza, under the auspices of the viceroy, made the first planned entry into the region of New Mexico in 1539.[6] His orders stated that he was to explore the area mentioned by Cabeza de Vaca, note the peoples and places in the new lands, and be on the lookout for news of both the South Sea and the North Sea (Pacific and Atlantic oceans).[7] Estebanico, one of the three survivors with Cabeza de Vaca, was to join the expedition, along with Indians from that region who had accompanied the survivors to Mexico. Another friar, named Onorato, enlisted for the expedition but did not complete the trip, for he became ill soon after it was initiated.

The group left Culiacán in early March 1539 on foot. They took no horses or mules. They proceeded northward through Sonora and Arizona up to the vicinity of present St. Johns and then northeastward to the Zuñi pueblo. Along the route from Sonora, Estebanico had gone ahead of Fray Marcos with a contingent of three hundred Sonora Indians. All but three of the Indians were killed by the Zuñi. Quite understandably, Fray Marcos did not visit the Zuñi pueblo. He only got within sighting distance of it.

Fray Marcos reached Compostela near the end of June and was back in Mexico City by August 23 to report his findings to Mendoza. His glowing reports soon led to rumors of greater riches to be found in this new region, which might contain *otro México* (another Mexico), *otro Perú* (another Peru).[8] Fray Marcos's reference to the new province, the home of the Cebola tribes settled in six pueblos, as the Seven Cities of Cíbola[9] led to the far more ambitious Coronado expedition into the same region within the following year.

Francisco Vásquez de Coronado,[10] governor of Nueva Galicia, set out in search of the wealthy cities of Cíbola with an expedition from Compostela. He had over 300 men besides wives and children of a few of the soldiers and several hundred Indians, most of whom were from Michoacán. By the time the expedition had reached Culiacán, there were as many as 250 Spaniards on horseback and more than a thousand horses and mules.

Coronado went northward through present Sina-loa, Sonora, and Arizona, and then eastward into New Mexico, reaching Cíbola (present Zuñi pueblos in western New Mexico) in July 1540. Coronado then sent captains in several directions on reconnaissance missions. Pedro de Tovar and Fray Juan Padilla went northwestward and visited the Hopi pueblos in Arizona. Upon their return, García Lopez de Cárdenas was sent out with twenty-five horsemen on August 25, 1540, to look for the great river in the west (the Colorado). He saw not only the river but the Grand Canyon as well. Within four days, Hernando de Alvarado and, again, Fray Juan Padilla, along with more than twenty other Spaniards, went toward the east to explore the upper Río Grande valley (near Albuquerque), eastern New Mexico, and the buffalo plains. They discovered the pueblos of Acoma, Tiguex, Taos, and Pecos.

Coronado wintered that first year on the Río Grande at Tiguex. He departed for the Quivira (Kansas) province in late April 1541 and arrived at the Barrancas (Cap Rock escarpment) in western Texas in late May. Most of the army was sent back to Tiguex, however, because of damage suffered in a hailstorm. In early June, Coronado decided to go on with thirty mounted men and six footmen in search of Quivira. He traveled through the Texas and Oklahoma panhandles, through southern Kansas to the Arkansas River, going as far as present Lindsborg. He began the march back in mid-August 1541.

[6]Herbert Eugene Bolton, *Coronado: Knight of Pueblos and Plains*, pp. 23–39; "The Narrative of the Expedition of Coronado, by Pedro de Castañeda," in *Spanish Explorers in the Southern United States*, ed. Hodge and Lewis, pp. 273–387; John Francis Bannon, *The Spanish Borderlands Frontier, 1513–1821*, pp. 8–27.

[7]It was believed at this time that another isthmus like that dividing North and South America existed even farther north and would make passage from one ocean to the other easier at those latitudes.

[8]These are references to the conquests of Mexico and Peru, which had netted the Spaniards great wealth.

[9]The Seven Wealthy Cities had earlier been sought in the Caribbean by the Spaniards. These were thought to be in Antilia, thus the naming of the islands as the Antilles. Other long-sought places thought to contain great riches were Gran Quivira (Kansas), and the Kingdom of the Texas.

[10]"Expedition of Coronado," in *Spanish Explorers in the*

As was customary during this time, supplies for the expedition were sent by sea. Two supply ships, under Hernando de Alarcón, left Acapulco on May 9, 1540, and sailed up the coast. By late August, Alarcón had navigated the mouth of the Colorado River and had traveled upstream for fifteen days as far as Yuma, in his efforts to reach Coronado and Cíbola. Alarcón failed to make contact, so he left the Colorado River about the middle of October 1540 and sailed for Colima.

Although Coronado failed to find the riches reported by Fray Marcos, his expedition discovered more lands, which were to be settled later on. He had seen the Zuñi pueblos in New Mexico; Tovar had seen the Hopi in Arizona; Cárdenas had discovered the Grand Canyon; Alarcón had explored the lower Colorado; and Coronado himself had gone as far as Kansas, crossing the Texas and Oklahoma panhandles along the way.

When Coronado and his men returned to Mexico, three friars decided to remain and work among the natives. Fray Luis de Escalona went to the Pecos River and established his headquarters at Ciquíque; Fray Juan de la Cruz stayed in Tiguex; and Fray Juan de Padilla chose Quivira as his field of endeavor. Two Indian *donados* (lay brothers wearing the habit of friars) named Lucas and Sebastián from Zapotlán and a Portuguese soldier named Andrés do Campo went with Fray Juan to Quivira. All three friars were eventually killed by the Indians.

After Fray Juan de Padilla's martyrdom in 1542, Do Campo and the lay brothers managed to escape. They made their way back to Mexico City, traveling from Quivira southward through Oklahoma and Texas, crossing into Mexico near present Eagle Pass, going through Coahuila and Nuevo León, climbing over the mountains into Tamaulipas to Pánuco, and finally reaching their destination in 1547. Do Campo had spent one of those five years in captivity. His reports of his odyssey renewed interest in Quivira.

And so ended the initial penetration into New Mexico, western Texas, and Kansas.

Explorations along the northwestern reaches of the frontier were also conducted during Mendoza's term as viceroy.[11] Juan Rodríguez Cabrillo, a Portuguese navigator, was commissioned to explore the upper California coast for the purpose of finding the northern strait, which would afford a new route to Europe. He was also to be on the lookout for news of Coronado.

Cabrillo sailed from Puerto Navidad (twenty miles above Manzanillo) on June 27, 1542, explored the coast of Baja California, and finally reached San Diego Bay on September 28, 1542. He sailed up the California coast to just above present Santa Barbara by mid-October. After some delay caused by several storms, the journey was continued by early November. Although Cabrillo went beyond present San Francisco, he did not see the Golden Gate or Monterey Bay farther down the coast. The expedition returned several weeks later to winter on San Miguel Island, across from Santa Barbara.

Cabrillo died on January 3, 1543, as a result of an injury (broken arm) received on the same island sometime earlier. Bartolomé Ferrelo, chief pilot, then took over the command of the expedition. The explorations were resumed northward in early February, and by March 1 the farthest point north was reached into present Oregon near the Rogue River. The ships were back in San Diego by early March and in Puerto Navidad by early April 1543.

The central and extreme northwestern parts of the frontier of New Spain were explored within two decades of the conquest. Further exploration, settlement, and missionary work were to be concentrated within the north-central region for the remainder of the sixteenth century.

By the middle of the sixteenth century the north-central frontier of New Spain had been pushed as far as Zacatecas (1548) and within fifteen years northwestward to Durango (1563).[12] Before 1580, mines had been opened farther north in Santa Bárbara, Parral, San Bartolomé, and other places. By

Southern United States, ed. Hodge and Lewis, pp. 273–387.

[11]Herbert Eugene Bolton (ed.), *Spanish Exploration in the Southwest, 1542–1706,* pp. 1–39.

[12]Ibid., pp. 135–280.

the late sixteenth century settlements had reached the head of the Conchos River. It was from these frontier settlements that expeditions toward New Mexico were initiated.

The first of these expeditions was led by Fray Agustín Rodríguez, who was accompanied by two friars, Francisco López and Juan de Santa María; nine soldiers, led by Francisco Sánchez, known as Chamuscado; and sixteen Indian servants. They left Santa Bárbara on June 5, 1581, passed down the Conchos to the Río Grande, followed that river northward into north-central New Mexico, and visited the Acoma and Zuñi pueblos. Sánchez and the soldiers returned to Nueva Vizcaya, but the missionaries stayed at Puaray (near Bernalillo), where they were later killed by the Indians. Fray Santa María had been killed earlier by the Maguas Indians.

The second expedition into New Mexico, led by Antonio de Espejo, was originally organized to aid the friars left at Puaray. Although news of their death was received, the "relief" expedition set out from San Bartolomé, just east of Santa Bárbara, on November 10, 1582. Espejo had twelve soldiers, Fray Pedro de Heredia and Fray Bernaldino Beltrán, servants and interpreters, and 115 horses and mules. They followed the same route, down the Conchos and then up the Río Grande into New Mexico. They explored the Magua province to the east, the Acoma and Zuñi to the west. Once missionary work was initiated in the area, Espejo explored farther north in search of a lake of gold. Failure to find the gold did not deter exploration, which was then continued westward into Arizona, where rich ores were found. The entire Espejo expedition returned to San Bartolomé by late September 1583.

Another venture (unauthorized) into New Mexico was led in 1590 by Gaspar Castaño de Sosa, lieutenant governor of Nuevo León. This time the expedition was organized far to the east in the mining town of Almadén (present Monclova), later the capital of Nueva Extremadura. Sosa, who had been left in charge of the settlement when Luis de Carbajal was arrested by the Inquisition and taken to Mexico City, had deserted Almadén with more than 170 persons

and gone to New Mexico. Sosa went as far as Taos, conquering all the way. In the midst of his successes he was arrested by Captain Juan Morlete, who had been sent for that purpose from Saltillo by the viceroy.

One other unauthorized expedition was made from Nueva Vizcaya into New Mexico in 1593 by Francisco Leyva de Bonilla and Antonio Gutiérrez de Humaña. They went as far as the Arkansas in eastern Kansas and continued as far as the Platte. On the way Humaña murdered Leyva and took command, but later he and nearly all of his party were destroyed by the Indians.

The first major settlement in the north-central region was led by Juan de Oñate, a Mexican-born Spaniard (Guadalajara), who in 1595 was granted permission to colonize the district north of the Río Grande. Oñate left Mexico City early in 1596 but suffered long delays, mostly inspections, along the way in Zacatecas, San Bartolomé, and other towns. Finally, on February 7, 1598, he left Río Conchos with 400 men, of whom 130 had their families, 83 wagons and carts, and a herd of more than 7,000 head of stock.

Just north of El Paso, Oñate took possession of the new lands; eventually, Pueblo country farther north was reached. In July 1598 the pueblo of Caypa (northern New Mexico), christened San Juan de los Caballeros, became the first capital of New Mexico. The first church was built here in the same year.[13] After settlements were established, Oñate continued explorations to the northeast, the southeast, and the west (Arizona) in that same year. By 1601 he had explored the region seen by Humaña (the Arkansas) and had gone as far as present Wichita, Kansas. By October 1604 he had gone into Arizona to the Colorado River and had followed its left bank south to the Gulf of California. He was back in New Mexico by the following year.

The extreme northwestern frontier along the Pacific coast of California was also explored during this

[13]The first church built in New Mexico was begun on August 23, 1598, and completed on September 8.

same period.[14] Just as Mendoza had earlier sponsored an extensive program of discovery and conquest into New Mexico and California, now another viceroy, Luis de Velasco (1590–1595), renewed these efforts to explore and settle the frontier lands. The colonization of New Mexico by Oñate had been arranged during his tenure as viceroy. And now Sebastián Vizcaíno was commissioned to explore the Gulf of California and the eastern coast of Baja California, and to establish a colony at La Paz. This he attempted to do in 1596–1597.[15] His orders were later amended to include the exploration of the upper California coast, which he carried out in 1602–1603. All of this was done under the new viceroy, Gaspar de Zúñiga y Acevedo, Conde de Monterey (1595–1603), who continued to support these expeditions.

The Vizcaíno expedition, comprised of three vessels, set sail from Acapulco on May 5, 1602. Two vessels reached San Diego, while the third finally rejoined the expedition on Santa Catalina Island in early December. On December 15 the bay named after the Conde de Monterey was discovered. Vizcaíno's glowing reports of this bay were to cause some problems for Gaspar de Portolá 166 years later.[16] Portolá's expedition would bypass the bay, failing to recognize it as Vizcaíno's bay of Monterey.

Two of Vizcaíno's vessels continued northward in January 1603, while the third returned southward for supplies. One of the vessels reached the present border between California and Oregon. The other went a little farther along the Oregon coast than even the Cabrillo expedition of 1542 had done. The two vessels were not reunited until they reached Acapulco.[17]

The frontier to the northeast had not been extended appreciably during the sixteenth and seventeenth centuries.[18] Saltillo had been founded in 1565. In 1579 Luis de Carbajal had been authorized to found Nuevo León in the region. He founded León (now Cerralvo) in 1583 and Villa de Almadén in 1590. Unfortunately, the entire region with headquarters at Almadén was abandoned by Sosa in 1590 when he went into New Mexico. Although efforts were made

to reopen the mines at Almadén in 1603 and again in 1644, León remained the northeastern outpost of Nuevo León. Only when the frontier settlements were troubled by the tribes of the Coahuila district and the region beyond the Río Grande were steps taken in that direction. In 1655 a troop of 103 soldiers plus 300 Indian allies under Fernández de Azcue crossed the Río Grande in search of the Casastles, a marauding Indian tribe. They slew 100 and took 70 prisoners. This may have been the first crossing of the Río Grande by New Spaniards.[19]

A deeper penetration of Texas was made, however, from the north-central frontier, where all the major expeditions into New Mexico had taken place, and from New Mexico itself.[20] In 1629 Fray Juan de Salas, accompanied by Fray Diego López and three soldiers, left Santa Fe and traveled eastward into present West Texas. Three years later Salas returned to the same region, accompanied this time by Fray Diego de Ortega and some soldiers. Fray Ortega remained with the Indians (the Jumanos) for six months to carry out missionary work.

Captains Hernando Martín and Diego del Castillo traveled to Jumano country in 1650 and stayed there

[14]Bolton, *Spanish Exploration*, pp. 41–134.

[15]A settlement established by Vizcaíno at La Paz in 1596 was eventually abandoned due to lack of provisions, bad weather, and trouble with the Indians.

[16]Bolton, *Spanish Exploration*, pp. 91–93. Vizcaíno's description of the bay misled the Portolá expedition of 1769. Failing to recognize it as Vizcaíno's bay of Monterey, they called it "Bay of Pines." They were back in late March 1770, by then convinced that it was Monterey, after all.

[17]The *Santo Tomás*, under Captain Gómez, was sent back to secure supplies. The *San Diego* was Vizcaíno's ship, with Francisco de Bolaños as chief pilot. The *Tres Reyes*, under Sebastián Meléndez, succeeded in going farther north than the *San Diego*.

[18]Bolton, *Spanish Exploration*, pp. 281–423.

[19]Herbert Eugene Bolton, *Bolton and the Spanish Borderlands*, ed. John Francis Bannon, pp. 107–122. Other expeditions were carried out several years earlier for the same reasons against the Casastles. In 1653, Juan de la Garza led a campaign against them with soldiers from Saltillo and Nuevo León but did not cross the Río Grande. Others who led similar expeditions were Alonso de León and Juan de Zavala.

[20]Ibid., pp. 100–106.

for six months. The pearls they brought back to
Santa Fe were sent to the viceroy in Mexico, who at
once authorized another expedition.[21] They also re-
ported for the first time the existence of the "King-
dom of the Texas"[22] toward the eastern part of the
province.

The second expedition into western Texas, led by
Diego de Guadalajara with thirty soldiers, went into
Jumano country in 1654. They fought the Indians,
killed many, and took two hundred prisoners. Their
booty consisted of buckskins, elkskins, and buffalo
hides. Thus, interest in pearls, found in the Colorado,
and trade in peltry rather than missionary work were
the motivating forces behind subsequent exploration
into the area.

The next staging area for expeditions into West
Texas was located farther south in El Paso, where the
center of the New Mexico province had been trans-
ferred in 1659. The Mission de Nuestra Señora de
Guadalupe had been founded by Fray García de San
Francisco in that year.[23] By the early eighties, mis-
sionary work had been extended along both sides of
the Río Grande to La Junta, near present Presidio,
Texas. Before the end of 1684 seven churches had
been built in this region. These were eventually
abandoned as a result of Indian uprisings.

Fray Nicolás López and Captain Juan Domín-
guez de Mendoza left El Paso on December 5, 1683,
and followed the Río Grande toward La Junta, the
region near the junction of the Conchos and the Río
Grande. From there they turned north on January 1,
1684, and went to Pecos, then east beyond present
San Angelo, near the junction of the Concho and the
Colorado.

Fray López wrote to the king on April 24, 1684, to
recommend that further missionary work be carried
out in the area.[24] He described the region, reported
the number of tribes found there, and gave the num-
ber of missionaries he considered necessary for the
conversion of the natives. Unfortunately, there were
more pressing matters, so these recommendations
were not carried out.

Exploration of Texas from the southeast was reini-
tiated in the last quarter of the seventeenth century

from Nueva Extremadura, now established as sep-
arate from Nuevo León. Antonio de Valcárcel was
made *alcalde mayor* of the new region in 1674. Al-
madén, abandoned in 1690 by Sosa, was refounded
by Valcárcel, who renamed it Nuestra Señora de
Guadalupe. It was from this outpost of Guadalupe
(present Monclova) that later expeditions into Texas
were organized.

Antonio de Valcárcel sent Fernando del Bosque
and Fathers Juan Larios, of the province of Santiago
de Jalisco, and Dionysio de San Buenaventura across
the Río Grande in 1675 to explore the country and to
initiate missionary work. Other expeditions into the
region followed between 1686 and 1690, when news
of La Salle's expedition into southeast Texas became
known.[25] A series of explorations followed, four by
sea and five by land from Monterrey and Monclova.
The main purpose of all these expeditions was to
find the French settlement, the Bay of Espíritu San-
to (La Bahía), and the country of the Tejas.

The first sea exploration sent by the viceroy from
Veracruz in 1686, under Juan Enríquez Barroto,
found nothing. The second, under Martín de Rivas
and Pedro de Iriarte, with Barroto as pilot, set out
the following year. They found the wrecks of two of
La Salle's vessels in Matagorda Bay. The other ex-
peditions were made from Nuevo León by Alonso de
León. The first two expeditions, carried out in 1686
and 1687, were concentrated along the lower Río
Grande. In 1688 León went after Jean Géry, a
Frenchman, who was reported to be in the region.
He was captured and sent to Mexico City. In 1689
León, accompanied by Fray Damián Massanet, 4
friars, and 110 soldiers, crossed the Río Grande and
went as far as Matagorda Bay in search of the La

[21]This was Viceroy Luis Enríquez de Gúzman, Conde de
Alba de Liste, Marquez de Villaflor.
[22]Bolton, *Bolton and the Spanish Borderlands*, p. 106. The
quest for the Kingdom of the Texas was in line with those ex-
peditions of the sixteenth century that had been carried out in
search of the Seven Wealthy Cities and the Gran Quivira.
[23]Ibid., p. 115. The mission was founded on the south side
of the Río Grande, now Juárez, Mexico.
[24]Ibid., pp. 118–119.
[25]Ibid., pp. 120–122.

Salle settlement. Within the following year they went farther north to the Neches River in eastern Texas. Here two missions were founded in 1690: San Francisco de los Tejas, probably southwest of Nacogdoches between the Trinity and the Neches, and El Santísimo Nombre de María, on the Neches a few miles north of San Francisco.[26] These were abandoned within three years because of a lack of success in converting the Indians and failure to receive asked-for support from the authorities.

Eventually, explorations as far as the Red River valley and along the coast were made by Domingo Terán de los Ríos in 1691 before the pullback of the northeastern frontier.

At the time that Texas was being reexplored in the late seventeenth century and the first missions were being founded in East Texas, another similar development was taking place in the far northwestern province of New Spain. This was in Pimería Alta, where the Jesuit priest Father Eusebio Francisco Kino carried out explorations and missionary work among the Pápago and Pima Indians.[27]

Father Kino left Mexico City on November 20, 1686, and went to Guadalajara, where he secured special privileges from the Audiencia for his work in the northern borderlands. He set out in mid-December and reached Sonora early in 1687. His assignment was centered in Pimería Alta, where he began explorations, conversion, and mission building that was to last for the next twenty-four years until his death in 1711. He founded Mission Nuestra Señora de los Dolores at the Indian village of Cosari. From this outpost he pushed the frontier across Pimería Alta to the Gila and Colorado rivers (southern Arizona). By 1695 he had founded a chain of missions up and down the valleys of the Altar and Magdalena rivers in Sonora and another chain northward to the east of Dolores mission.

Father Kino eventually carried out fourteen expeditions into southern Arizona and many more throughout Sonora. His contribution to exploration, beyond the great number of missions established throughout the area, was to disprove the idea that California was an island, thus bringing the colonization of that province a step closer.

Father Kino founded San Xavier del Bac in April 1700.[28] This was to be the headquarters for the next great explorer of the area, Fray Francisco Garcés.

The final round of explorations and settlement into Texas in the early eighteenth century and into California fifty years later came as a result of French encroachment along the eastern borders of the former, and fear of Russian incursions along the northwestern borders of the latter.

Efforts to contain French interests in East Texas were initiated in 1716 by Domingo Ramón as a result of a French trading expedition led a few years earlier by Louis Juchereau de St. Denis from Louisiana into Texas and across the Río Grande into San Juan Bautista.[29] St. Denis was eventually sent to Mexico City, where plans were made to establish missions and to occupy East Texas. St. Denis accompanied the expedition led by Ramón, along with more than seventy men, women, and children. Fray Isidro Félix de Espinosa and eight Franciscans and three lay brothers from the Missionary College of Querétaro and others from the College of Zacatecas accompanied the expedition.[30] Among those from Zacatecas was Fray Antonio Margil de Jesús, who was to later found important missionary establishments in Texas.

The expedition crossed the Río Grande at San Juan Bautista in 1716. By late June they had reached a point between the Trinity and Neches rivers, where they met peacefully with the Indians of the area. A chain of six missions and a presidio were eventually

[26]Hallenbeck, *Spanish Missions*, pp. 49–50.

[27]Bolton, *Spanish Exploration*, pp. 425–463.

[28]Father Kino also founded Mission San Gabriel de Guevavi, near Nogales. The Franciscans later renamed it Los Angeles de Guevavi. After its destruction by the Indians in 1782, the *visita* of Tumacacori, also founded by Father Kino, was made a mission in its place.

[29]Bannon, *Spanish Borderlands Frontier*, p. 110.

[30]Marion A. Habig, "Mission San José y San Miguel de Aguayo," *Southwestern Historical Quarterly* 71 (April 1968): 497. The College of Santa Cruz de Querétaro, first college of Propaganda Fide founded in the new world, dates from 1683. In 1704 the Franciscan fathers from the College of Querétaro were authorized to establish the College of Nuestra Señora de Guadalupe de Zacatecas. Father Antonio Margil de Jesús, named guardian in 1706, went there in 1707, the year it was officially established.

established. The two old missions were reoccupied and four more were founded between the Trinity and Sabine rivers.[31]

The founding of missions and settlements in San Antonio took place at about the same time. Martín de Alarcón, governor of Coahuila and Texas, led an expedition into San Antonio with Fray Padre Antonio de San Buenaventura y Olivares in charge of all the missionary work.

Alarcón arrived in Saltillo in June 1717 and was in San Juan Bautista by August. Fray Olivares had left Mexico City and gone by way of Querétaro, where two missionaries joined him on the trek northward. They reached the Río Grande in May 1717 and established themselves downriver from San Juan Bautista in the Mission San Francisco Solano in the Valley of San José. A long delay followed, pending final instructions for the expedition from Mexico City. These finally arrived in April 1718, but Alarcón, impatient at such a long delay, had set out on April 9. Seventy-two persons accompanied him on the expedition. They had 7 droves of mules, 548 horses, and an undetermined number of cattle and goats. The expedition went up to the Bay of Espíritu Santo (La Bahía) and then to the San Antonio River. On May 1, 1718, Mission San Antonio de Valero (the Alamo), named after Viceroy Marqués de Valero, was founded, and within five days the Presidio de Bexar was established.

By 1719 all the settlements in Texas were again threatened by the French. France had challenged the Spanish occupation of Sardinia and invasion of Sicily. When war broke out between the two countries, the French in the New World took Pensacola and then attacked the missions in East Texas, forcing the missionaries to retreat to San Antonio. The New Spaniards responded by launching an expedition under the Marqués de Aguayo, who enlisted and equipped eighty-four men for this purpose. By the time he was ready to go in October 1720, he had over five hundred men. He set out to reoccupy the province, restore the missionaries in East Texas, and fortify the Bay of Espíritu Santo. The main body of his army was in San Antonio by April 1721 and in East Texas as far as the Trinity by early July, reaching the old site of San Miguel Mission in late August. Fray Antonio Margil de Jesús relocated the mission, which he renamed San Miguel de los Adaes. A fort was soon established in the area and manned by one hundred soldiers, equipped with six cannons. Aguayo was back in San Antonio in January 1722 and in Mexico City by May of the same year.

Three new missions had been added to the seven founded before the retreat;[32] there were two more presidios and many more men guarding these frontier outposts. Texas was secured for the time being.

The last of the major expeditions took place in California, spurred by the fear of a southward move along the Pacific coast by the Russians. The first of the northwestward expeditions was sponsored by José de Gálvez, Visiter General of New Spain.[33] A land-and-sea expedition was authorized with Gaspar de Portolá, the governor of Baja California, as

[31]Bannon, *Spanish Borderlands Frontier*, pp. 114, 116. The missions founded by mid-1716 were (1) San Francisco de los Tejas, (2) Nuestra Señora de la Purísima Concepción de Acuña, (3) Nuestra Señora de Guadalupe de los Nacogdoches, and (4) San José de los Nazones. Fray Antonio Margil founded (5) Mission San Miguel de Linares de los Adaes in the fall of the same year. The last mission was (6) Nuestra Señora de los Dolores de los Ais.

[32]James Wakefield Burke, *Missions of Old Texas*, pp. 69, 71, 91, 116, 120–124. Four missions were reestablished in East Texas: (1) San Francisco de los Tejas was reestablished on August 5, 1721, and renamed San Francisco de los Neches; (2) Nuestra Señora de la Purísima Concepción, (3) San Miguel de Linares de los Adaes, and (4) San José de los Nazones were also reestablished in 1721. (5) Nuestra Señora de los Dolores de los Ais, a new mission, was founded in the same year. (6) San Francisco Xavier de Náxera, just south of San Antonio, and (7) El Espíritu Santo de Zúñiga, near Matagorda Bay, were established in 1722. Three other missions had been founded at or near San Antonio several years earlier: (8) San Antonio de Valero in 1718, (9) San José y San Miguel de Aguayo in 1720, and (10) Mission de las Cabras, Floresville, in 1720. Nuestra Señora de Guadalupe de los Nacogdoches, abandoned earlier, was finally reestablished in 1726. In 1730 three of the East Texas missions were moved to the Colorado River, near Austin, prior to their final move to San Antonio in the following year. San Francisco de los Neches (formerly San Francisco de los Tejas) became San Francisco de la Espada; Nuestra Señora de la Purísima Concepción retained its name; and San José de los Nazones became San Juan Capistrano.

[33]Bannon, *Spanish Borderlands Frontier*, pp. 154–160.

commander in chief of the undertaking and Junipero Serra, head of the Franciscan missions of the same province, in charge of the missionary work. The purpose of the expedition was to establish presidios at San Diego and Monterey, found missions, and convert and civilize the Indians.

The sea expedition was comprised of three ships. The *San Carlos,* with sixty-two persons aboard under Vicente Vila, left La Paz in early January 1769 and spent 110 days at sea. The pilot misread the charts, bypassed San Diego Bay, and went as far as the channel islands off Santa Barbara before turning back. The *San Antonio,* with a crew of twenty-six under Juan Pérez, sailed on February 15 and reached San Diego in 54 days. The supply ship *San José* never arrived in San Diego.

The overland expedition was divided into two companies. The first group, under Fernando de Rivera y Moncada, accompanied by Fray Juan Crespi, twenty-five soldiers, three muleteers, and some forty Indians from the old missions, left Velicatá (San Fernando) on March 24, 1769, and arrived in San Diego on May 13. The second group, under Portolá and Serra, left the port of Loreto in mid-May and reached San Diego the last day of June. Both groups arrived in San Diego without incident. However, the sea voyages had inflicted such hardships on the crews and passengers of the two ships that eventually the entire expedition was reduced to 126 New Spaniards. Twenty-three had perished on the vessels or after landing.

Portolá was determined to continue the expedition northward. Leaving Fray Serra and two other Franciscans, a few soldiers, and some workmen to start a settlement, Portolá set off on July 14, 1769. Fray Serra dedicated the first mission in California, which he named San Diego de Alcalá, two days later. Portolá with sixty-four men, among them the friars Juan Crespi and Francisco Gómez, began the march northward toward Monterey. They arrived in early October, but Portolá was not sure that this was the bay Vizcaíno had described almost two centuries before. They continued to explore farther north, going as far as Halfmoon Bay. From Mountain Montara they sighted Point Reyes to the north-

west (Drake's Bay).[34] On November 4 the San Francisco Bay was sighted for the first time at Palo Alto by a scouting party led by José de Ortega. These sightings of the spectacular San Francisco Bay did not, however, deter Portolá from searching further for Monterey Bay. Giving up for the time being, the Portolá party returned to San Diego in late January 1770. During their absence, fifty more persons had died there. The fortunate arrival on March 19 of the supply ship *San Antonio* from San Blas saved the new colony.

By late March 1770 Portolá and Crespi were back in Monterey, now convinced that this was the bay mentioned by Vizcaíno. Serra arrived aboard the *San Antonio* on May 31, and within a few days the bay was secured with the establishment of the presidio and mission of San Carlos Borromeo. Portolá returned to Mexico to make his report to Viceroy Carlos Francisco de Croix (1766–1771). As a result, missionary work was expanded to include the founding of five more missions.[35] Ten more friars, sent on the *San Antonio* to carry this out, arrived in Monterey in May 1771.

In July 1771, Pedro Fages and four friars sailed southward to San Diego. From there an expedition was organized that led to the founding of Mission San Gabriel (Los Angeles) on September 8, 1771. One of the other missions was authorized for Point Reyes on Drake's Bay, which was still designated as San Francisco Bay. A way around the actual San Francisco Bay had to be found. Fages, left in charge of Monterey when Portolá returned to Mexico, had explored the eastern side of the bay in 1770. By the spring of 1772, Fages and Fray Crespi made an effort

[34]Ibid., p. 26. Cabrillo had first discovered the bay in 1542, twenty-five years before Drake sighted it. Sebastián Meléndez Rodríguez Cermeño lost a rich cargo from the Philippines at this bay in 1595. Late-eighteenth-century attempts to skirt the Contra Costa (Oakland and Berkeley) were made in order to reach this bay by an overland route.

[35]Ibid., p. 158. The so-called chain of missions was eventually established during a seven-year period from 1769 to 1777. San Diego de Alcalá (1769) and San Carlos Borromeo (1770) were followed by San Antonio de Padua (1771), San Gabriel Arcangel (1771), San Luis Obispo de Tolosa (1772), San Francisco de Asís (1776), San Juan Capistrano (1776), and Santa Clara de Asís (1777).

to reach the so-called San Francisco Bay. They traveled over Fages's former trail and continued north and east as far as Suisan Bay and then turned back. They were unable to cross the water at this point.

The next stage of the California colonization process took place in the northwestern part of New Spain in Pimería Alta. Viceroy Fray Antonio María de Bucareli y Ursua (1771–1779) ordered that San Francisco Bay was to be occupied and two missions set up. An essential part of this undertaking was the opening of an overland route from Sonora to California.

From the late seventeenth century, when Father Kino had been establishing missions all through Pimería Alta, to the eighteenth, the dream of an overland route from Sonora to California had persisted in New Spain. However, the constant warfare with the Indians along the northwest frontier had delayed carrying out any moves in this direction.[36] When the last major expeditions of exploration and settlement were carried out in upper California, it became apparent that such a land route would be absolutely essential, for Baja California would not be adequate as a source of supplies as had other provinces during earlier step-by-step northward extension of the frontier. Besides, sending supplies by sea was too dangerous and too expensive. A way to send supplies from the more prosperous Sonora settlements to Alta California had to be found.

Fray Francisco Garcés, assigned to the Mission San Xavier del Bac in 1768 when the Jesuits were expelled from the area,[37] explored the region to the west and north. He followed Father Kino's explorations along the Colorado and Gila rivers on two occasions and then went farther west into present southern California on a third journey. It was on this trek westward as far as present Calexico that Fray Garcés became convinced that a way could be found through the Sierras to the settlements along the Pacific coast.

When Juan Bautista de Anza, a third-generation Sonoran, learned of the Garcés trek, the stage was set for the next step in the establishment of an overland route to California.[38] Anza, also convinced that such a route was possible, wrote to the viceroy in May 1772, asking that he be allowed to open a road from Sonora to the sea. The viceroy's approval of the plan reached Anza in late January of the following year. His instructions stated, among other things, that a road to San Diego and Monterey by way of the Gila and Colorado rivers was desirable. As Anza requested, Garcés was to serve as guide and missionary for the expedition.

Final preparations were made in San Miguel de Horcasitas, the capital of Sonora and the place of residence of the governor. Anza left Horcasitas on January 6, 1774. Two days later he left Tubac (south of Tucson), the staging area for the expedition, with the friars Garcés, Juan Díaz, and Juan Bautista Valdez; twenty volunteer soldiers from the presidio; an interpreter; a carpenter; five muleteers; two servants; thirty-five muleloads of provisions; and sixty-five head of cattle. They traveled southward and then northwestward toward the Colorado and Gila rivers. They followed the Colorado south to the present Arizona, Sonora, and California borders and then continued west. They were forced to turn back to the Colorado when they failed to find sufficient water for the cattle. After an eighteen-day delay, Anza set off again through the desert on March 2, leaving the stock behind in the care of the Yuma chief Palma.[39] This time they were successful, and by the twenty-second the party had reached San Gabriel (north of

[36]Ibid., pp. 124–143, 149, 151–152, 154. The coastal Pima revolted in 1737. There was also unrest among the Mayo and Yaqui Indians. In late 1751 the entire Pimería erupted under the leadership of the Pima Indian Luis of Saric. Around one hundred New Spaniards were killed. During the 1750's and the 1760's the Seris and the Apaches continued to be a threat. In the 1770's the New Spaniards had trouble with the Seris and the Apaches in Sonora.

[37]Ibid., p. 154.

[38]Herbert Eugene Bolton, *Outpost of Empire*, p. 30.

[39]Ibid., pp. 44–45, 89, 326–332. The Yuma chief Olleyquotequiebe ("Wheezer"), known to the Spaniards as Palma, was to play an important role in the opening up of the new road to California. Anza and Garcés made the crossings of the Colorado, during the initial exploratory trip and later with the colonists, with Palma's help. Anza was so grateful that he took Palma to Mexico City, where he was feted by the viceroy. The high point in Palma's sojourn in Mexico City was his baptism in the cathedral.

present Los Angeles). Anza went on to Monterey, while Garcés returned to the Colorado.

With the opening of the new road to Monterey, the way was now clear for establishment of a colony in San Francisco. The colonists were enlisted from the Sinaloa settlements of Culiacán, Fuerte, Mocorito, and Sinaloa.[40] Anza led the expedition of 177 persons from Horcasitas in the fall of 1775. Fathers Pedro Font, Garcés, and Tomás Eixarch accompanied the expedition. By the time they had left Tubac on October 23, the group had grown to 240 persons. Among the soldiers was Lt. José Moraga, who was to lead the colony from Monterey to San Francisco. There were 8 veterans from the presidios of Sonora, 20 recruits, 10 soldiers from Tubac, 29 wives of soldiers, 20 muleteers, 3 *vaqueros*, 3 Indian interpreters, and 4 servants. They had more than 1,000 head of stock — 695 horses and mules and 355 head of cattle.

The expedition went north through present Tucson, by Casa Grande near the Gila River, and then westward, following the river to the Colorado. This way was considered less dangerous than the southern route taken by Anza earlier.[41] On the Colorado they met the Yuma chief Palma, who had been so helpful to the Anza exploration party a few years earlier. From here the route was basically the same through the desert as far as present Calexico and beyond the mountains to San Gabriel, which they reached in early January 1776. They were in Monterey by March and in San Francisco by June 27. As soon as Anza had selected the sites for the presidio and the mission in San Francisco, he placed the colony under the charge of Moraga and returned to Mexico to make his report to the viceroy.[42]

Orders to select the sites for the presidio and the mission had been given several years earlier by the viceroy so that these would be ready for the colonists when they arrived. A land-and-sea expedition was commissioned to carry this plan out. Only the sea exploration was accomplished. Rivera, encharged with the land expedition, was involved with other matters and was unable to fulfill these orders. The *San Carlos*, commanded by Juan Bautista de Ayala,

was to explore the harbor of San Francisco. Ayala sailed from Monterey on July 27, 1775, and arrived in front of the Boca (the Golden Gate) on August 5. He drifted in with the tide that same day. For the next four weeks Ayala explored the islands (Angel, Yerba Buena, and Mare), San Pablo Bay, and Suisan Bay as far as the mouth of the San Joaquin River, the north and the south as well. He set sail on September 7 and got through the Boca on the eighteenth, reaching Monterey the next day. By the time the land expedition had reached Point Lobo after several delays on September 22, the supply ship *San Carlos* had departed.

Summary

The earliest sightings of that territory which is now the Southwest (Texas, New Mexico, Arizona, and California) were made by Caribbean-based Spaniards. Even the conquerors of Mexico were from the islands in the Caribbean. The sightings of the Texas coast and the Hernán Cortés expedition to Mexico took place in the same year. Within two decades the entire northernmost region designated as Nuevo México was explored and claimed by Spain. Settlers entering the central part of the region toward the end of the sixteenth century continued to move into the eastern and western portions of it over the next two hundred years. Thus were New Spanish roots established in the Southwest. The earliest penetration was made into present New Mexico in the sixteenth century, followed by movements into Texas and Arizona during the late seventeenth and early eighteenth centuries. By the time California was settled, the cities in central and northern New Spain were already over 250 years old.

Throughout this three-hundred-year period New

[40]Ibid., pp. 133–154. See note 27, Introduction.
[41]Ibid., pp. 162–163. The trek through the Altar Valley during the initial trip through the "Desierto del Diablo" had been a most arduous one. Even though the northward route from Tubac to the Gila and from there to Yuma was dangerous—Apaches—it was shorter, and water was more plentiful.
[42]Ibid., p. 274.

Spain (Mexico), itself, had gone through a transformation that was manifested in part by rich and varied architecture, painting, and sculpture. The constant extension of the borders ever northward had as one of its attendant features the development of art and architecture that echoed central Mexican models.

The change in political boundaries during the second quarter of the nineteenth century did not have any effect on the cultural boundaries, particularly in New Mexico, where a sculptural tradition continued largely unchanged throughout the nineteenth century and well into the twentieth.

No longer part of New Spain or the Republic of Mexico, the Southwest nonetheless retained close ties with Mexico. Therefore, for purposes of convenience, this territory, where most Mexican Americans continue to live, will be designated as Mexican America in the body of this study.

2. Art and Architecture
Seventeenth to Nineteenth Centuries

The Missions

THE MAIN PURPOSE of the missions was to introduce the faith among the Indians, although they served defensive and political purposes as well.[1] In carrying out their primary religious tasks, the friars also acted as explorers, builders, cattle raisers, and teachers. Fray Marcos de Niza was the first of these explorers to go into the new lands later named Nuevo México. Fray Agustín Rodríguez rediscovered the province of New Mexico. Father Juan Larios was active in Coahuila. Father Eusebio Francisco Kino made more than forty journeys across the deserts of Sonora and southern Arizona. He demonstrated that California was a peninsula and not an island. Father Francisco Garcés traveled over two thousand miles through Arizona, California, and New Mexico in efforts to find a better route to California (Santa Fe to Monterey).[2]

Beyond their role as explorers, the friars, by converting and civilizing the Indians, helped colonize and settle the new lands. The mission, a religious and self-sustaining economic unit (ideally), was indispensable to the success of this entire process.

The friars often went into the wilderness to convert and civilize the Indians before colonists were sent out. During the first several centuries after the conquest, the Crown made it an official policy to use and support the missions in the process of bringing, and retaining, ever larger areas and their populations under Spanish rule.[3] There were notable failures, of course, like the intractable Comanches and Apaches, who constantly raided the missions and, later, the civilian settlements. But, by and large, the missionaries succeeded in introducing the faith among the Indians and, in so doing, brought a whole

[1]Herbert Eugene Bolton, *Bolton and the Spanish Borderlands*, ed. John Francis Bannon, pp. 187–211.

[2]Ibid., pp. 255–269, and Herbert Eugene Bolton, *Outpost of Empire*, pp. 291–298. Garcés, on his own after the colony had been safely guided to San Francisco, set out to find an overland route between Santa Fe and Monterey. He actually traveled as far as eastern Arizona before turning back. Before doing so he sent a letter by Indian courier to the settlements in New Mexico. The letter, written by Garcés on July 3, 1776, is published in a volume containing letters and other documents by and related to Fray Francisco Atanasio Dominguez (*The Missions of New Mexico, 1776*, trans. and annot. Eleanor B. Adams and Fray Angelico Chávez, p. 283).

[3]Bolton, *Bolton and the Spanish Borderlands*, p. 197.

new array of technical and economic knowledge, which helped to develop the outer reaches of New Spain. Farming, grazing, stock raising, and a number of trades were introduced and carried out at the missions. In Texas and California these became veritable on-going industrial, ranching, and farming concerns during the eighteenth and nineteenth centuries.[4]

The same process had been carried out earlier in central Mexico, immediately following the conquest. The Franciscans were the first to arrive in 1524, followed by the Dominicans in 1526, and the Augustinians in 1533. The Jesuits arrived in 1556. During the early years of the conversion, the Franciscans stayed in the central area and in the western provinces. They eventually moved into the entire northern frontier of New Spain into the present Southwest. The Dominicans concentrated their efforts in southern Mexico, in present Oaxaca and Chiapas, while the Augustinians stayed nearer Mexico City, to the northwest in present Michoacán, and to the north in present Hidalgo.[5]

The Franciscans, initially assigned to the north-central and northeastern parts of the frontier in Coahuila, Nuevo León, Nuevo Santander, New Mexico, Texas, and Florida, eventually took over the missions in the northwestern portions of the frontiers, as well. For a brief period during the late seventeenth and eighteenth centuries, the Jesuits had founded and built missions in Sinaloa, Pimería Alta, Nueva Vizcaya, and Baja California. These mission fields were assigned to the Franciscans when Charles III expelled the Jesuits from all of the Spanish dominions in 1767.[6] Further assignments came for the Franciscans when conversion of the Indians in Alta California was initiated in 1768–1769. Personnel for this missionary work came from Baja California, where they had only recently arrived, following the expulsion of the Jesuits. The Dominicans then took over the missions in Baja California.

By the time that missions were established in New Mexico, Arizona, Texas, and California, the headquarters for many of the outlying stations had also moved northward into Guadalajara, Zacatecas, and Querétaro.[7] Friars stationed along the frontier usual-

ly came from these centers. Missions San Antonio de Valero and San José y San Miguel de Aguayo were run by Zacatecan friars, while the three other missions in San Antonio — San Juan Capistrano, San Francisco de la Espada, and Concepción — were staffed by Querétaran friars. Father Kino in Pimería Alta received his instructions and assignment from the Audiencia of Guadalajara, although, for administrative purposes, the diocese had been moved from that city to Guadiana, or Durango, in the 1620's to accommodate the expanding frontier. Franciscan friars in California all came from San Fernando College in Mexico City.

The earliest missions were established in New Mexico, followed by those in East Texas, southern Arizona, and, finally, California. The missions in New Mexico were founded at least a century before those in California and Texas. The latter mission fields represented far western and eastern flanks of the borderlands. And only when these were threatened by other European powers in the eighteenth century did New Spain move to shore up its position in these territories. The missions in Arizona belonged to a slightly earlier period of development. Those

[4]Ibid., p. 209: "At the four Querétaran missions [San Antonio] there were now [1762] grazing 4,897 head of cattle, 12,000 sheep and goats, and about 1,600 horses, and each mission had from 37 to 50 yoke of working oxen . . . maize, chile, beans, and cotton were raised in abundance, and in the *huertas* a large variety of garden truck. . . . [In California] in 1834, on the eve of the destruction of the missions, 31,000 mission Indians at twenty-one missions herded 396,000 cattle, 62,000 horses, and 321,000 hogs, sheep, and goats, and harvested 123,000 bushels of grain . . . *corresponding skill and industry were shown by the neophytes in orchard, garden, wine-press, loom, shop, and forge.*"

[5]Pablo C. Gante, *La arquitectura de México en el siglo XVI*, see map facing p. 108 containing principal sixteenth-century *conventos* founded by the Franciscans, Augustinians, and Dominicans in central Mexico.

[6]Bolton, *Bolton and the Spanish Borderlands*, p. 192.

[7]The friars also received their pay, or annual stipends (*sínodos*), from the government through these centers. "In 1758 . . . the treasury of New Spain was annually paying *sínodos* for twelve Querétaran friars in Coahuila and Texas, six Jaliscans in Coahuila, eleven Zacatecans in Texas . . . twenty Zacatecans in Nuevo León and Nueva Vizcaya, seventeen Zacatecans in Nuevo Santander . . . thirty-four friars of the Provincia del Santo Evangelio in New Mexico" (ibid., p. 194).

in the far northeastern section of the state belonged to the New Mexico Pueblo missions. Those in the south represented the northernmost limit of the extensive mission development carried out in the late seventeenth and early eighteenth centuries by Father Kino in Pimería Alta.

The first mission in New Mexico was built and dedicated in 1598 at San Juan de los Caballeros, the first capital of that province. Fray Padre Alonso Martínez and ten Franciscans (eight priests and two lay brothers) who accompanied the Juan de Oñate expedition were in charge of the missionary work. Almost a century later, Fray Damián Massanet, who accompanied Alonso de León on the last two of five expeditions into Texas, founded San Francisco de los Tejas in East Texas in 1690. Padre Eusebio Kino founded San Xavier del Bac in southern Arizona in 1700. Fray Padre Junípero Serra founded the first mission in California in 1769, dedicated to San Diego de Alcalá. By 1630 New Mexico had twenty-five missions among the Pueblos and the Hopis (eastern Arizona). Texas had as many as fourteen missions at one time, while Arizona had only four, although these were only a fraction of those founded immediately south of the present border between the United States and Mexico. Twenty-one missions

were eventually established in California between 1769 and 1823.[8]

New Mexico, then, represents the most important outpost of New Spain, dating from the late sixteenth and early seventeenth centuries. Models for its mission architecture, although based on the use of local materials, are found in central Mexico. Plans, elevations, and types of structures are variations on central Mexican prototypes.[9] Thus, the New Spanish transformation of Spanish models (composites of Gothic, Moorish, and Renaissance architectural vocabularies) is in turn used by its namesake — New Mexico — in the seventeenth and eighteenth centuries.[10] Only in this way can New Mexican art and architecture be considered — as variations of Mexican colonial art and architecture, demonstrating a difference in degree not in kind.

New Mexico

Of the many churches built in New Mexico during the New Spanish period, San Esteban at Acoma stands out for its austere simplicity and its location atop a vast rock boulder, which makes it visible from afar. The prototypal New Mexico mission is found here, with adobe fabric covering all exterior surfaces,[11] and the walls thicker at their bases than at their crests, thus forming subtle battered surfaces on all four sides. The face is plain with a single doorway with horizontal header in the center and a rectangular window at choir level. The plain façade is flanked by twin towers with slightly tapering profiles. Very small belfries were located atop these towers.

The church, built after 1629 and before 1641,[12] is separated from the Indian settlement by a large open space but remains a part of it, being located atop the rock mesa. It is a single-nave church with a polygonal apse. Two windows are located on the south nave wall. The friars' quarters are located on the north side within a *claustro*, which has a roofed-over walkway. The choir loft faces the sanctuary and is reached through the north wall from an outside ladder.

The plan, the choir loft, the *claustro*, and the *atrio* (open space in front of the church, sometimes

[8]See Cleve Hallenbeck, *Spanish Missions of the Old Southwest*, pp. 23, 41, 53, 65, for maps showing names and locations of the missions in New Mexico, Arizona, Texas, and California.

[9]See Joseph A. Baird, *The Churches of Mexico, 1530–1810*, fig. 1, for a characteristic plan of a sixteenth-century Mexican monastery. In Mexico the large open area in front of the church, defined by a wall with *posas* (oratories) at each corner, is called the *atrio*. Adherence to this configuration is not rigorously followed in the borderlands but its function as a cemetery was the same. Besides the church, there is the *convento*, or monastery, where the friary (*claustro*) was located. The cloister itself is sometimes referred to as the *patio*, since it was not always defined by quarters on all four sides. Thus, the units were the same, if not their configuration.

[10]Manuel Toussaint, *Colonial Art in Mexico*, trans. and ed. Elizabeth Wilder Weismann. See other references listed in note 28, Introduction.

[11]George Kubler, *Religious Architecture of New Mexico*, p. 25. Adobe, from the Spanish *adobar*, "to daub," or "to plaster," derives from an Egyptian hieroglyph for brick, via Arabic to Spanish. In northern New Mexico adobe is the most common building material.

[12]Dominguez, *Missions of New Mexico*, p. 190 n.

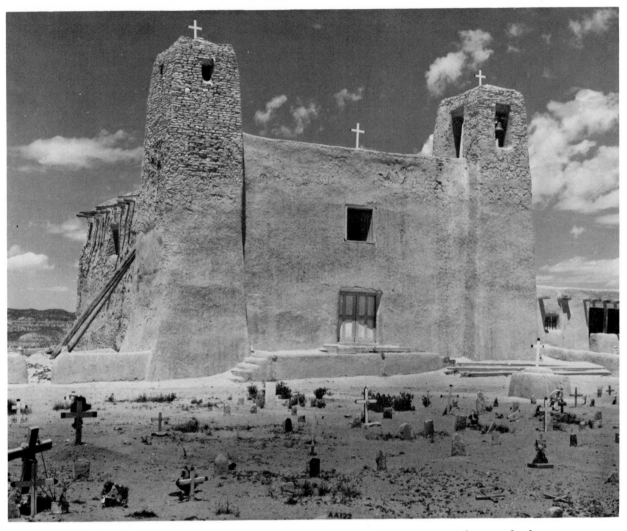

San Esteban Mission (façade). ca.1629–1641. Acoma, New Mexico. (Photography by Sandak, Inc., New York City)

walled in and used for burials) are all based on central Mexican models.[13]

The mission San José (St. Joseph) de Gracia, built almost 160 years later during the third quarter of the eighteenth century in the New Spanish town of Trampas, demonstrates variations on the basic structure.[14] The façade is broken by a balcony that is built on the choir-loft beams and is nestled between the flanking towers. The church is based on a cruciform plan, that is, a nave with transepts. Illumination of the sanctuary comes from the transept windows. There is another window, or transverse clerestory, directly above the nave side of the crossing. The roof rises slightly at this point so that a long narrow skylight parallel to the transept arms is afforded, adding appreciably to the lighting of the sanctuary. This unusual feature is not found elsewhere in New Spain.[15]

[13]See note 9 above.
[14]Dominguez, *Missions of New Mexico*, pp. 99–101.
[15]Kubler, *Religious Architecture*, p. 133.

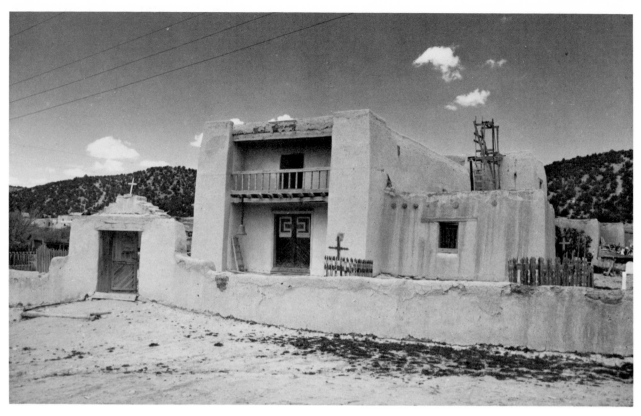

San José de Gracia Mission (façade). ca.1770. Trampas, New Mexico. (Photography by Sandak, Inc., New York City)

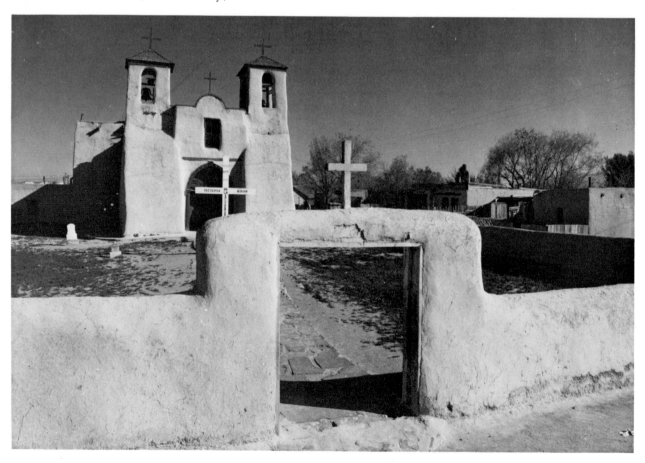

San Francisco de Asís Mission (façade). ca.1760. Ranchos de Taos, New Mexico. (Photography by Sandak, Inc., New York City)

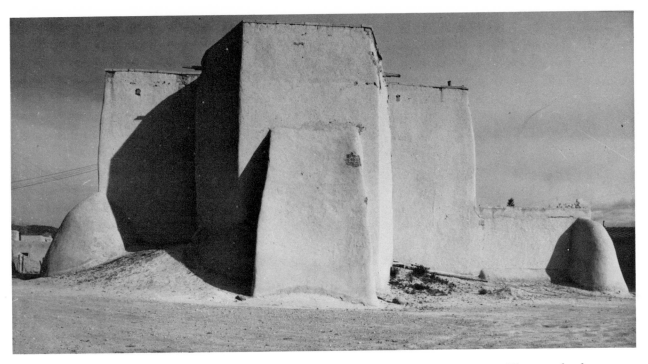

San Francisco de Asís Mission (apse). ca. 1760. Ranchos de Taos, New Mexico. (Photography by Sandak, Inc., New York City)

Farther north, near Taos, is the famous church at Ranchos de Taos, dedicated to San Francisco de Asís. The settlement existed as early as 1744, although the town was not actually built until 1779. The church, of cruciform plan, probably corresponds to a building date of around 1760.[16] The portal is comprised of the doorway with horizontal header and a wooden tympanum carved with simple designs. Above this is a rectangular window at choir level. The customary horizontal cornice of the façade rises in the center over the choir window into a semicircular extension of the façade, which echoes the archivolt of the entrance and the headers of the belfries on either side. The portal appears to be recessed within two massive buttresses attached to each tower base. This battered surface, with its clear geometric diagonals that contrast with the more nearly vertical walls of the towers and the façade, is even more effective in a plastic sense on the back of the church. The buttress attached to the apse is slightly narrower than the area it supports, thereby creating a series of rhythmic patterns based on the

diagonal of the buttress, its sides parallel to the nave walls, and the opposing directional thrusts of the transept arms. The perspectival effects based on the converging lines of the buttress and the nave walls are dramatically terminated by the transept walls, which run perpendicularly to these and parallel to the buttressed apse. The articulation of these surfaces creates a series of very dramatic dark and light fields. These geometric configurations, based on ever-expanding profiles of the outer fabric of the church, are particularly appreciated by twentieth-century observers.

San José y San Miguel de Aguayo

The most impressive of the five missions in San Antonio is San José y San Miguel de Aguayo, founded on February 23, 1720, by Fray Antonio Margil de Jesús.[17] The mission was named after Joseph de

[16] Ibid., p. 120.
[17] Marion A. Habig, "Mission San José y San Miguel de Aguayo," *Southwestern Historical Quarterly* 71 (April 1968): 496.

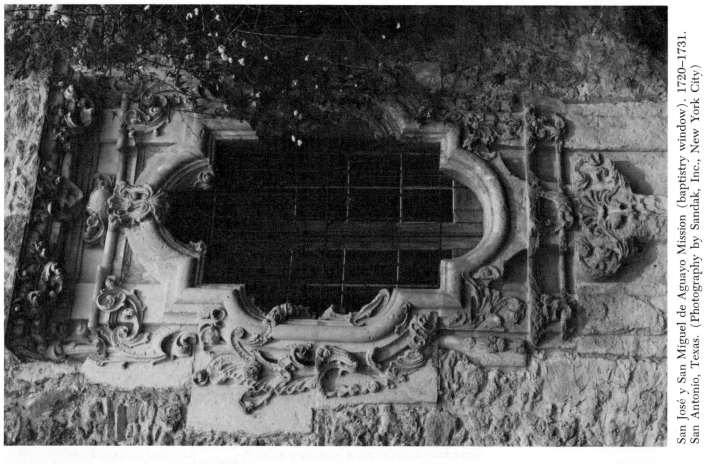

San José y San Miguel de Aguayo Mission (baptistry window). 1720–1731. San Antonio, Texas. (Photography by Sandak, Inc., New York City)

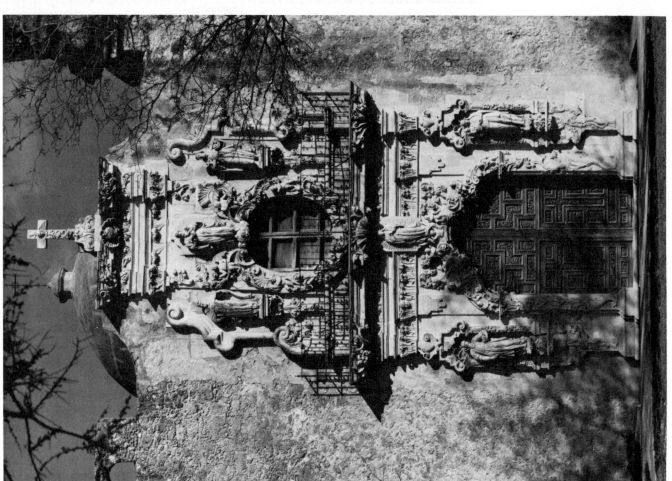

San José y San Miguel de Aguayo Mission (main portal). 1720–1731. San Antonio, Texas. (Photography by Sandak, Inc., New York City)

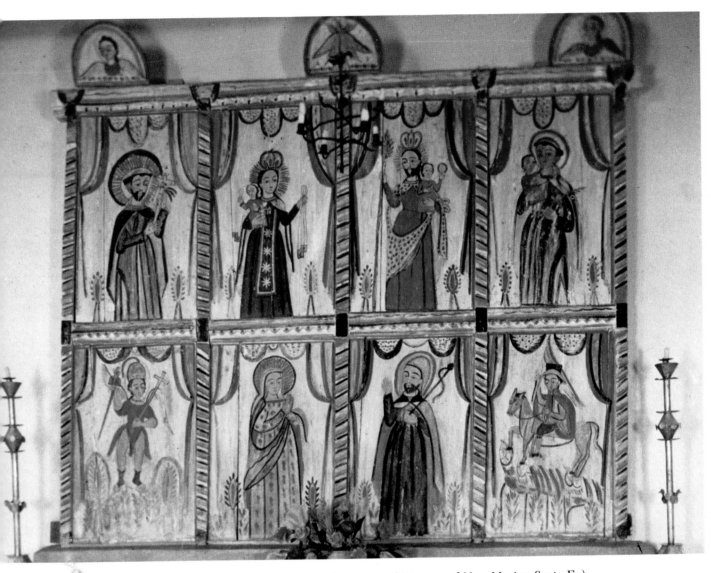

José Rafaél Aragón. *Reredos*. 1825–1850. (Courtesy of Museum of New Mexico, Santa Fe)

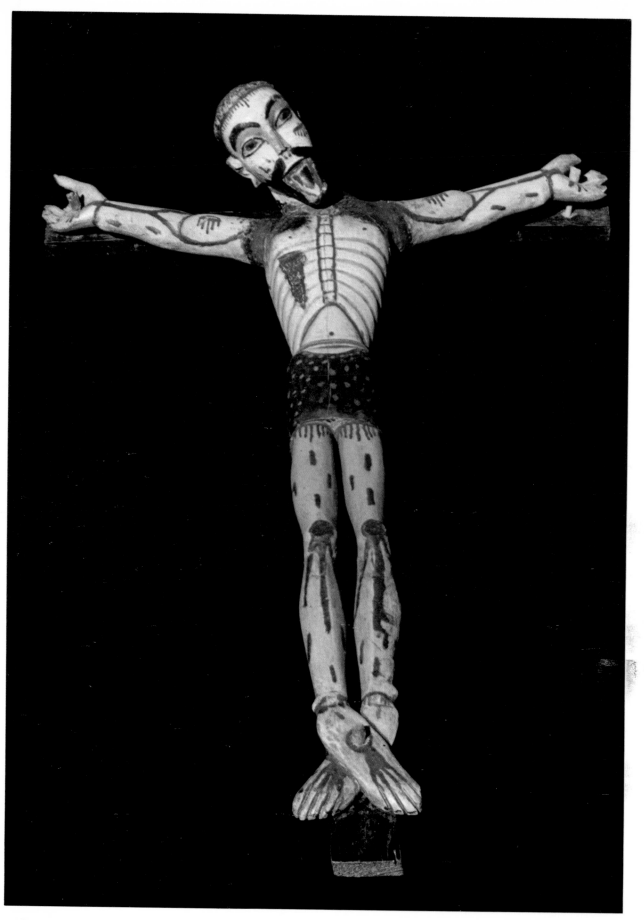

Juan Ramón Velázquez. *Crucifix*. Late nineteenth century. Pine, gesso. (Courtesy of Museum of New Mexico, Santa Fe)

Azlor y Virto de Vera, Marqués de San Miguel de Aguayo, who issued a decree accepting Fray Margil's request for the establishment of the mission.

The present church, corresponding to a third and final location,[18] was started on March 19, 1768. Dependencies, such as the granary, houses for the Indians, and the friary, were built earlier. In 1749 there were more than 200 Indians living in stone houses. By 1758 there were seventy-two houses for the Indians, which were located within squares, each of which had eighteen houses. These, along with twelve other houses built outside the compound, afforded housing for 281 Indians. By the time the present church was started, there was a large square enclosed by a wall 611 feet long on each side. Houses for 350 Indians, as well as a number of workshops, were built alongside and against the walls. At this time the granary had a vaulted roof. By 1777 the friary had two stories with galleries.

The present church is primarily the work of Padre Pedro Ramírez de Arellano, missionary in charge. The single-nave church with twin tower bases framing the façade has a chapel half the length of the nave built parallel to it on the south side. Next to it on the east side at right angles is the baptistry. The north wall of the church is extended beyond the apse to a length approximately equal to the length of the nave. This forms the north wall of the dormitory, or friary, which, with its arched cloisters, now equals the width and the length of the nave. The friary faces the enclosure, bounded by the baptistry on the west and other structures on the east.

The domical vaulted nave does not have transept arms. However, a dome with drum fenestration is placed where the crossing would have been, in front of the sanctuary. Only one single-story belfry was built on the south tower. The two tower bases, of equal width and height, frame a single portal of equal dimensions.

The main portal of the façade has a one-to-two arrangement of parts. On the first level is a single entrance with a mixtilinear header flanked by single-niche pilasters on each side. A representation of the Virgin spans a rather shallow entablature, and the crown rests on the archivolt. A secondary and greatly projecting cornice divides the first and second stories. A large oval window at choir level sits directly on this cornice, rather than on the podia of the second story, thereby breaking what would otherwise have been a wide horizontal. Tall slender bases for statues flank the window, whose axes correspond to the jambs of the first doorway. The entire second story is then framed by a series of scrolls, whose bases are in line with the niches on the first story. The inward tilt of these frames leads our attention to the entablature with projecting cornice, which is now as wide as the window frame.

The contrast in bold relief with very fine detail, achieved by alternating highly worked areas with relatively plain ones, is impressive at close range. At a greater distance cohesion is partially lost, with the outer profiles of the portal, particularly at first-story level, diffused by the detail. The highly worked surface fails to contain the verticals. Stronger outlines would have offset the horizontals of the projecting cornice dividing the first and second stories. The podia of the first story are too low for the rest of the portal, giving the impression of an outward move, or projection, of the relief as one moves upward. This effect is sustained on the second story by the heavier relief of outer profiles, window frame, and horizontal definitions above and below.

There is no such disparity between structural and decorative aspects in the baptistry window. Here a balance is achieved between the geometric and organic design programs.

San Xavier del Bac

Padre Eusebio Francisco Kino first visited the Indian settlement of Bac in 1692 and in 1700 founded its first church, which he dedicated to Saint Francis Xavier.[19] The present church, however, was begun by the Franciscans in 1783 and completed by them in 1797.[20]

The nave, transept arms, and apse of the cruciform-planned church are defined by a system of

[18]Ibid., pp. 499–501.
[19]Lawrence Hogan, "Mission San Xavier del Bac," *Arizona Highways* 46, no. 3 (March 1970): 9.
[20]Ibid.

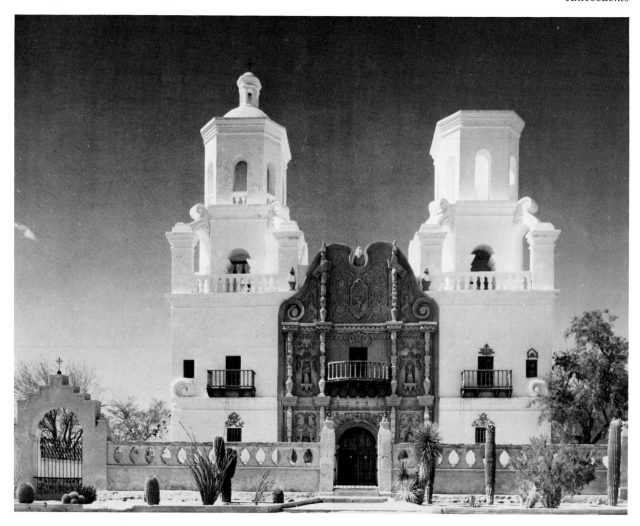

San Xavier del Bac Mission (façade). 1783–1797. Tucson, Arizona. (Photography by Sandak, Inc., New York City)

identically vaulted bays. Each bay of equal dimensions is groin vaulted, although the interior surfaces have been treated so as to make them appear like the soffits of shallow domical vaults. The circular dome over the crossing sits on an octagonal drum, which has four mixtilinear framed windows on alternating sides. The second story of each belfry is also octagonal in plan, although the first stage is square like the lower bases. Only the western tower dome with lantern was completed. The two-stage belfries, of much smaller plan in comparison to their tower bases, are incorporated visually by the use of flying buttresses, which are attached to pillars placed at the corners of each tower. Balustrades, placed between the spatial intervals of the pillars, form a horizontal transition between tower base and belfry.

The portal of the façade has the usual three-to-three arrangement of *retablos* and façades in eighteenth-century Mexican churches, that is, three bays and three stories.[21] The central bay at first and sec-

[21]See Baird, *Churches of Mexico*, fig. 15, for an arrangement of three bays and three stages of a typical later seventeenth-century Mexican retable.

ond levels is approximately double the width of each side bay. Each side bay is framed by double columns, which are close in spirit if not in actual profile to the *estípites* of Churrigueresque columns used in Mexico during the eighteenth century.[22] The inverted *obelisques* so important in the *estípite*, taking up the better part of the shaft of the column, are here greatly reduced in size and relegated to the lowest level. Each miniaturized *estípite* is topped by numerous rectangular units. The strong verticals established by these columns are balanced by the entablatures at each level. The third story is framed by a strong undulating revetted cornice with chamfered center. The inner columns of each side bay on the first and second levels are continued into the third, where the Franciscan emblem is located.

The sand-colored *retablo* façade is beautifully offset by the stark white of the towers and the belfries.

Two-stage *retablos* are found in the apse and in each transept arm — the Epistle and Gospel chapels. The same supporting member found on the façade is used here to frame the niches where sculptures of saints and other important holy figures are placed.

San Francisco de Asís

The small mission dedicated to the founder of the Order of Friars Minor, San Francisco de Asís, was founded in San Francisco in 1776. The second church was begun in 1782.[23]

This church presents some rather unusual features. The single arched doorway and its steps are flanked by double columns, which sit on very high bases. This places the podia of the columns just directly below impost level of the doorway, thereby leaving a large area between the archivolt and the cornice. A very small rectangular window at choir level, located directly above the cornice of the first story, is overwhelmed by three belfries located above but still within this second story. Six half columns, extensions of those on the first story and the door jambs, frame the window and the belfries. The

[22]Ibid., fig. 23.
[23]Hallenbeck, *Spanish Missions*, p. 70.

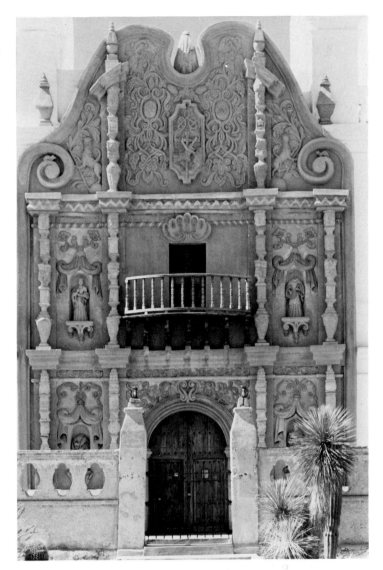

San Xavier del Bac Mission (main portal). 1783–1797. Tucson, Arizona. (Photography by Sandak, Inc., New York City)

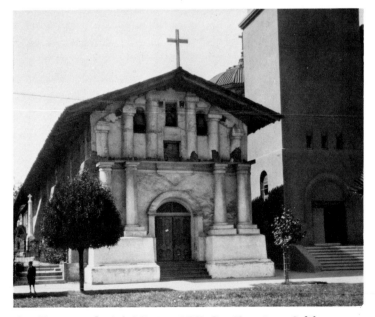

San Francisco de Asís Mission. 1776. San Francisco, Califor-

raking cornice with wide overhang eaves on the sides gives the second story the appearance of a pediment, a unit that brings this into the type of façade based on the Greek temple front. Yet, in spite of all these "aberrations," the whole is pleasing, due to the combination of full and half columns, the horizontal division between first and second stories, and, finally, the gentle peak of the raking cornice.

Santos

A great deal has been written about the *santos*, or holy images, made for the past two hundred years for the churches and homes of New Mexico.[24] Although destined, in most cases, for contemplation within a church interior, these have long since been taken out of their original settings and exhibited in museums and galleries of the Southwest.[25] But, whether we view these as carriers of religious and cultural meanings or as art objects, we must keep in mind that they represent efforts by the *santeros* to create objects of veneration, objects that were ultimately the result of deeply felt religious convictions.

The artisans who worked during this period, from 1700 to well into the late 1930's, are called *santeros*, or makers of *santos*, Spanish for saint.[26] This is a reference to a carved or painted representation of holy persons, not exclusively restricted to saints. The holy family and the crucifixion, as well as saints, were represented either in figures in the round, called *bultos*, or more correctly *imagen de bulto*, or painted on large panels for altars, called *reredos*, or on other panels, called *retablos*. *Bultos* made of pine or seasoned cottonwood root were assembled with dowels, never with nails, and then covered with a thin layer of gesso. Water-soluble colors, usually reds, yellows, blues, and greens, were then applied over the dry gesso ground. Browns were also used, as well as black for outlines. The small wooden panels, or *retablos*, usually made of pine, were also especially prepared with a gesso ground and painted with water-soluble or tempera colors. *Retablos* can also be paintings on canvas, on large altar screens, as well as on small panels.

Most of the artisans are anonymous, although a few are identifiable by name during the mid-eight-eenth century and early decades of the nineteenth. Even considering the paucity of names, the stylistic identities of only twelve painters and ten carvers have been established by twentieth-century specialists.[27]

Some of the known *santeros* are José Aragón of Chamisal (heart of the Sangre de Cristo Range), working in the 1820's and 1830's, and José Rafaél Aragón (no relation) of Córdova, active between 1826 and 1850. There is the work of Molleno of the Taos area, spanning the entire first half of the nineteenth century from 1804 to 1845, and that of Juan Ramón Velázquez (1820–1902) of Canjilón, exemplifying the second half. Celso Gallegos (1860–1943) of Agua Fria (near Santa Fe) and José Dolores López (1868–1938) of Córdova were two of the last woodcarvers working in the *santero* tradition in the twentieth century.[28]

Since questions of style and history of the *santos* have been well covered elsewhere,[29] the few *bultos* and *retablos* selected for discussion are intended not as representative, but rather as illustrative, of this type of work.

One of the most prolific early nineteenth-century *santeros* was Molleno, who produced the large altar screens at the Ranchos de Taos church, the Santuario de Chimayo, and at Talpa, as well as a great number of small *retablos*. Few of his *bultos* have survived.[30]

Some of Molleno's early works are *bultos* and *retablos* produced for the Ranchos de Taos church before 1818, while those of a decade later, his middle period, represent the personal style for which he is best known. His stylized representation of scrolls

[24]E. Boyd, *Saints and Saintmakers of New Mexico*; idem, *Popular Arts of Colonial New Mexico*; idem, *The New Mexico Santero*; José E. Espinosa, *Saints in the Valleys*; Mitchell A. Wilder and Edgar Breitenbach, *Santos: The Religious Folk Art of New Mexico*.

[25]Major collections of *santos* are found in the Taylor Museum of the Colorado Springs Fine Arts Center and in the Museum of New Mexico in Santa Fe.

[26]Boyd, *New Mexico Santero*, p. 5.

[27]Boyd, *Saints and Saintmakers*, p. 7.

[28]Boyd, *New Mexico Santero*, pp. 22–23.

[29]Boyd, *Saints and Saintmakers*. This and other studies by Boyd represent the most thorough analysis of these works.

[30]Boyd, *New Mexico Santero*, pp. 11–12.

and acanthus leaf forms used as space fillers so resembled chili peppers that, before his name was known, he was referred to as the "Chili painter."

The small Talpa altar screen (7′ x 8′), dated 1828, is one of the most beautiful *retablos* by Molleno. His representation of San Antonio on the lower right-hand panel of the altar screen is particularly charming. The painted architectural frame as a setting for the saint is typical of similar representations in Mexico. However, a suppressed ogival arch rather than the usual rounded headers of the cloister arcades is used here. The undulating archivolt is echoed by similar linear fillers on columns and objects on either side of the saint. The broad sweeping lines of the figures contrast beautifully with the meandering fillers. The juxtaposition of thick and thin lines to define the figures and their attire demonstrates a fine calligraphic and spatial sense. Even the inscription is in keeping with the formal program, which reads, "Se hizo y se pintó en ese feliz año de 1828 a devoción de Bernardo Durán este oratorio de Mi Señora de San Juan" (It was built and painted in that happy year of 1828 by devotion of Bernardo Durán this chapel of My Lady of San Juan).[31]

José Rafaél Aragón of Córdova[32] also worked during the first half of the nineteenth century. His *bulto* of Santo Tomás de Aquino is typical of the elongated body proportions of these figures. Boyd refers to this artist as Rafaél Aragón to avoid confusion with the earlier José Aragón, who was born in Spain.[33]

Nuestra Señora de Guadalupe (24½″ high) in the Museum of New Mexico is another important *bulto* by Rafaél Aragón. Here the three-dimensional figure is presented within a primarily pictorial format, complete with the usual arched frame of the paintings. The header has an indented crown with a truncated hollow. This forms the base for the downward flying dove and the field for the inscription INRI. The slightly curved vertical axis of the main figure is followed by the floral motif depicted on the columnar supports of the frame. The repetition of the stems,

[31]Charles D. Carroll, "The Talpa Altar Screen," *El Palacio* 68, no. 4 (Winter 1961): 222.

[32]Boyd, *New Mexico Santero*, pp. 14–15.

[33]Ibid.

Molleno. *San Antonio de Padua.* 1828. Panel painting, part of the altar screen at Talpa, New Mexico. (Courtesy of Museum of New Mexico, Santa Fe)

long drawn-out **S** forms, going in one single direction on both sides, is similar to the work of primitive and folk artists, who represent two left or right hands attached to a single figure. Aragón has very successfully used the stems to emphasize the figure's pose.

José Rafaél Aragón also painted altarpieces. The *reredos* from the chapel Nuestra Señora del Carmen at Llano Quemado, now in the Museum of New Mexico, is a good example of the many altarpieces

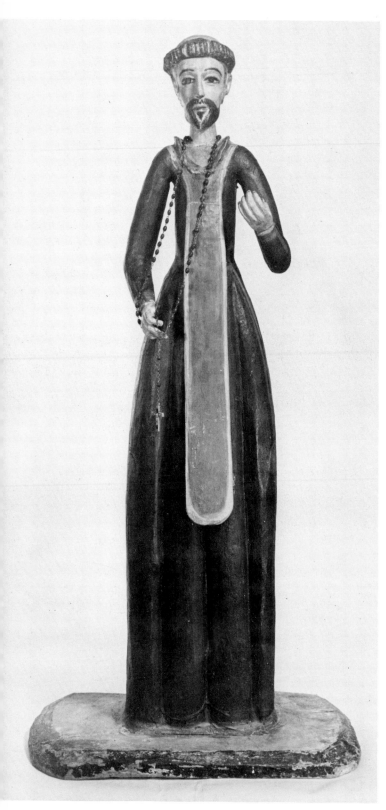

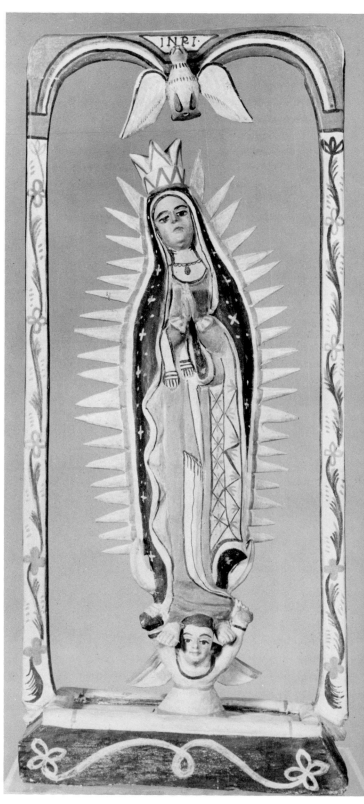

José Rafaél Aragón. *Santo Tomás de Aquino.* ca. 1825–1850.
Bulto. (Courtesy of Museum of New Mexico, Santa Fe)

José Rafaél Aragón. *Nuestra Señora de Guadalupe de Méxi-
co.* ca. 1825–1850. *Bulto.* (Courtesy of Museum of New
Mexico, Santa Fe)

painted by this artist. Holy personages are represented on six panels of equal size. Three lunette-shaped pieces with images surmount the *reredos* on the left and the right and over the center. Six large personages of equal size are depicted on the two central panels below and on the four panels above. Two smaller figures are placed within the two lower outer panels.

An unvarying schematic representation of spiral columns and draperies is used for each panel as a frame for the figures. All figures face toward the center. Their torsos are turned slightly to form an angular pose.

The artist has alleviated the drawbacks of a basically static format by altering the positions of the arms to create an overall effect of movement. The further articulation of the figures in terms of outline, color, and angular pose demonstrates the artist's keen feeling for space and light. The figures appear to be very animated and alive. Yet, they are also somehow free of the usual gravitational pull and appear to be weightless and transparent.

With the introduction of commercially produced religious objects, in the late nineteenth century, the need for the work of *santeros* declined. The only patrons left were the brotherhoods of *penitentes* who continued to commission works for their chapter houses, called *moradas*. Among the principal figures required for each *morada* were a Nazarene Christ, a crucifix, Our Lady of Sorrows, and a Saint John, the Disciple.[34] Juan Ramón Velázquez received commissions from the brotherhoods of *penitentes* during this period.

A crucifix (31″ high), now in the Museum of New Mexico, is typical of *bultos* by Velázquez. J. E. Espinosa gives a good description of these figures with large eyes and the characteristic articulation of the facial planes: "The upper lids are deep cut, and details of the eyes are heavily outlined. Eyebrows are unusually wide and sweeping. The forehead bulges, with a deep cut at the point where the forehead is

[34]Ibid., p. 21.
[35]José E. Espinosa, "The Discovery of the Bulto Maker Ramon Velázquez of Canjilón," *El Palacio* 61, no. 6 (June 1954): 190.

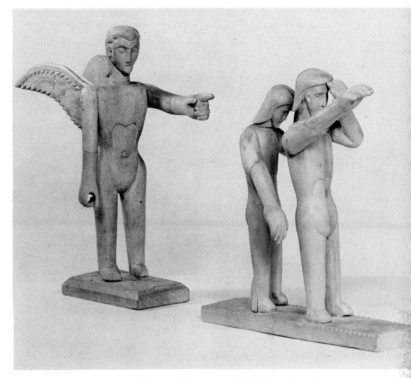

José Dolores López. *Adam and Eve Expelled from Paradise.* Twentieth century. Wood carving. (Courtesy of Museum of New Mexico, Santa Fe)

joined to the bridge of the nose. The nose is long, with deep furrows separating it from the cheeks, which are concave in the area in line with the mouth. The mouth is always small and half-puckered. . . . The form of the ear . . . is divided into two separate ellipsoid parts, unlike that of any other carver."[35]

The three-piece carving entitled *Adam and Eve Expelled from Paradise* by José Dolores López (1868–1938) of Córdova is a good example of the work of twentieth-century New Mexico wood carvers. The cottonwood figures are no longer covered with a coat of gesso and then polychromed, although the technique of carving and putting the pieces together with glue and dowels remains the same. The figures are much more stylized, with extremities undifferentiated between upper and lower parts. Feet are barely emphasized, while hands are large in relation to the rest of the figure. Attention is placed primarily on the heads and the arms. The Angel's clear gaze and his commanding gesture are con-

trasted by the expelled couple's closed eyes and their groping motions.

The artist has used the arms to establish the mood of the story and to weave the participants into a plastic whole in which the figures and the spaces between them become equally important. The Angel's outstretched arm fills the void between him and Adam and Eve. The gentle curve of his wings balances his left arm, while his right arm initiates a step-by-step counterbalancing move in the opposite direction terminating with Adam's outstretched right arm.

The work of the New Mexico *santeros* is unique in conception and execution. The isolation of the province, the lack of readily available materials and images for models, contributed to the creation of sculptures and paintings that are regional yet most vital in character.[36] The elongation of body proportions of the *bulto* figures and their strict frontality

[36]Boyd, *New Mexico Santero*, p. 4.
[37]George Kubler, *Santos: The Religious Folk Art of New Mexico*, p. 5. Kubler refers to this position as a diagonal figure presentation.

are in marked contrast to the much shorter *retablo* figures, which are usually presented in three-quarter views.[37] Although heavy lines were used for the definition of forms and details in both paintings and sculptures, the ultimate effect of each is distinctive. While the paintings are primarily schematized representations of holy personages, the sculptures are more forceful, more immediate in their embodiment of their religious content. The creation of a *bulto*, wherein the artist was involved with the materialization of a single figure whose attributes were known and felt, may explain the disparity. Or, put in another way, perhaps the symbolic and formal structures embodied in a single piece afforded the kind of concentration that was necessary for the creation of truly expressive *bultos*, whereas the less-malleable aspects of the two-dimensional surface of the *retablo* with its multiple compartments may have diffused the artist's creative energies. Regardless of the different artistic levels achieved by the artists, who were often sculptors as well as painters, the *bultos* and the *retablos* testify to a rich artistic tradition in New Mexico of several centuries' duration.

3. Mexican Muralists in the United States

CENTRAL MEXICAN PRESENCE in the Southwest and other parts of the country increased in the twentieth century as a result of political upheavals in Mexico starting in 1910.[1] Even before this date Mexicans had continued to come to the United States as immigrants during the late nineteenth century and the early years of the twentieth. The Southwest had always remained easily accessible to Mexicans. Language, culture, and proximity made it easy for the new arrivals to fit in with the older Mexican groups. The natural outcome of these successive waves of immigration served to reinforce the native Mexican's or the Mexican American's cultural ties with Mexico.

The great movements of peoples appear to have crested in the twenties and thirties. Subsequent migrations during and after World War II were basically different in that legal (the *bracero*) and illegal (*mojados* and *alambristas*)[2] entries were made for exclusively economic reasons. These men came to work in the fields to pick fruit, to harvest crops, and

so on. The earlier migrations, on the other hand, had consisted of entire families as well as individuals driven from their homes by the revolution. Among these early arrivals were artists who were trained and formed in Mexico—the famed Mexican muralists. The others, who came as children and received their formal education and developed as artists in this country, are rightly considered Mexican Americans along with those born in this country, whose parents, grandparents, or great-grandparents were born in Mexico.

The events that took place during the first half of

[1]Francisco Madero's return to Mexico via Juárez from El Paso on November 20, 1910, signals the start of the revolution.

[2]*Bracero* comes from *brazo*, Spanish for arm; these were the workers from Mexico who came legally into this country during and after World War II, as a result of an agreement reached between the two countries. *Mojado*—wet, or "wetback"—refers to the illegal entries made across the Río Grande. Those crossing over other parts of the border by merely climbing a fence dividing the two countries were called *alambristas*, from *alambre*, Spanish for wire.

the twentieth century have to be considered on several different levels. The most important of these for our purposes concerns the presence of the muralists in this country. (1) Within the ranks of these artists a distinction has to be made between those who were more or less established in Mexico—Diego Rivera and David Alfaro Siqueiros—and those who were not —José Clemente Orozco and Rufino Tamayo. Although all four painted murals in this country, only the works of the latter two will be considered here. (2) The muralists' influence on American art of the thirties has yet to be evaluated. (3) The fact that muralism has ceased to attract many of the leading young Mexican artists over the last twenty years has not deterred Americans from commissioning the work of some of the older second-generation Mexican muralists (e.g., Juan O'Gorman's mosaic mural for the 1968 San Antonio HemisFair).

1. Within an amazingly short time after the so-called Mexican Mural Renaissance got started (1920–1925),[3] Rivera, Siqueiros, and Orozco were invited to paint murals in this country. During 1930–1931 all three were in California, where they painted murals in several cities. Rivera returned to California in 1940 to paint a mural for the Golden Gate International Exposition.

Orozco painted a mural in the Frary Hall of Pomona College at Claremont, near Los Angeles (1930); Siqueiros painted exterior murals in Los Angeles at the Chouinard School of Art and at the Plaza Art Center (1932); and in San Francisco, Rivera painted murals at the Stock Exchange Luncheon Club and the California School of Fine Arts, now called the San Francisco Art Institute (1931). The mural painted for the Golden Gate Exposition was later placed in the San Francisco City College (1940).[4]

Beginning in late 1930 and most of 1931, Orozco painted a series of panels in New York at the New School for Social Research. During the years 1932 and 1933 Rivera was in Detroit, Michigan, where he painted panels in the large enclosed courtyard at the Detroit Institute of Fine Arts. Orozco then went to Hanover, New Hampshire, to paint murals in Baker

Library at Dartmouth from 1932 to 1934. During the same period Rivera had accepted a commission to paint a mural in the then newly completed Rockefeller Center in New York. The panel, destroyed by Rockefeller as a result of the furor caused by the inclusion of Lenin's portrait, was later re-created by the artist at the Palace of Fine Arts in Mexico City in 1934. Rivera and Orozco had returned in that year with the change in government, which again had made it possible for the muralists to work in Mexico.[5] Orozco was asked to do a panel opposite Rivera's painting. The other two artists were later asked to paint similar panels, Siqueiros in 1945 and Tamayo in 1952.

Rufino Tamayo, an easel painter as well as a muralist, also painted murals in Northampton, Massachusetts, at the Hillyer Art Library of Smith College in 1943, in Dallas at the Museum of Fine Arts in 1953, and in Houston at the Bank of the Southwest Building in 1955 and 1956.

2. The great impact made by the muralists in this country during the thirties has by now diminished if not entirely disappeared. Whatever debt the American Abstract Expressionists of the forties and fifties may have owed the Mexican muralists has yet to be evaluated. Contact between the older established muralists like Orozco and Siqueiros and the young American artists during the mid-thirties in New York (e.g., Jackson Pollock) is often mentioned, but its bearing on the later development of American art is ignored.[6] The far more apparent debt to Surrealism, dramatically transmitted a few years later by European artists exiled in New York at the beginning of World War II, has eclipsed the earlier Mexican muralists' contribution to American art.[7]

3. The years between 1930 and 1934 had been

[3]See Jean Charlot, *The Mexican Mural Renaissance, 1920–1925.*

[4]Virginia and Jaime Plenn, *A Guide to Modern Mexican Murals*, pp. 139–149.

[5]This was Lázaro Cárdenas's presidency (1934–1940).

[6]Francis V. O'Connor, *Jackson Pollock.*

[7]William S. Rubin, *Dada, Surrealism, and Their Heritage*, pp. 158–159. European artists in exile: Marc Chagall, Fernand Léger, Jacques Lipchitz, Piet Mondrian, Yves Tanguy, Max Ernst, Matta Echaurren, and others.

highly productive for the muralists in this country. The field of activity then shifted to Mexico, where murals of major importance continued to be painted until well into the early fifties. Although murals continue to be painted in Mexico and in this country, muralism as a vital force no longer exists in Mexico.

Other muralists have worked in this country, but, by and large, their works have failed to create a stir. Among these are Federico Cantú's work in Philadelphia's Museum of Art, done in 1936; Jesús Guerrero Galván's 1942 mural in Albuquerque at the University of New Mexico; and Pablo O'Higgin's mural in Seattle, Washington, in the Ship Scalers' Union Hall, done in 1945.[8]

Even though Rivera and Siqueiros painted murals in this country, the study of their work belongs elsewhere. Their stays here were very limited. They came at the request of patrons who commissioned them to paint murals. Once these were finished, they returned to Mexico. Orozco and Tamayo, on the other hand, had come to this country to stay, to seek their way as artists. Both had failed to receive recognition for their work in Mexico. Orozco had been living in New York for three years when he received a commission to paint a mural in California. Tamayo had been in the same city for five years before he began work on the Smith mural in Massachusetts in 1943. Both eventually returned to Mexico once conditions had changed, due largely to the international acclaim and recognition they received for their work.

José Clemente Orozco

Although José Clemente Orozco was trained and all of his early work was done in Mexico, some of the most important of his mature work was first done in this country.[9] He had only begun to find himself as a muralist when he left Mexico for the second time in 1927 and went to New York. He had earlier been in San Francisco and New York from 1917 to 1919 but had not been active as an artist. He returned in 1934 to Mexico, where he painted numerous murals until his death in 1949.

Orozco, born in Zapotlán, Jalisco, in 1883, first left Mexico in 1917, when he was thirty-four years old,

". . . finding the atmosphere in Mexico unfavorable to art and wishing to know the United States, I resolved to go North."[10] He went first to San Francisco, where he worked as a photo finisher and an enlarger.

An indication of Orozco's situation, as well as that of other Mexicans in San Francisco, is given in his description of the city during this time: "Mexicans swarmed through San Francisco, so that often pure Spanish was to be heard in the streets. To the numbers of the Mexicans native to California were added the exiles, victims of the Carrancista regime, or malcontents, or simply those who had come up from Sonora or Sinaloa to escape the vexation of civil war."[11] It is interesting to note that early twentieth-century immigrants to the city had come from the same region where Anza had recruited the colonists for the settlement of the city in the late eighteenth century.[12]

Contrary to what may be supposed, Orozco did not leave Mexico as a direct result of the revolution. Although his departure did come shortly after three of the most turbulent years in modern Mexican history, this did not have a direct bearing on it. In fact, his involvement with his country's struggles during the early years of the revolution (1913–1915) later made it possible for him to exhibit his work. His work was first shown in what was initially a government-sponsored show in May 1916.[13] In September of the same year, he had his first one-man show. The reception given his work by the critics so discouraged Orozco that he was inactive for several years. It was during this period that he decided to leave the country.

[8]Plenn, *Guide*, pp. 145, 147, 149.

[9]Among the numerous books on Orozco, the one written by Justino Fernández is still one of the best: *J. C. Orozco: Forma e idea.*

[10]José Clemente Orozco, *José Clemente Orozco: An Autobiography*, trans. Robert C. Stephenson, p. 59.

[11]Ibid., p. 61.

[12]See Herbert Eugene Bolton, *Outpost of Empire*, pp. 133–154. Also note 27, Introduction.

[13]Charlot, *Mural Renaissance*, p. 217. Carranza had thought of assembling a group show by Mexican painters to tour the United States. The actual exhibition in Mexico was all that remained of the original plan.

Orozco had earlier chosen to side with the followers of Venustiano Carranza, one of the leaders who was vying for control of the presidency in 1914.[14] Francisco Madero's assassination in 1913 and the subsequent flight of Victoriano Huerta, the man responsible for his death, in the following year had brought chaos to the country. After Carranza's takeover, others began to fight to gain control of the government. Among these were Francisco Villa and Emiliano Zapata, who, in November 1914, forced Carranza out of the capital. Carranza then set up a government in exile in Veracruz. It was at this point that Orozco, choosing to join the Carrancistas in Orizaba, Veracruz, began to work as a cartoonist and poster maker for the field journal *La Vanguardia*.[15] Carranza's return to power in August 1915 and U.S. recognition of his government brought relative calm for the next several years. Orozco's association with the Carrancistas had brought him work in the field and a commission in 1917 to do a painting that dealt with the 1825 departure of Spanish troops from Mexican soil at San Juan de Ulúa.[16] Remaining in favor during the period of Carranza's presidency in Mexico City had made it possible for Orozco to exhibit his work in 1916.

Tiring of San Francisco, Orozco went to New York, where he worked for a time before returning to Mexico. He continued to be relatively inactive as an artist until 1923 when he received a commission to paint murals at the Preparatoria School. He started in July 1923 and continued to work on these walls off and on until late 1926.[17]

In spite of Orozco's work at the Preparatoria (1923–1924 and 1926) and at other locations like the House of Tiles (1924) and the Industrial School in Orizaba, Veracruz (1926), he still did not receive general recognition as an artist in Mexico. Even as late as 1924, when he was forty-one years old, he was labeled a pupil of Diego Rivera![18]

Again experiencing difficulties in selling his work even with the generous help of friends, Orozco left Mexico for the second time and went to New York. "There was little to hold me in Mexico in 1927, and I resolved to go to New York, counting upon gen-

erous support from Genaro Estrada, Secretary of Foreign Relations, who found the money to defray my journey and a stay of three months."[19] The three months stretched to seven years.

In October 1928, Orozco exhibited a number of ink-and-wash drawings at the Marie Sterner Gallery in New York. These were the famous Mexico in Revolution series done between September 1926 and August 1927, shortly before his departure for New York.[20] While in New York he did a series of paintings based on bridges, streets, the elevated, and the subway of his adopted city. In 1930 he received a commission to paint a mural in the student dining area known as Frary Hall of Pomona College, Claremont, California. He chose Prometheus as his subject for this single panel. After the completion of this project he went to San Francisco for a short visit before returning to New York. Highly indicative of Orozco's attitude at this time is his description of his return to New York in 1930: "When I reached Manhattan my heart was light with the joy and confidence of one who returns to his hearth—of skyscrapers, subways and art. Home sweet home."[21]

Shortly after his return to New York in late 1930, Orozco began to work on a series of murals at the New School for Social Research, which he completed in 1931. Early in 1932 he went to Dartmouth College, Hanover, New Hampshire, to work on the walls of Baker Library. He finished sixteen continuous panels (each 3 x 4 meters) and ten smaller ones in 1934.

Much of the descriptive and evaluative work on Orozco's murals done in the United States and their placement within historical perspective has been pre-

[14]Bernard S. Myers, *Mexican Painting in Our Time*, pp. 7–8.

[15]Charlot, *Mural Renaissance*, p. 215.

[16]Ibid. The complete title of Orozco's painting that dealt with the closing episode of the war of independence: *The Last Spanish Forces on Mexican Soil Evacuate with Military Honors the Fortress of San Juan de Ulúa in 1825*. It is now in the Museum of San Juan de Ulúa, Veracruz.

[17]Ibid., pp. 225–240.

[18]Ibid., p. 223.

[19]Orozco, *Autobiography*, p. 123.

[20]Myers, *Mexican Painting*, p. 98.

[21]Orozco, *Autobiography*, p. 140.

sented elsewhere and need not be repeated here.[22] His importance in the development of American art during this period has yet to be properly assessed but also falls outside the purposes of the present study. But the fact that he spent seven very productive years in this country and that during those years he matured as an artist is important and should be emphasized. When he returned to Mexico in 1934 to work on the large panel now entitled *Catharsis* at the Museum of Fine Arts, Orozco had so developed the thematic and formal aspects of his work that this and subsequent production in Mexico could only be more fully understood with the study of his key works done in the United States.

The most radical departure from Orozco's previous mural production (1923–1926) was the use of a stronger, brighter palette. These formal changes coincided with the development of very important symbols. One of these was fire, first used in his *Prometheus* mural. It later became an integral part of the Museum of Fine Arts panel, as it did in all three of the Guadalajara mural programs: the main wall of the lecture hall, University of Guadalajara (1936); principal wall, Government Palace, Guadalajara (1937); dome, Hospicio Cabañas, Guadalajara (1938–1939).[23] He continued to use this element in subsequent paintings, but it never reached the level of intensity in form and meaning of the Hospicio Cabañas *Man on Fire*.

The writhing suffering masses in the *Prometheus* appeared again and again in later murals in Mexico: humanity consumed by flames, destroyed by machinery, trampled and stabbed to death. Fire, the all consuming agent of destruction, was also the symbol of salvation seen initially in Promethean terms.

Experimentation with thematic and formal structures in the Dartmouth murals served Orozco well in his late mural production in Mexico.[24] He had already tentatively used pre-Columbian and conquest themes in his Preparatoria stairwell paintings; but the entire mural program was largely based on the revolution. Nothing was comparable to the force of his Quetzalcóatl panel at Dartmouth, showing the deified legendary figure leaving Tula under adverse conditions, vowing to return some day to reclaim his "Kingdom."[25] The formidable figure surrounded by writhing serpents—an important attribute of Quetzalcóatl—points toward the east as he departs.

[22]Fernández, *Forma e idea*; Myers, *Mexican Painting*, pp. 89–114; MacKinley Helm, *Man of Fire: José Clemente Orozco*.

[23]In the first example, the masses being consumed by the flames are rising against the false leaders (1936). In the second, a gigantic figure—Hidalgo—feeds the flames with a torch while the masses directly below him kill each other amid flying banners, knives, and fire (1937). The final one is a representation of a striding man completely enveloped by flames (1938–1939).

[24]Orozco murals in Mexico: *Allegory of Mexico* and other panels in the Public Library Gabino Ortiz, Jiquilpan, Michoacán (1940); *Justice, The Working Class Movement*, and other murals in the Supreme Court of Justice, Mexico City (1941); a mural in the Hospital de Jesús Nazareno, Mexico City (1942); *Juárez and the Reform* in the National Museum of History, Mexico City; and others.

[25]There is some confusion regarding the deity Quetzalcóatl and the historic personage who also bore that name. History and legend are intermingled in the chronicles relating to this man, born in the year Ce Acatl (One Reed), who later became a leader in Tula toward the end of the ninth century (873 A.D.). A rival group under Tezcatlipoca (the god Smoking Mirror) forced One Reed, otherwise known as Quetzalcóatl, to flee Tula with some of his followers in 895 A.D. He went toward the east to the land of the red and the black (Tlillan Tlalpallan), that is, the land of writing (lands of the Mayas of Yucatán). Versions of his departure toward the east vary. In some he is said to have continued his journey on a ship comprised of serpents; in another, he is supposed to have sacrificed himself in a great bonfire and as a result turned himself into the morning star, which appears in the east. He is variously identified as Tlahuizcalpantecuhtli when he is in this guise or as Xolotl when he appears as the evening star. In any event, part of the legend has it that he would some day appear in the east to reclaim his "Kingdom." It is this part of the story that so affected the conquest. Hernán Cortés, arriving in the year One Reed, was thought to be the legendary figure-deity.

In order to understand how Cortés could be taken for the legendary figure, one must look at the calendric systems used by the peoples of central Mexico. For it is here that this cyclic point of view is best exemplified. Existence was governed by a constantly recurring series of events that could be foretold by careful monitoring of the calendar, which in fact was comprised of two calendars running concurrently. One was a sacred calendar (Tonalpohualli) comprised of 260 days or 260 different combinations of the numbers 1 to 13 and 20 day names. This was combined with a solar year calendar (Xihuitl) of 360 days (18 *veintenas*, or "months," of 20 days

Cowering and moving away on the left are massed figures, which are defined by a truncated pyramidal shape. This shape, as well as the actual pyramid behind the figures, emphasizes the strong diagonal in the paintings. The "blind" (blue-eyed) visage of the white-maned Quetzalcóatl is similar to two other representations in the courtyard murals of the Preparatoria done six or seven years earlier: the suspended head of Christ belonging to an earlier mural and incorporated into the panel entitled *The Strike* on the first floor; and the head of the mother in the panel entitled *The Mother's Farewell*, painted on the third floor.[26]

Orozco's productions in California, New York, and New Hampshire are uneven. The formal inconsistencies are apparent in the *Prometheus* panel, with the large central figure surrounded by the masses subjected to strong diagonally oriented geometric configurations. The volumetric definition of the central figure is contrasted by the primarily flat and distorted

peripheral figures. This is not as pronounced in his *Departure of Quetzalcóatl* panel in Baker Library. Here all parts of the visual surface are given equal emphasis, so that there is a more coherent visual statement. Yet even in Dartmouth, as in the New School for Social Research panels, there is an overall thematic and formal inconsistency, alternating between the strong *Migration* panel and the shrill caricature of the *Unknown Soldier* panel on the opposite wall.

Even with the tentative statements in which formal and thematic experiments were conducted, Orozco eventually attained a consistency in his painting, which came to fruition in his Fine Arts *Catharsis* and the Guadalajara murals in the University, the state Government Palace, and the Hospicio Cabañas. Yet, even in the Palace stairway he fell back on caricature. Still, the use of fire, with its destructive and generative powers, and a stronger palette reinforced by a formal clarity are characteristics of Orozco's work that postdate his stay in this country. In retrospect, it appears that his U.S. sojourn was a most important gestational period in his artistic career.

Rufino Tamayo

Rufino Tamayo, born in Oaxaca in 1899, began his art studies at the San Carlos Academy in 1917.[27] He left to study on his own in 1918. After his first one-man show held in Mexico City in 1926, he traveled to New York, where he stayed until mid-1928. He exhibited his work in several galleries.[28] He visited New York again in 1930, when he once more showed his work. During this time, he worked in Mexico in a number of minor government positions.[29] In 1936 he was back in New York, this time as a delegate, along with Orozco and Siqueiros, representing the LEAR (League of Revolutionary Writers and Artists) at the First American Artists Congress held in that city.[30] Failure to make any headway in Mexico with regard to his work finally convinced him to make the break in 1938. He decided to stay in New York, where he became a professor of art at the Dalton School. For the next ten years he lived in New York and spent his summers in Mexico. Conditions in Mexico were finally propitious in the late forties for his

each) plus 5 unlucky days. The use of these two calendars made 18,980 different day combinations possible, or the equivalent of 52 solar years and 73 sacred calendar years. Now, only 52 of the 260 differently named days of the sacred calendar could ever occupy the first position of the solar year. These were the "year bearers." Because of the combinations of numbers and day names in this complex system, only 4 of the day names could occupy this position. One of these was the day Reed. These day names could be numbered from 1 to 13, allowing for 52 different "year bearers." Thus, One Reed could only occur every 52 years. This is the reason that Ce Acatl's birth and Cortés's arrival happened to have the same "year bearer": One Reed. See Alfonso Caso, "Calendric Systems of Central Mexico," in *Archaeology of Northern Mesoamerica*, part one, ed. Gordon F. Ekholm and Ignacio Bernal, pp. 333–348, vol. 10 of *Handbook of Middle American Indians*, ed. Robert Wauchope; *Códice Chimalpopoca: Anales de Cuauhtitlán y leyenda de los soles*, pp. xxx, 7–14; César A. Saenz, *Quetzalcóatl*, pp. 9–17; J. Eric Thompson, *Maya Hieroglyphic Writing: An Introduction*, pp. 123, 124, 128.

[26]Myers, *Mexican Painting*, figs. 33, 42.

[27]Ibid., pp. 127–132.

[28]Rufino Tamayo, biodata: Tamayo's first exhibitions in New York were held at the Wethe Gallery and the Art Center.

[29]Myers, *Mexican Painting*, p. 132. In 1931 he was appointed to a small council for fine arts in the Ministry of Education. The following year he was chief of the Department of Plastic Arts.

[30]Ibid.

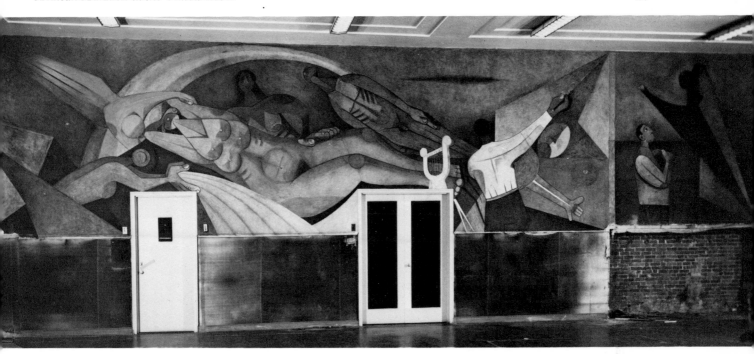

Rufino Tamayo. *Nature and the Artist*. 1943. Fresco. Hillyer Library, Smith College, Northampton, Massachusetts. (Courtesy of Smith College Museum of Art)

return, as they had been for Orozco some fifteen years earlier.

As in Orozco's case, Tamayo's first major easel paintings and murals were done in this country. His first important mural in Hillyer Art Library dates from 1943. At variance with his countrymen, Tamayo chose an abstract idiom and a nonrevolutionary subject for his painting, called *Nature and the Artist*. Behind him were the formative years in New York, where he had concentrated on easel painting. His contact with Picasso's work in 1939 had brought about a decisive change in his work,[31] which was to culminate in the style for which he is so well known: the chromatically rich abstractions that postdate the late forties.

The mural is based on the use of anthropomorphic figures to symbolize "Nature" (a reclining female with four breasts signifying abundance), "Water" (a

blue female nude), "Fire" (a red male figure), and "Earth" (a dark figure). A rainbow symbolizing "Color" ties the figures together.[32] Here Tamayo has emphasized the one element he continued to consider the most important in painting: color.

The long horizontal format of four hundred square feet of wall is broken by two doorways of unequal size at the bottom. The large Nature figure straddles both headers, with her head forming the apex of a pyramidal form on the left and the lower part of her legs resting on the right. All other figures reinforce or echo these directions. Even the rainbow is attenuated so that it forms the blunted apex of a much larger pyramidal container whose base runs from the extreme left to the right border, formed by the artist's canvas. The foreshortened canvas, the artist's painting arm on the right, and the lunging fire figure on the extreme upper left tie the major diagonals to the upper parts of the panel. Here the artist has subjected all figural references to this tightly knit geometric arrangement. Volumetric definition of the figures, their proportions, and their placement create

[31]Ibid., p. 257. Picasso Exhibition at Museum of Modern Art, held in 1939.
[32]Ibid., p. 260.

a space in which positives and negatives are strongly emphasized. Yet, all figures and objects are basically flat patterns whose penetration of the spatial envelope is not very deep.[33]

Tamayo eventually suppressed the differences between the positive and negative areas by diffusing the outlines of the shapes and by using color to give figure and ground equal emphasis. No longer was the visual surface broken down into these two distinct spheres, comprised of clearly defined shapes. The distinctions became blurred, even though he was to continue to emphasize a figure's displacement and pose in relation to the observer in some of his paintings, so that these were often presented in foreshortened poses.

In his mural entitled *America*, Tamayo synthesized the previous approaches in which the abstracted figures with clear configurations and a rich palette were emphasized. Here the color binds all areas within the painting, without at the same time sacrificing the figural portions, a clear mark of all his subsequent production.

[33]The mural was recently transferred to a new facility, the Smith College Museum of Art.

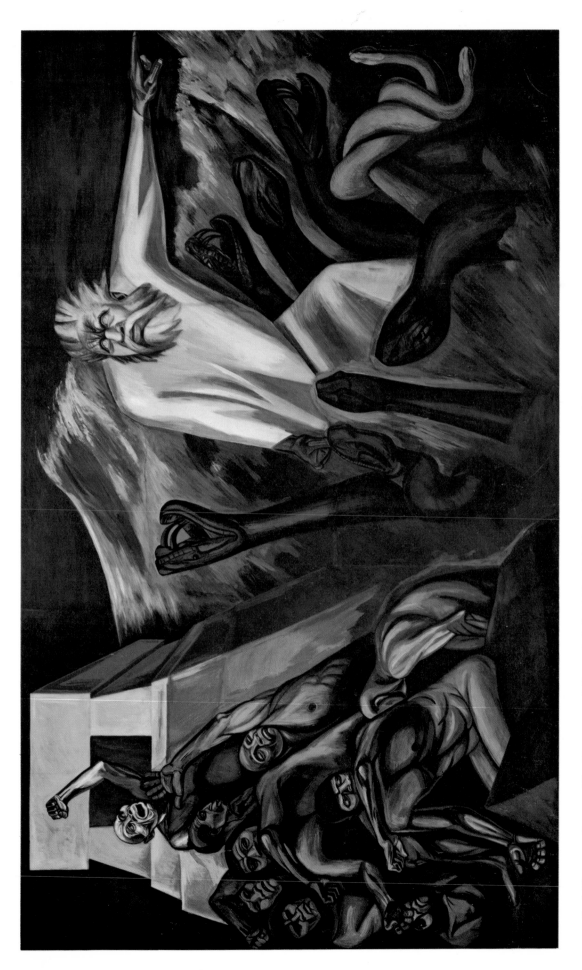

José Clemente Orozco. *The Departure of Quetzalcóatl.* 1932–1934. Fresco. (By permission of the Trustees of Dartmouth College, Hanover, New Hampshire)

Rufino Tamayo. *America*. 1955–1956. Vinylite portable mural. Bank of the Southwest Building, Houston, Texas. (Courtesy of Bank of the Southwest National Association, Houston, Texas)

Part Two. Mexican American Art

Twentieth Century

Although the headings used for each chapter in this part may imply historical placement of the artist, and his work as well, they are used primarily for purposes of convenience and exposition. As stated in the Introduction, an individual's placement within chapteral boundaries is based on his birth date, which usually but not always predicates his appearance as an artist. Thus the first two groups, born during the first two decades of this century, began their careers as students and artists in the twenties and the thirties, but have continued to work up to the present. They could be considered *forerunners* but only in the temporal rather than the developmental sense. Their work is discussed in Chapters 4 and 5, which are entitled *First Decade: 1901–1912* and *Second Decade: 1915–1923*.

Artists born during the late twenties and the early thirties came to maturity in the forties and the fifties. These could be considered as the *interim* artists, but only in the sense that their appearance on the "scene," and not their work, is intermediate in time. For, like their predecessors, they continue to be very active as artists. These groups are discussed in Chapter 6, which is headed *Third Decade: 1926–1934*.

Artists born right before and after World War II are discussed in Chapter 7, which is headed *Fourth Decade: I, 1937–1940; II, 1943–1946*. These subdivisions correspond to the slight difference in age of these artists, who have only recently emerged in the last decade from their status as students and who are well on their way as artists.

Several different views of Mexican and Mexican American, or Chicano, art, expressed by artists from San Antonio and Sacramento, are included in Chapter 8.

4. First Decade: 1901-1912

THE MEXICAN AMERICAN ARTIST is not difficult to identify in the twentieth century. His parents, grandparents, or great-grandparents may have come originally from Mexico. He may have been born in Mexico himself but has spent a good part of his life in the United States. He may be a first- or a sixth-generation American. The important thing is that somewhere there is a tie with Mexico, or New Spain before that. Thus, he is part American, part Mexican, and part New Spanish. Which part plays the dominant role in his life depends upon many variables, all of which are tempered by his own talents, intelligence, and sensitivity.

The first generation of Mexican American artists bridges both cultures. Some are self-taught, like Octavio Medellín (b. 1907), Chelo González Amézcua (b. 1903), and Porfirio Salinas (b. 1912). Others, like Antonio García (b. 1901) and Margaret Herrera Chávez (b. 1912), have received most of their formal art training in the United States.[1] Still, close ties with Mexico have been retained (all, except Salinas and

Herrera Chávez, were born in Mexico). Medellín has returned to his native country on several occasions to work and study, and García, to travel. Miss González and Mrs. Herrera Chávez acknowledge Mexican themes in their works as inspirational points of departure. Salinas, better known for his landscapes, likes to paint bullfight scenes and counts among his friends the best painters of this genre in Mexico and Spain.

Antonio García

Antonio García, a well-known painter in central Texas and Mexico, was born in Monterrey, Mexico, in 1901. He came to this country with his family when he was twelve years old. He attended grammar school in San Diego, Texas, and later studied at the

[1]Most of the information in this chapter was gathered from taped and unrecorded conversations with Chelo González Amézcua, Octavio Medellín, and Margaret Herrera Chávez and from extensive correspondence over the last three years with all artists included in this chapter.

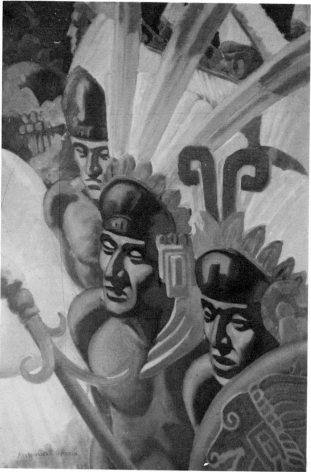

Antonio García. *Aztec Advance*. 1929. Oil. (Collection of Richard Colley, Corpus Christi, Texas)

Chicago Art Institute from 1927 to 1930. Since then he has studied portrait painting, watercolor, and painting techniques with noted specialists. For the last twenty years he has taught art in the adult education courses offered at Del Mar College, Corpus Christi, and every year since 1954 he has conducted a workshop in Saltillo and San Miguel, Mexico, for Mexican and American students.

García has illustrated several books and has painted frescoes in La Bahía Mission, Goliad, Texas, and in the Sacred Heart Church and Minor Seminary, Corpus Christi. During the thirties under the auspices of the PWAP he did a mural for the San Diego

(Texas) High School. Another major work, done in egg tempera, casein, and acrylics, was painted for the National Scapular Center, Aylesford, Illinois.

In one of his early works done in 1929, García used a pre-Columbian theme. The painting, entitled *Aztec Advance*, shows the upper part of various Aztec warriors as if seen from above. The one nearest the observer is presented on the lower right-hand side of the painting. The others are then placed alongside to form a foreshortened figural group whose placement and diminution in size comprise a diagonal from lower right to upper left of the work. This movement is balanced by three thick feathers, going in opposite directions, worn by the second warrior, who is actually in the exact center of the work. The raised eye level, the foreshortening of the figures, and the diagonal thrust give the work a most unusual effect of movement and drama.

Although García does landscapes and on occasion a narrative scene, he is attracted to portraiture. One of this type, done in the early thirties and exhibited in the Texas Centennial Exhibition in Dallas, is of his wife standing in front of a simple mirror. She is seen from behind as she pauses in front of her mirror. A system of diagonals is also seen here. As with the Aztec warriors, the initial diagonal is represented by the figure's position in relation to the observer, who now seems to be earthbound. Her feet are foreshortened in a diagonal moving from left to right, with the foreshortening of her legs establishing the movement in the opposite direction. However, the left-to-right movement is constantly echoed by the oval throw rug on which she stands, by the foreshortened dressing table with objects in front of her, and by the combined diagonal of the lower edge of the mirror and the upper part of the large covered couch next to it. The figure is set slightly off to the right of the central axis of the visual plane. The strong verticality of the figure is balanced on the extreme left of the picture by the outer edges of the mirror and the table. But perhaps more effective is the way in which García has dealt with the figure itself. Although she faces away from the observer

toward a left-to-right diagonal, she twists her body to her left to face her reflection. García uses the arms to establish the change in direction so that the figure's right arm and the tilting of her head to her left draw our attention to the reflected image in the mirror. Here the tilt of the torso is accentuated so as to offset the predominant left-to-right movement of the diagonals already described. The slightly tilted axis of the torso seen in the mirror is echoed by the outer right edge of her skirt.

This unusual portrait demonstrates the artist's interest in the figure and its placement in space. He developed this interest into an unusual presentation of dancing contestants in his *Juneteenth Revue*, exhibited in the Southern State League in 1939. Here the use of diagonals and diminution in size of the figures stands out above all else. The rather studied poses of the contestants in the foreground soon give way in the middleground to freer, more expressive, and genuinely felt body movements of the young girl seen between the first two contestants and of those who follow them on the raised platform. Again the artist used a shallow left-to-right diagonal, which he then changed in direction by the inclusion of a zigzagging platform on which the contestants move rhythmically toward the area where the band is located. García has effectively established the foreground, middleground, and background with this device, as well as with the changes in size of the figures seen in the center of the painting going up the stairs to begin their presentation on the dance-way. The audience is treated in the same way in order to emphasize the foreshortened ground, which recedes away from us. García has then established strong verticals on the left with a fragment of a structure and on the right by the trees, which, by their definition, also echo the writhing movements of the dancing figures.

García has continued to work on several major mural programs for chapels in Texas and elsewhere. One of his most important mural panels was done for the Our Lady of Loreto Chapel in Goliad, Texas. The earlier emphasis on placement of figures so as to create great diagonal thrusts in the paintings gives

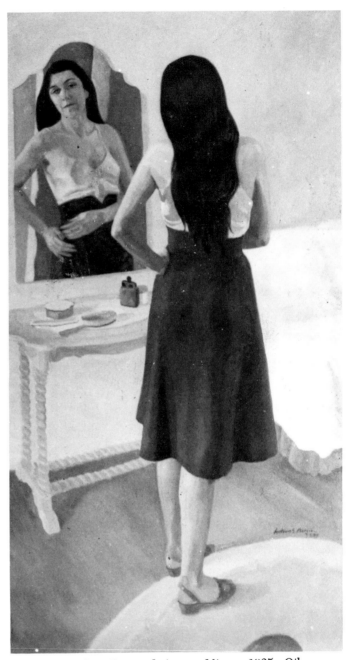

Antonio García. *Woman before a Mirror.* 1935. Oil. (Courtesy of the artist)

way in these panels to an arrangement in which the verticals and the horizontals are paramount. In his *Immaculate Conception* and the *Virgen de Guada-*

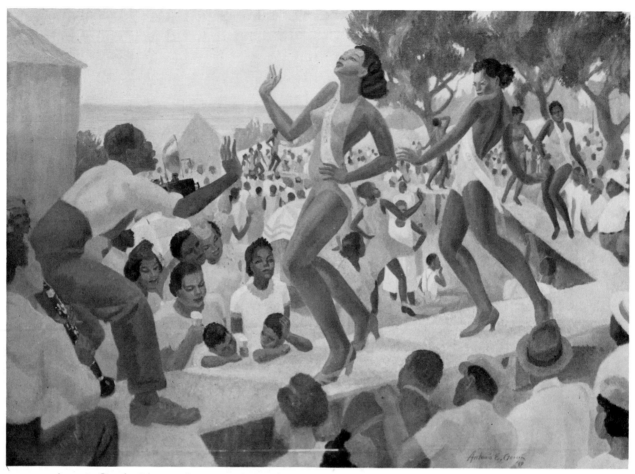

Antonio García. *Juneteenth Revue*. 1939. Oil. (Courtesy of Art Museum of South Texas, Corpus Christi)

lupe panels, the vertical axes of the main figures dominate the paintings. A sense of calm and expectation is expressed. García has created a number of meticulously drawn figures in which detail, volume, and placement in space are emphasized.

Chelo González Amézcua

Consuelo (Chelo) González Amézcua has remained largely unknown outside Del Rio, Texas, until very recently when her work was shown in San Antonio.[2] She has not received any formal art training or followed any of the traditional paths in the arts. She uses ball-point pens on paper or cardboard to represent, in highly intricate linear patterns, Aztec poets and rulers, muses, and other regal personages,

which in themselves evoke a certain mystical and magical quality.

Chelo, born in Mexico in 1903, was raised in Del Rio, Texas, where she still lives.

Chelo received a scholarship from San Carlos Academy, Mexico City, in the thirties but was unable to attend because of her father's death. As a result, she is a completely self-taught painter. This is evident even in her responses to my questions concerning artists, influences these may have had on her work, and the materials she uses. She was al-

2"Filigree Drawings by Consuelo González Amézcua," Marion Koogler McNay Art Institute, San Antonio, February 11– March 10, 1968.

ways candid in her responses. She was either not familiar with a particular artist's work or perhaps had never heard of him. Such was the case when I asked her whether she had ever seen the pen-and-ink drawings of Saul Steinberg: "No, I am not familiar with anything. I am not familiar with cultural things."[3]

Like many other artists, Chelo started drawing and coloring at a very early age. Her family, however, was largely indifferent to her work. Even in later years Chelo's sister did not seem to think much of her efforts either in painting or in writing poetry. She relates: "And when I was writing a poem she would act as if I was committing a sin. I would be writing poems when she didn't see me because she would say, 'How can you write? You don't know Spanish.' Well, I don't know, but I try to do the best I can."

Chelo has since won prizes for her poetry in Ciudad Acuña, Mexico, and has had her work exhibited in San Antonio, Monterrey (Mexico), Dallas, New York, and Springfield, Massachusetts.

Chelo calls her paintings "Filigree Art, a new Texas culture," because they are so much like the intricate metal work found in the earrings and bracelets she loves to wear.

Since Chelo sometimes uses poems in some of her work, I asked her about precedence. Usually she starts with a painting. A poem can be added while the painting is still in progress or else when it is finished. Rarely has she written a poem and then illustrated it. Each has its own importance.

There is no major preparation, in terms of either research or sketches, in Chelo's method of operation. There is instead a great deal of thought and concentration. She works from an idea, thinks it out thoroughly before putting anything down on paper. She rarely uses pencil sketches. She works directly.

Her technique entails sketching in the outlines of the major forms and figures and then filling in the details. At the beginning she worked with black on white. Later she began to use color. In either case the work is meticulous and painstaking. She works an average of eighteen days on each painting: three to five hours a day, usually in the late afternoon and the evening. Only once has she departed from this

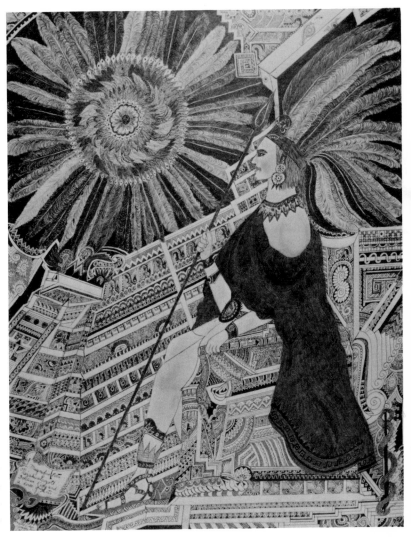

Consuelo González Amézcua. *El Magnífico Poeta Netzalhualcóyotl, King and a Lover of Arts.* 1969. Colored inks on paper. (Courtesy of the artist)

routine—when her brother gave her a book several years ago on Netzahualcóyotl, a famous fifteenth-century Náhuatl poet and king. She was so taken with this personage that she decided to do a portrait of him. She was very happy with the results but was not sure that she would try another like it, because it took her a month to finish.

Chelo named this work *El Magnífico.* Netzahual-

[3]Taped conversation with Chelo on June 11, 1970.

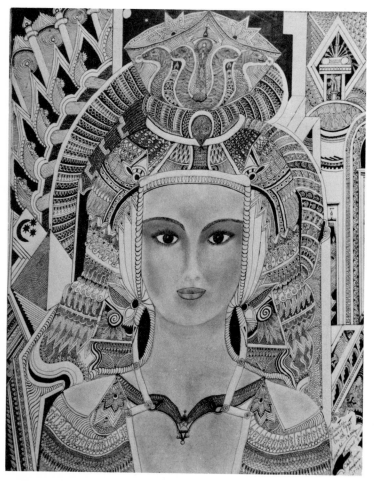

Consuelo González Amézcua. *Cleopatra, Queen of Egypt.* 1969.
Ink and pencil on paper. (Courtesy of the artist)

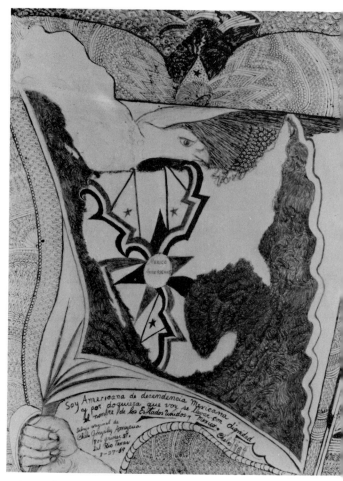

Consuelo González Amézcua. *Mexico Americans.* 1969.
Colored inks on paper. (Courtesy of the artist)

cóyotl, she explains, "was the most intelligent Indian ever born. Under his kingdom, temples, monuments and cities were built. In Texcoco, where his castle was built, he was keeping his riches, material and spiritual. He was a pacifist and he loved luxury; he had palaces, gardens and resorts and he was considered as the guardian of high culture and a representative of the Indian culture. This [painting] is a true version."[4]

The use of the Netzahualcóyotl book as an inspirational point of departure is rare for Chelo. She in-

[4]Netzahualcóyotl (1418–1472) was a ruler of Texcoco (east of Mexico City). See George C. Vaillant, *Aztecs of Mexico: Origin, Rise, and Fall of the Aztec Nation,* p. 105.

formed me that she is not an avid reader. She reads very little, in fact. Many of her subjects come from the Bible and what she has heard in church. Yet she is just as apt to be drawn to religious subjects, *Ojitos de Santa Lucía* and *God Created the Heaven and Earth,* as she is to royal personages, *Cleopatra, Queen of Egypt,* and special events, *HemisFair Filigree Queen* and *HemisFair Filigree Sunflower.*

Chelo does not use canvas or the traditional brushes or other drawing materials. She prefers cardboard and ball-point pens. I must admit that her use of ball-point pens was somewhat of a shock at first. About a year ago she sent me a drawing she had made with different colored ball-point pens. At the

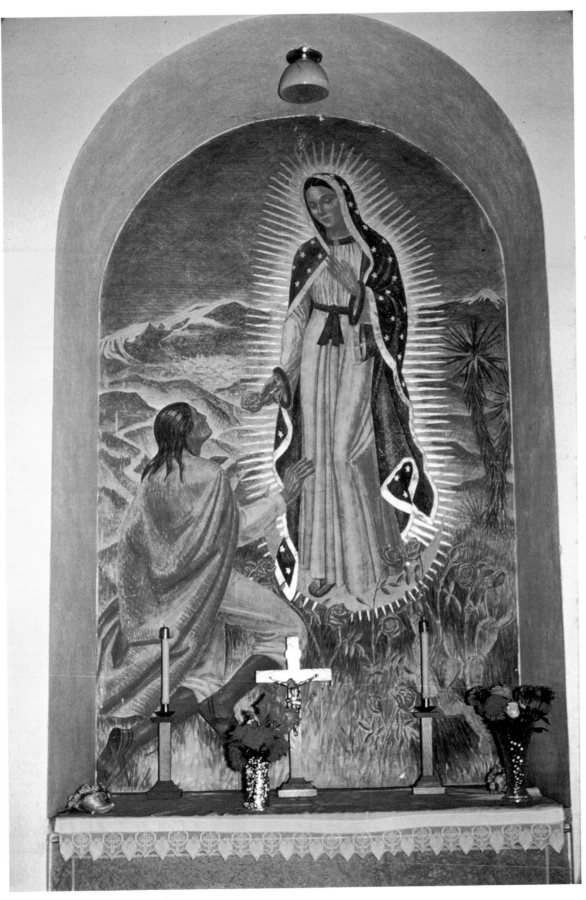

Antonio García. *Virgen de Guadalupe*. 1946–1947. Fresco. Sacred Heart Church, Corpus Christi, Texas. (Courtesy of Sacred Heart Church)

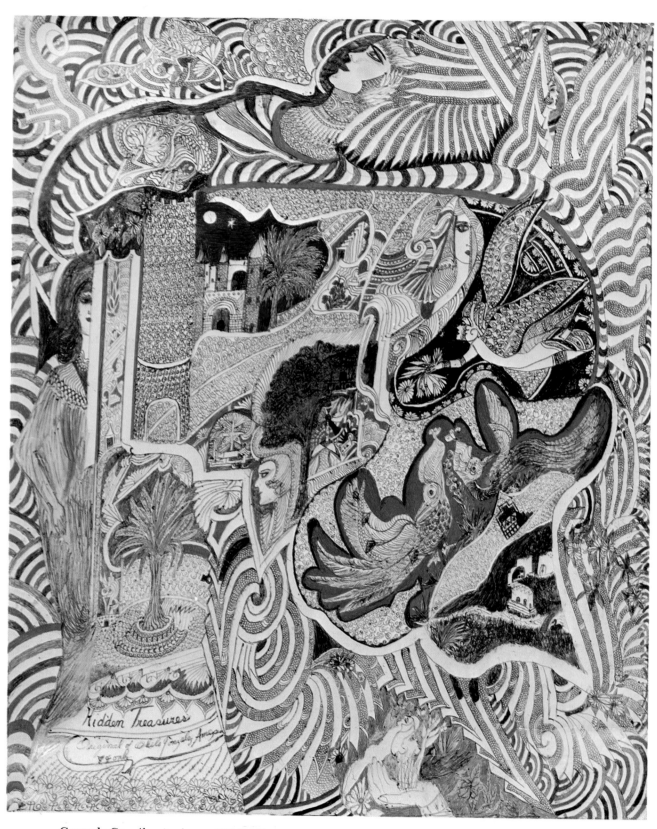

Consuelo González Amézcua. *Hidden Treasures*. 1969. Colored inks on paper. (Courtesy of the artist)

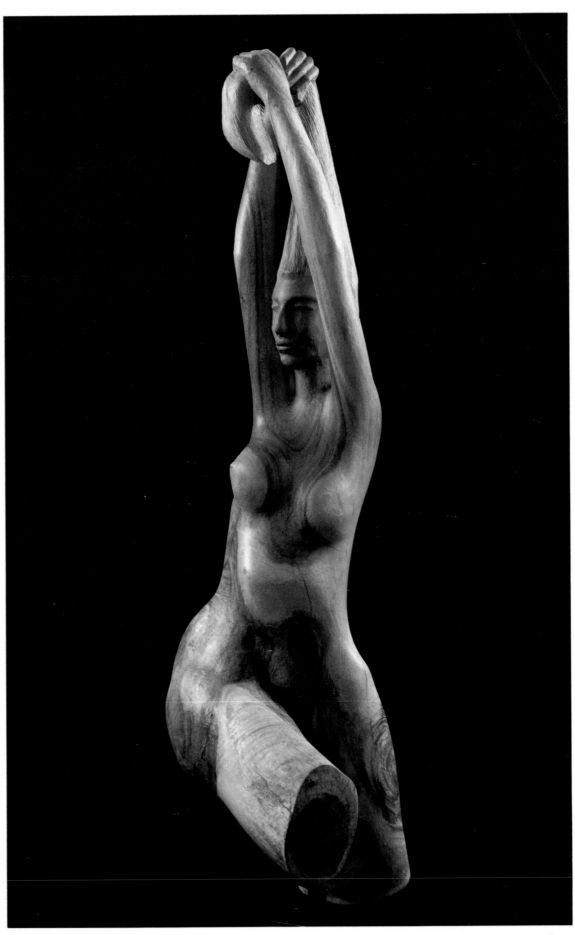

Octavio Medellín. *The Bather*. 1966. Monkeypod. (Collection of Mr. and Mrs. Harold Simmons, Dallas, Texas)

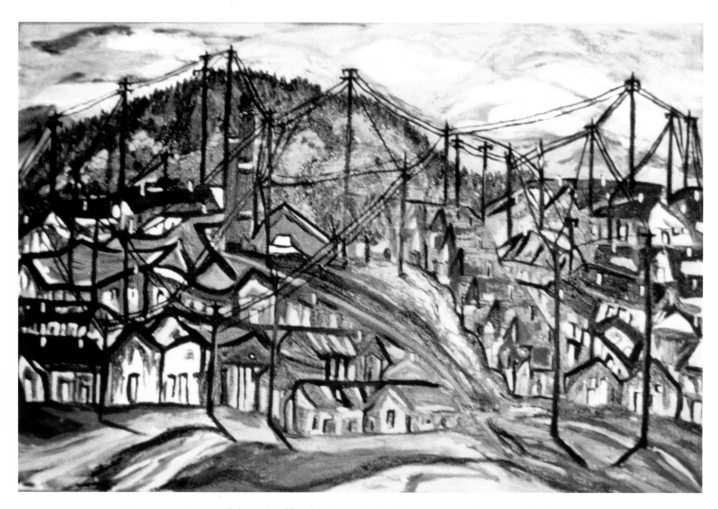

Margaret Herrera Chávez. *Highland Village*. 1953. Oil on canvas. (Courtesy of the artist)

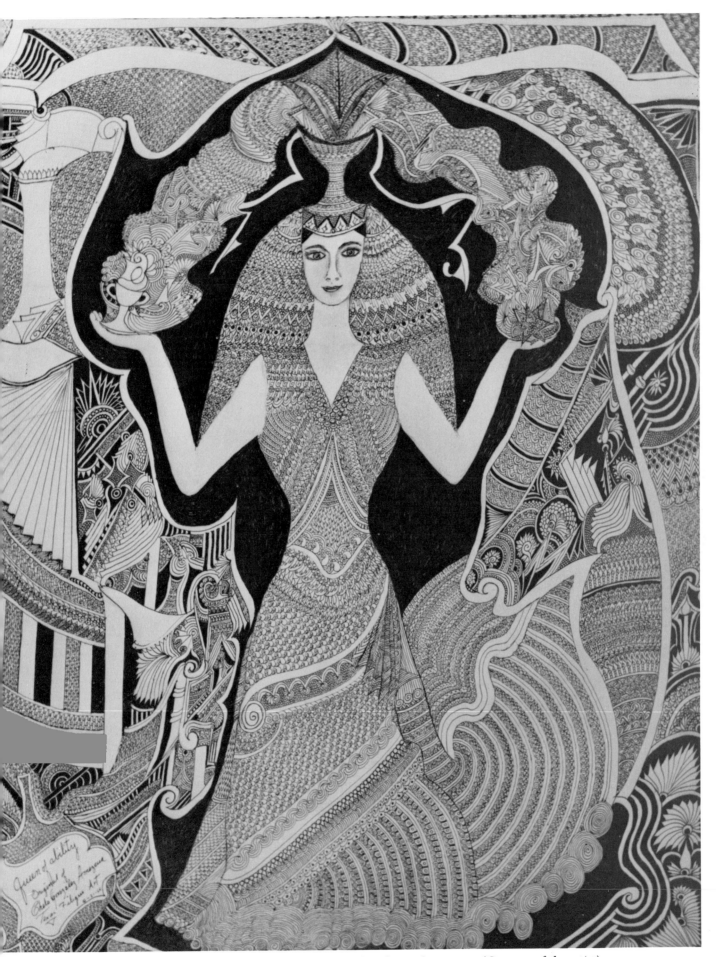

Consuelo González Amézcua. *Queen of Ability*. 1968. Ink and pencil on paper. (Courtesy of the artist)

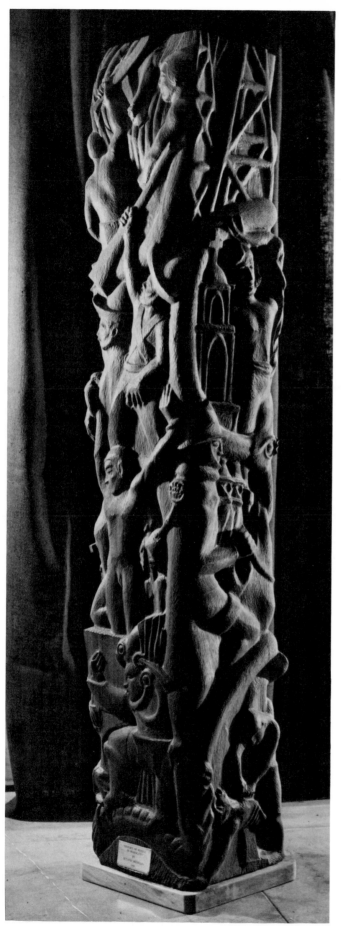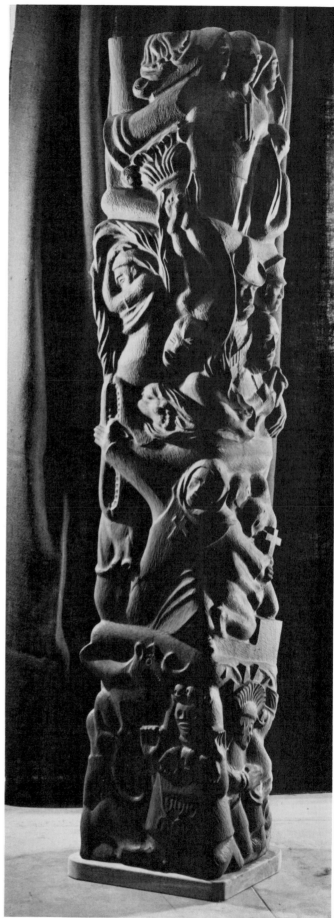

Octavio Medellín. *History of Mexico*. 1949. Honduras mahogany. (Collection of Frank Paxton Company, Kansas City, Missouri)

time I assumed that she had hurriedly made this expressly for the *Humble Way* article.[5] Prior to our meeting I had seen her black-and-white works only in reproduction. Changes in surface texture, color, and indentations are not apparent in these reproductions, which are also greatly reduced in size. I assumed that most of her work was done with pen and ink.

Chelo has used ball-point pens from the very beginning. She has tried to use the other kind of pen with india ink at the urging of John Leeper, Curator of the Marion Koogler McNay Art Institute in San Antonio, but does not like it. She was asked to do the cover for the catalogue of her show at the institute in pen and ink, for purposes of reproduction. Nevertheless, she found these pens too difficult to use. Besides, the constant "spilling of ink ruined the drawings." Instead she prefers the inexpensive ball-point pens, which are available in four colors: red, green, blue, and black. For purple and pink she has to buy another brand.

The ball points have many advantages as far as Chelo is concerned. No special technique is required. Long continuous lines can be executed without having to worry about constant dipping in an ink well. Nor is there concern about the spilling of ink. The fine nuances that can be created with pen and ink are not of major importance in her work. There is no great need for any differentiation in thickness or thinness of line. These subtleties would get lost in her works. What is imperative is that line be used to define all forms, which in turn are arranged in highly intricate patterns and designs. These are best defined with the uniform type of line that can be obtained with the fine ball-point pens.

Now that I have gotten to know Chelo a little better, I feel that she is probably fortunate that she did not attend art school. Formal art training can sometimes have a debilitating effect on the aspiring artist. Once started on this course he eventually begins to question everything he has done prior to entering art school. He learns to use new tools and devices, becomes aware of the artistic achievements of the past and those of the present. All these new experiences obviously affect him. Doubt sets in. All this

has to be digested, perhaps forgotten, before he can find his own identity. Throughout this process he gets notions as to what constitutes good and bad art, what is appropriate or inappropriate as far as subject matter is concerned, what are proper or improper materials. All these things Chelo missed. She is probably better for it. This kind of exposure could conceivably have destroyed her talent, sensitivity, simplicity, and the openness with which she faces her work and the world around her.

Octavio Medellín

Octavio Medellín is a well-known Texas sculptor.[6] His works in wood or stone, usually based on representations of a figure or an animal, are strong and monumental regardless of their size. One is always conscious of the figure's mass and weight in these works. His subjects are depicted in broad, firm strokes. Surface textures and other details are subordinated to the total sculptural statement.

Medellín, born in Matehuala, Mexico, in 1907, exemplifies the hardships and dislocations suffered by many thousands during the Mexican revolution. His family, forced to move often, finally settled in 1920 in San Antonio, where he began his art studies. All his early training was under the direction of painters rather than sculptors. He soon sought his own way as a sculptor, however, and in this respect is self-taught. Some of the strongest influences have come from Mexico, where he has studied the native and primitive crafts of the Indians who live in the small villages of Veracruz and Yucatán. The directness of their work has had an enduring impact on his sculpture.

In 1921 Medellín studied painting with José Arpa and life drawing under Xavier González at the San Antonio School of Art. For the next several years he continued his studies in painting at the same school's evening-class program. By 1928 he was able to attend night classes at the Chicago Art Institute. In the following year he tried to enroll in San Carlos Acad-

[5]Jacinto Quirarte, "The Art of Mexican-America," *The Humble Way* 9, no. 2 (Second Quarter 1970): 1–9.

[6]One entire day in early 1970 was spent with the artist at his home and studio.

emy of Mexico but was not accepted, because of his lack of formal training. It was after this that he began his travels in rural Mexico. His return to the United States in 1931 and his marriage that year provided the kind of impetus that was to help him devote all his time to his sculpture. He still credits his wife with giving him the necessary encouragement to continue in this direction. His first sculptures in wood and stone were started in 1933.

Lucy Maverick, painter and art benefactor and Medellín's first patron, played an important role in the artist's life during these formative years in the thirties. With her help, a group of San Antonio artists, among them Medellín, founded the Villita Art Gallery in that city. For the next three years Medellín taught sculpture at the gallery and at the Witte Memorial Museum. In 1938 Miss Maverick was instrumental in getting Medellín to do research on the art of the Maya-Toltec sites of Chichén Itzá and Uxmal, Yucatán. Part of this work was later used as the basis for a book, entitled *Xtol*, commissioned and published by the Dallas Museum of Fine Arts.[7]

Since the late thirties Medellín has exhibited widely throughout the United States in group shows and in one-man exhibits, has received commissions, and has taught in several colleges and universities, among them North Texas State College, Denton, Texas, from 1938 to 1942, and Southern Methodist University, Dallas, from 1945 to 1966. In 1963 the Syracuse University Library asked for his papers and art studies for inclusion in its Collection of Manuscripts of Sculptors. For the past several years, since his resignation from the teaching staff of the Dallas Museum of Fine Arts, Medellín has run his own art school in Dallas.

Medellín thinks always in three-dimensional terms, even when he deals with relief sculpture. This is particularly true of the sculpture entitled *History of Mexico*, which is comprised of numerous figures represented on all four sides of a seven-foot square column. The figures appear to be literally lunging out beyond the ground or surface that contains them within the confines of the blocklike column. And yet

[7]*Xtol: Dance of the Ancient Mayan People.*

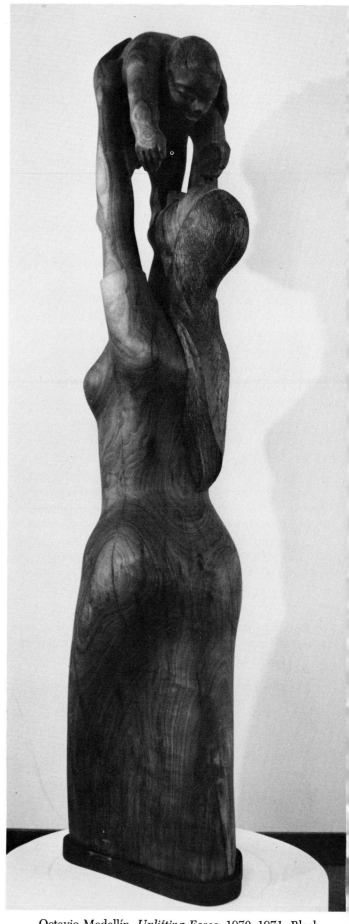

Octavio Medellín. *Uplifting Force.* 1970–1971. Black walnut. (Photograph by Don Hagen; courtesy of Liquid Paper Corp., Dallas, Texas)

the figures and objects, defined in terms of constantly billowing forms that melt directly into the background as they recede away from the observer, are held firmly in place. Most of the figures are defined in terms of swelling and receding forms instead of contours or outlines, thus the preponderant effect of a constantly changing surface that is always in a state of becoming figure and ground but never quite achieving it. Every figure and form is positive with its negative areas nudging alongside, always on the verge of becoming positive areas as well. This creates the effect of a highly charged surface. There is nothing calm about this column, and indeed with reason, since its theme — the history of Mexico — demands it. Medellín has chosen to deal with the most turbulent aspects of that history: the pre-Columbian world in its most sanguinary aspects, the conquest period, the evangelization process, the revolution, and the postrevolutionary period.

Although Medellín has dealt with a narrative that sometimes spills over physically from one side to the next, he maintains strict boundaries between the narratives found within the vertical surface of the column. In fact, Medellín has followed in this work pre-Columbian pictorial formats — reliefs and paintings — which are based on horizontal registers. There are four registers, with a period of Mexican history represented in each. With the four sides of the column, the artist is able to present four aspects of each period. And it is in this direction that the overlapping is encountered. The lowermost level represents the pre-Columbian period with a human sacrifice to the Aztec war god Huitzilopochtli;[8] next to it are the Mayan and Aztec traditions and Coatlicue, the Aztec goddess of earth and death; on the third side the Toltecs are shown conquering the Mayans; and on the fourth Medellín presents a Toltec leader subjecting Maya prisoners.[9] The second register has

[8]Vaillant, *Aztecs*, p. 105. Huitzilopochtli was the chief god of Tenochtitlán: war and sun god. Coatlicue, earth goddess associated with spring, was the mother of Huitzilopochtli.

[9]Toltecs from central Mexico began to appear around the tenth century A.D. in Yucatán. Their conquest of the Mayas was commemorated in a twelfth-century mural in Chichén Itzá, Yucatán: Upper Temple of the Tigers.

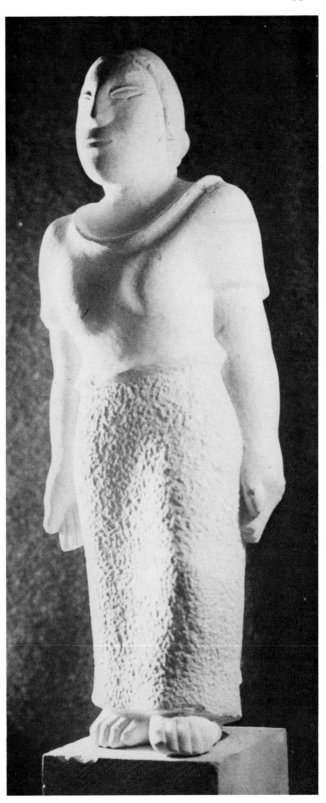

Octavio Medellín. *Indian Woman.* 1931. Limestone. (Collection of Mrs. Vladimer Golschman, New York City)

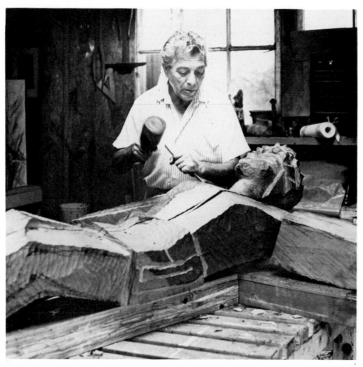

Portrait of Octavio Medellín working on figure of Christ for St. Andrew's Catholic Church, Fort Worth, Texas. 1971–1972. Bois d'arc. (Photograph by Phillip Poole for Photo-Graphics; courtesy of the artist)

Cortés invading Mexico, the Franciscans teaching, the establishment of the Christian church, and the Inquisition. The third register has the militant church, the revolt and misery of the young, the leaders of the revolution (Villa, Madero, and Obregón),[10] and the uprising of the oppressed people. The fourth and final stage deals with oil (one of the most important natural resources), the decline of European influences, the establishment of schools, and the corn harvest.

The figures and gods in the lowermost register are surprisingly stunted in proportion. They bear the brunt of the impending conquest represented directly above with figures that are twice as large as those seen below. In almost all cases the figures are half immersed within the nucleus of the column. They lunge outward, only to be contained by others nearby or by the dictates of another adjacent scene with its own spatial and areal necessities.

Medellín has continued to create large-scale pieces in wood. Some of his more spectacular works in which the wood color and grain are important expressive elements are *The Bather* and *Uplifting Force*. The first is made of monkeypod wood; the second of black walnut. The closed impenetrable configurations are particularly strong in the *Uplifting Force*, even though Medellín has perforated the upper portion of the seven-foot piece in defining the upraised arms of the woman and the small child. The monolithic aspect is pronounced even in a very early (1931) small piece (18″ high) made of limestone, entitled *Indian Woman*.

There is a sensual quality in Medellín's works, which is carried by the gently swelling and receding surfaces of *The Bather* with upraised arms and by *Uplifting Force*. The surfaces, which appear to be comprised of a thick film tautly drawn so as to contain the throbbing forms, lend a heroic quality to these pieces. The monumental effect is pronounced. The figures are anchored to the ground, yet they reach out and penetrate the space around them, while at the same time they are compressed impacted configurations. The interaction between the two demonstrates Medellín's ability to incorporate these and other sculptural elements in creating impressive works of art.

Margaret Herrera Chávez

Margaret Herrera Chávez was born in 1912, in Las Vegas, New Mexico, where she attended local country schools.[11] She grew up on her parents' ranch in Gascon, Mora County. The mountainous region with its attendant changes in scenery has obviously remained an important influence in her work. Much of her work, whether transcribed in watercolor, oils, or printmaking, is based on landscape. Although she may include a microcosm of the city, as she did in her print *Old Albuquerque Park*, or a view of the Isleta Church, she deals in overviews.

[10]Alvaro Obregón was among those who helped Venustiano Carranza gain power after Huerta's ouster. Francisco Villa is, of course, well known, along with Emiliano Zapata.

[11]Margaret Herrera Chávez was interviewed in late May 1971.

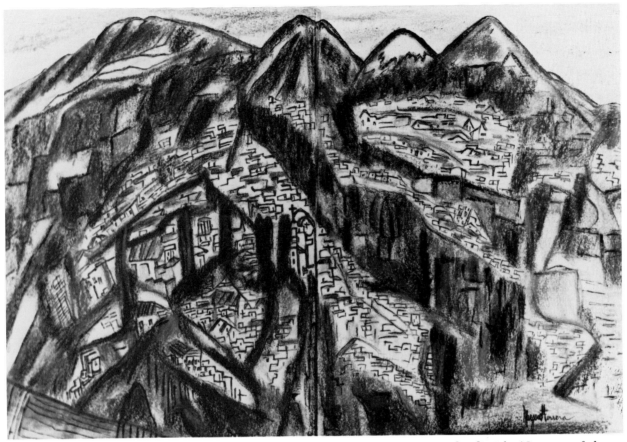

Margaret Herrera Chávez. *Living High on the Andes.* 1967–1968. Wax crayon and india ink. (Courtesy of the artist)

In New Mexico one never sees anything close up, for then the greater totality of the environment will become lost. One is conscious of broad sweeping vistas that comprise our peripheral vision as much as things directly in front of us. One is never very far from an elevation where the landscape will open up before dropping away in subtle changes in elevation until a range of mountains defines the far distance. Then you know that the landscape will open up again into similar configurations, only to be brought up short again by yet another mountain range. Even when one is in the low country, one is aware of the dropping away, the rapidly receding land that is punctuated in a north-south axis by the Río Grande.

So that, for all intents and purposes, Margaret establishes herself in relation to her subject somewhere within the middleground, never close up. To do so would negate the visual possibilities. The observer is removed from the subject by the intervening space not only in a horizontal extension already described but vertically, as well. One is never on the ground looking out; one is somewhere in the air, so that a great deal of what would naturally fall away in great receding vistas from a normal earthbound position is negated. Margaret in effect tilts the surface of her landscapes so that many of them can be seen more readily than would be possible otherwise. She is thus attracted to landscapes that correspond to this way of seeing. Landscape in northern New Mexico forms the basis for much of her work. Small towns nestled in the mountains attracted her as subjects for works after her trips to Central and South America, Mexico, Spain, and Portugal and, more re-

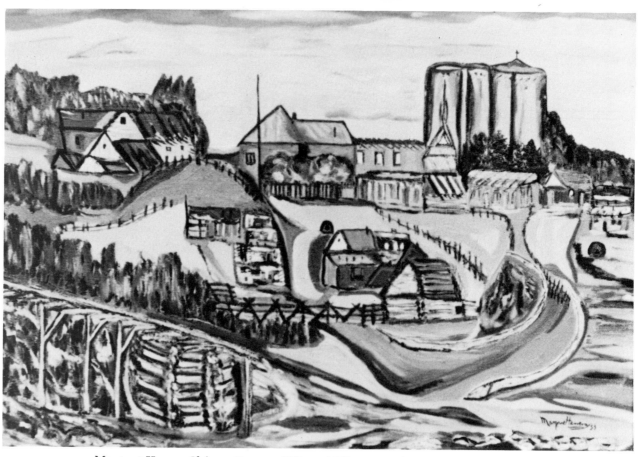

Margaret Herrera Chávez. *Trampas Village.* 1953. Watercolor. (Courtesy of the artist)

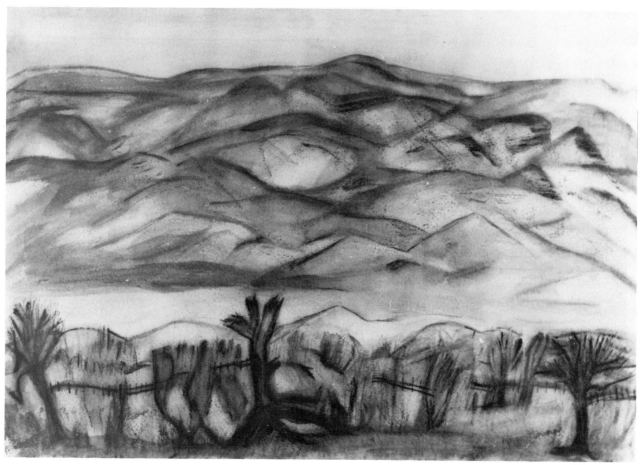

Margaret Herrera Chávez. *Sandía Mountain Spring Time.* 1970. Watercolor. (Courtesy of the artist)

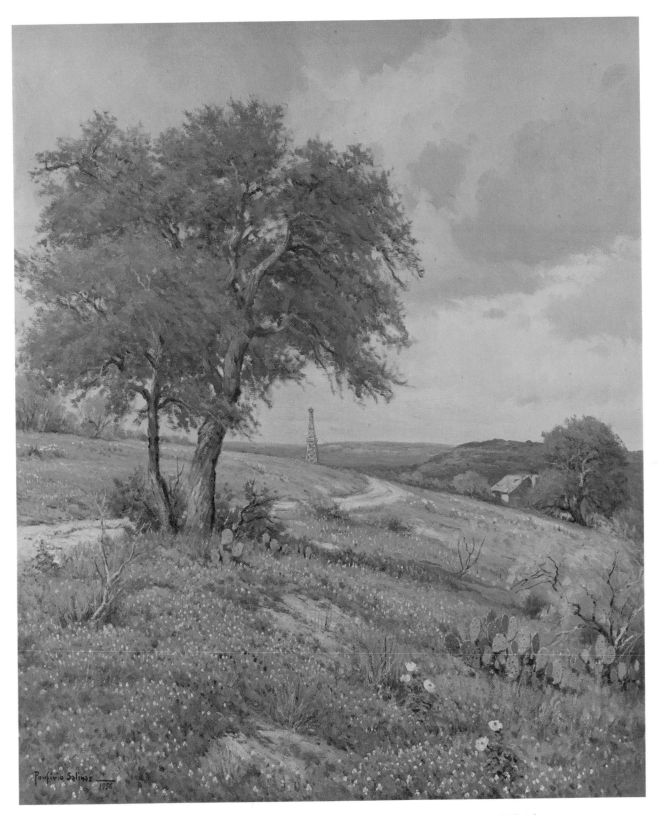

Porfirio Salinas. *Bluebonnets*. 1956. Oil. (Courtesy of Exxon Company, U.S.A.)

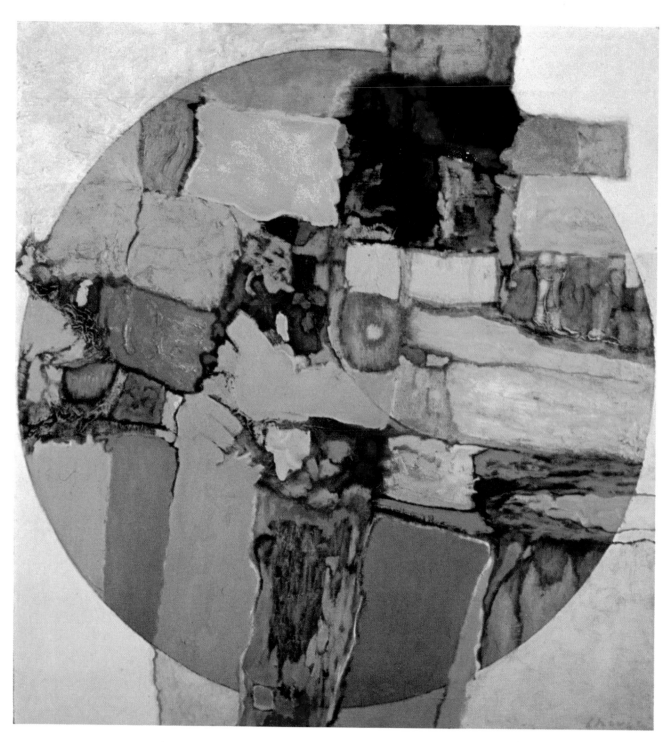

Edward Chávez. *Ocate I*. 1965. Oil on canvas. (Courtesy of the artist)

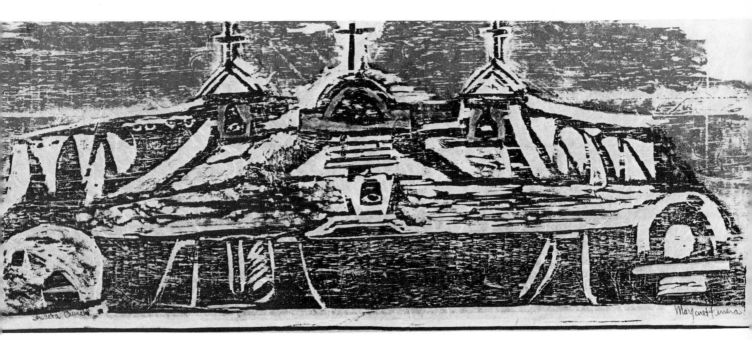

Margaret Herrera Chávez. *Isleta Church.* 1962. Colored block print. (Collection of Mrs. Thomas H. Wortham, Jacksonville, Arkansas)

cently, the National Forest Monuments of California, Wyoming, Washington, Oregon, British Columbia, and Canada.

One of her block prints in several colors deals with the mountain city of Quito, Ecuador, which she entitled *Quiteños on the Mountainside.* She deals with villages and towns in northern New Mexico in similar fashion. The watercolor of Trampas Village near Peñasco is one such example, or watercolors entitled *Overlooking the Río Grande, Sandía Mountain Spring Time, Taos Pueblo,* and so on.

Even when she takes a segment of the landscape, as she does in her mixed-media work *Yucca* (piñon pines and ant hills), she treats it as a landscape. The definition of the constituents, their configuration, is done in such a way that we are still treated to a long view. We are still considerably separated from the subject. Little or no anecdotal data are allowed to intrude, so that one is conscious of the visual elements in the work, line, shape, and color. How these are used to fill in, to suggest, rather than to meticu-

lously define form gives these works an airy, light feeling. There is a transparency in Margaret's work, particularly in her watercolors, that is reminiscent of the New Mexico landscape. The light is bright; it does not penetrate, it reflects. Thus, all colors in nature are suffused, tinted, shaded, changed in value and intensity by this even clear light. And so it is in Margaret's work. Rarely does she use bright, highly saturated colors. They are all toned down, or lightened, particularly in her woodblock prints.

The block print of the Isleta Church, located just south of Albuquerque, is one such example. The background, which is allowed to show through the representation of the church itself, is comprised of different tints and shades of blues and greys. The shapes are defined with black lines and shapes, which are in turn highly textured so that some of the background will show through. The church towers and spires are defined as if seen from a distance and as if the observer were elevated somewhere, level with the upper part of the façade. This represents

another characteristic of Margaret's works. Every object is represented as if its broadest side were perpendicular to the observer's line of sight. Thus, there is never any foreshortening in her repertoire of forms. It is not essential that the observer's fixed position be the determinant as far as the definition of the forms is concerned. She is not tied down to a strict and faithful recording of surfaces of the objects she portrays, just as she is not interested in defining with precision her exact position in relation to those same objects. Although she uses recognizable objects, she uses them as points of reference from which she gains impressions. Unlike her predecessors, the Impressionists, she is not interested in capturing the effects of light on objects but rather in recording her subjective response to these objects. It is thus an interaction between the artist and her subject that becomes important in the execution of the work, rather than making a faithful visual record.

Porfirio Salinas

Porfirio Salinas has chosen a far more particularized path in his devotion to recording the landscapes of the Southwest with special reference to the environs of San Antonio. It is this immediate recognition of and emotional attachment to the land that Texans feel that have brought him such acclaim in his home state. One of his earliest admirers was Lyndon Johnson, who began to buy his works in the forties and whose elevation to the presidency brought national attention to Salinas's work. His paintings have been reproduced in articles, books, and other publications, especially his renditions of the fields of bluebonnets, which grow in profusion in Central Texas.[12]

Salinas was born in Bastrop, Texas, in 1912, one of seven children. He had a bare three years of formal schooling and is almost completely self-taught as a painter. As a child he was able to look on as the San Antonio artist José Arpa sketched in the streets and fields. His first painting job came soon after he was hired to dust the pictures and guide people through

the exhibits in a San Antonio gallery. Robert Woods, the landscape painter, often assigned the details he hated to do in his pictures to amateurs. Salinas was hired to paint the bluebonnets, the most difficult and bothersome of all. It was not long after this that Salinas began to paint on his own, and, while still a teenager, he sold his first painting to one of his former teachers. His next break came when Sam Rayburn saw one of his works in an Austin shop window, bought it, and took it to Washington. When Lady Bird Johnson saw the painting, she decided to commission the artist to do one as a surprise birthday gift for her husband. The Johnsons now have an extensive collection of Salinas's paintings. Since then a number of former Texas governors have collected Salinas's works, among them Beauford H. Jester, Allan Shivers, Price Daniel, and John Connally.

Salinas, an unassuming, simple man, does not theorize about his work. He merely records what his eyes see. And what he sees are the familiar scenes around San Antonio —bluebonnets, huisache trees, and cactus. As a result of these points of view, he literally becomes an unobtrusive presence in his work, an almost passive observer, who does not impose his emotions but rather becomes a transmitter of images that trigger in the observer, familiar with these scenes, feelings of immediate recognition of place and home. Salinas concentrates on all the visual data that will elicit these responses. Since there are no drastic changes in the Central Texas landscape except during spring when the fields are full of flowers, he tends to concentrate on this season for many of his works. Winters do not customarily bring snows or other perceptible seasonal changes. Live oaks retain their foliage year round. Colors become less bright, but by and large the landscape remains unchanged. Salinas carries it a step farther. Regardless of whether his works represent the spring, summer, or fall, the skies remain largely unchanged — very light blues interspersed with the ever-present cumulus clouds of this region. The vegetation is presented in a large number of green shades, spotlighted by bluebonnets and other spring flowers. In most cases, the large open fields are interrupted by

[12]Porfirio Salinas was interviewed in the fall of 1969.

at least one or more live oaks presented in the foreground or middleground. The landscape then extends far into the distance, occasionally interrupted by a softly rising hill. And, depending upon the theme, he will include cattle, or deer, an oil derrick by a meadow, a creek, a river.

Spatially there is no overriding sense of structure beyond that necessary to carry the theme. The gently rising and falling ground, tilting away from us, is used to create vast distances, so that the sky often occupies at least half and sometimes more of the visual surface.

5. Second Decade: 1915-1923

EDWARD CHÁVEZ (b. 1917) and Michael Ponce de León (b. 1922) are two truly outstanding members of the next generation of artists, whose formative years span the thirties and forties.[1] They have achieved national prominence, with their works being exhibited in every major museum in this country. Others who have gained some prominence in their home state of New Mexico are Joel Tito Ramírez (b. 1923), who depicts the landscapes and history of New Mexico in his paintings; and Rubén Estrada González (b. 1923), who explores all media, including steel and carved wood, in his assemblage paintings. And, finally, there is Pedro Cervántez (b. 1915) of Clovis, New Mexico, who concentrates on the landscapes of his home state.[2]

Edward Chávez

Primarily an easel painter, Edward Chávez has painted murals in several states and in Brazil. His work is based on the new pictorial languages developed by European artists before World War I, abstraction based on a cubist spatial grid. Color is spotted, and accents flicker over much of the visual field in his early paintings. These are sustained within strong patterns established and defined by dark rectilinear forms. In his most recent works these have been deemphasized, displaying a far richer palette. Large, clearly defined color fields take up large portions of the paintings.

Chávez, born in Wagonmound, New Mexico, in 1917, has had a long and an active career as an artist and a teacher. He has had one-man exhibitions of his work in Denver (1937), New York (1948–1961), Rome (1951), Santa Fe (1954), San Francisco (1954), and Detroit (1957). He has received many awards for his works and is represented in major museum collections in New York, Washington, Michigan,

[1]Michael Ponce de León was interviewed on June 4, 1970. Information on Edward Chávez was obtained from the artist through correspondence.

[2]All three artists supplied biodata through correspondence.

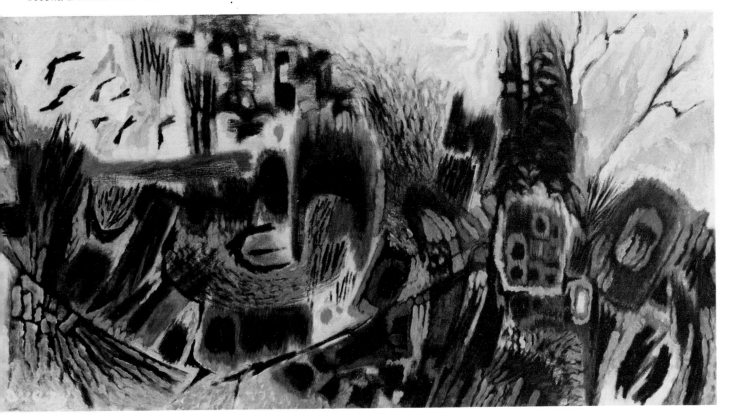

Edward Chávez. *Xochimilco*. 1965. Oil on canvas. (Photograph by O. E. Nelson; collection of Mr. and Mrs. Carl Pollet, Long Island, New York)

New Mexico, and Ohio. He has taught at the Art Student League (1954–1958), Colorado College (1959), Syracuse University (1960–1961), Dutchess Community College, Poughkeepsie (1963, 1969–1970), and Ogden School (1968).

Edward Chávez was first introduced to art in high school and later studied art briefly in the late thirties at the Colorado Springs Fine Arts Center. However, he considers himself to be largely self-taught. His extensive travels throughout Europe and his residency in New York for the last thirty years have, of course, placed him directly within the mainstream of twentieth-century art developments.

In 1954 Chávez spent three months traveling by jeep throughout Mexico, a trip he considers to have been entirely too brief. Mexico, its culture, and its history, remain a major center of interest for him. One of his most pleasurable preoccupations involves singing early Mexican *corridos* or *canciones rancheras*.[3]

Chávez has been attracted to the works of the early Italian *quatrocento* painters Paolo Uccello and Piero della Francesca and *trecento* painter Giotto, the Flemish painter Pieter Brueghel, and, more recently, the Mexican painter José Clemente Orozco, who exerted a great influence on him in his youth.

Although he has admired the work of Rufino Tamayo, whom he considers primarily a European rather than Mexican painter, and has been interested

[3] *Corridos* are narratives that are sung. They relate the story of an individual whose end is usually tragic. *Canciones rancheras*, usually in a more popular vein, are folk songs, which may or may not relate a story.

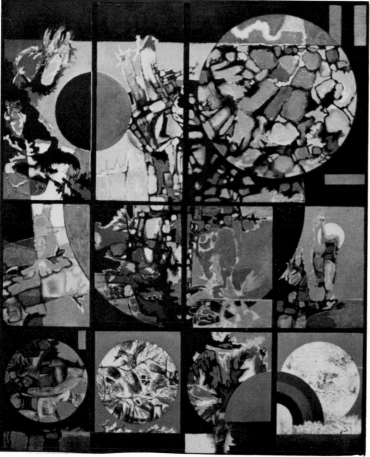

Edward Chávez. *Moon Journey*. 1969. Acrylic on canvas.
(Courtesy of the artist)

thing from room-size pieces to watch-pocket size. He usually begins with an "idea," or concept; however, in recent years his material has become more and more important, particularly in his sculpture. He considers it important to establish an open-ended situation in which his concepts can be developed, taking into consideration at all times the expressive possibilities of the materials used. The concept, rarely of a specific nature, and the materials are important as points of departure and as means, however, and are not the exclusive determinants of the end product.

Ultimately, the most important thing in Chávez's work is the formal configuration. Although he has used such place names as Xochimilco (a town south of Mexico City) as a subject, the reference to place is quite often of a very general nature, like *Beach, The Wave, The Rain Forest, Mesa*. Recently, moon missions and celestial phenomena have served as subjects for his paintings; examples are *Moon Journey* and *Eclypse*. Whether entitled "bird nest," the "magician," or "still life," all these works exhibit formal similarities that have more to do with Chávez's style than with the subject or the point of departure. These demonstrate uniform emphasis on use of the visual elements: line, color, shape, space, and texture. The most-favored shapes are geometric — rectangles with rounded corners and often with ill-defined contours and circles. Sometimes the works are speckled with innumerable rectangular shapes of different sizes and colors. At other times the circle becomes the dominant all-inclusive shape to which all visual phenomena are subjected. In all cases the underpinning of these works is a two-dimensional spatial grid. A good example is *Mirage*. There is no emphasis on spatial depth, no interest in using the traditional space indicators. These fall outside the vocabulary considered essential by Chávez. Everything takes place on the surface of the canvas. Line threads through, contains, and defines shapes, thus holding them together within this single visual plane. There are slight variations, of course, between colors and shapes within this tight spatial arrangement. But, basically, the effect is purposely arranged within this single visual plane.

in the works of the other Mexican muralists, particularly the work of Siqueiros, Chávez emphasizes that he has been affected by the "New York school" of art for the last twenty years.

Chávez has worked in graphics (lithography, serigraphy, and drawing in all media), painting (watercolor, egg tempera, casein, oil, acrylics), and sculpture (wood, steel, bronze, casting).

In preparation for a painting or a sculpture Chávez will make brief notes in sketch books as ideas occur to him. However, once he begins work on the actual canvas or sculpture he seldom refers to these and never makes additional studies. He prefers to work as spontaneously and unhindered as possible. Size is no major concern. He can work on any-

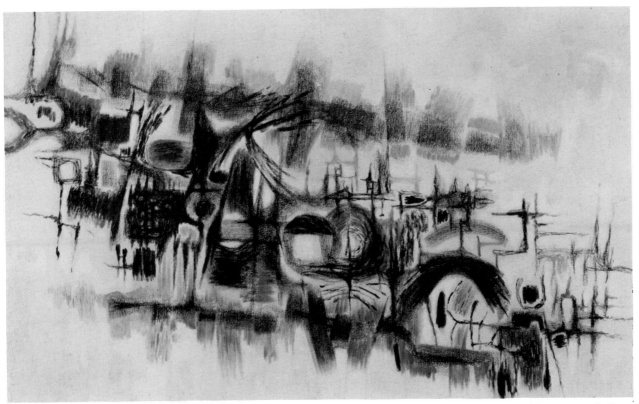

Edward Chávez. *Mirage*. 1961. Acrylic on canvas. (Photograph by O. E. Nelson; courtesy of Bennett Schiff Collection, New York City)

Some of Chávez's other works are comprised of constantly changing surfaces, flickering with light and color. These are clusters of line, color, and shape — all of them held together by placement (in clusters) and definition in terms of line. These highly textured surfaces are tilted onto a vertical position that is parallel with the picture plane. Sometimes these appear to be floating within the visual surface. At other times Chávez anchors them to the sides of the frame by adding or attaching one or several parts of these complex surfaces to it. Such is the case with *Ocate I*. All the main visual activity is contained within a perfectly defined circle. Still, Chávez has violated the boundaries of the container above and below so that there are attachments to the top and the bottom of the picture that are stopped short by the frame. There is no reason to do the same on the sides, since the effects would be repetitive, so here

Chávez altered the interval between the frame and the circle. There is a greater space between the circle and the frame above and below than at the sides, where the circle almost comes to the frame. There are two tentative movements on the upper left side and the lower right, but these do not compare with the emphatic anchorings to the top and the bottom. These latter rectangular units are tilted slightly off their vertical axis and are placed to left of center. There are, then, a number of different-sized rectangular shapes placed vertically and horizontally to form the desired balance.

The floating effect is even more pronounced in the work entitled *Landscape*.[4] Although the entire

[4]*Landscape* is reproduced in Jacinto Quirarte, "The Art of Mexican-America," *The Humble Way* 9, no. 2 (Second Quarter 1970): 5.

Portrait of Edward Chávez with woodcarvings. (Courtesy of the artist)

surface is covered with color, line, and shapes, this is due to the fact that, as we move to the edges of the frame, we see that the rectangular and square shapes with rounded corners are not constantly reinforced with color accents, as is the case with the areas found in the central part of the painting. The colors are toned down so that they create far subtler changes in the surface than do the areas to the center.

Michael Ponce de León

Michael Ponce de León, printmaker and teacher at the Pratt Graphic Center in New York, is well known for his relief prints made with specially designed presses. He creates bas-reliefs with special

papers and a press that applies ten thousand pounds of pressure per square inch. He thinks of his work as a confrontation between the artist, equipped with no preconceived notions, and his material, which is to be manipulated, molded, and made to respond to the artist's touch, while in the process it may impose or suggest certain possibilities. He explains his approach by saying, "I bring into my work all the insights gained from sculpture, paintings, cinematography, and music, and, by combining their resources and wedding these traditionally separate media through a single image, a new form emerges. My research, therefore, is not based on new ways of graphics per se, but in discovering a new meaning of art through graphics." Ponce de León's prints and his teaching have influenced graphic artists from all parts of the country, and from abroad. Students from Mexico and South America have come to New York specifically to study under him.

Ponce de León, born in Miami, Florida, in 1922, spent his early years in Mexico City, where he received his first formal schooling. He did not study art in Mexico, although he did think of becoming an architect because everyone in his family was either a journalist or an architect. He began to demonstrate an interest in drawing around his fourteenth year, yet architecture remained his ambition until he joined the U.S. Air Force during World War II. It was during this time that he began to submit to national magazines drawings and cartoons, which were accepted for publication. From 1942 to 1949 he was a free-lance cartoonist, contributing to such magazines as *Colliers, Saturday Evening Post, New Yorker,* and *American Legion.* From 1948 to 1954 he concentrated on a series of cartoons, entitled *Impulses,* which were syndicated in this country and in Europe.

The use of silhouettes and shadows in the *Impulses* cartoons remained a strong characteristic of his later works, even though at first glance the latter do not seem to have anything in common with the former. Just as these early experiences are reflected in his most recent work, his earlier schooling in Mexico is of equal importance in his development as an artist.

In referring to his studies of music, he says, "For a long time I have heard rather than seen colors. I hear sound [he demonstrates by knocking on various surfaces]. Now, that is a beautiful sound. If you can express sound in terms of color [this time he makes other sounds by rattling different items] . . . then you have accomplished something." Thus, to Ponce de León, sound may evoke color and vice versa.

When Ponce de León visited India under the auspices of the U.S. government a few years back, he was able to express his ideas about art to larger audiences in lectures delivered on his tour. When one newspaper reported his activities as being those of an "American Mystic artist lecturing throughout India," he was jubilant. "Boy, to be a mystic in India. That was terrific."

In spite of his views on color and sound, Ponce de León often does not think in terms of color when he is preparing and formulating an idea for later development into a print. During the preparatory phase he makes a miniature sculpture, which enables him to work out the solutions he has in mind. "Sometimes I don't even bother with colors. I just go to the shapes. In fact I had to do a sketch about this size [here he was referring to a small work]. And the reason I work very small is because it forces me not to embroider at this stage of the work. The shapes are the important thing." Once Ponce de León decides what he is going to do, he develops the concept into final print form. However, he differs from other printmakers in running ten instead of the usual fifty prints. Costs for the special papers and other materials make larger runs prohibitive. Even so he complains that he often does not clear expenses. The fact that he does not do series of one work also makes it difficult financially. Each print is a unit rather than one variation within a series.

The preparatory phases in the production of a print are very important to Ponce de León. "I get so many ideas but then none of them seem to be right. So what I do is choose four or five and put them together to form one. That's why my things are complex during the working stages but simple in final form."

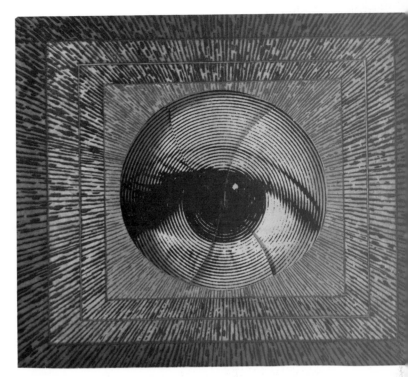

Michael Ponce de León. *Tell It Like It Is*. 1970. Lithograph-intaglio. Shutter expanded. (Photograph by Arthur Swogen; courtesy of the artist)

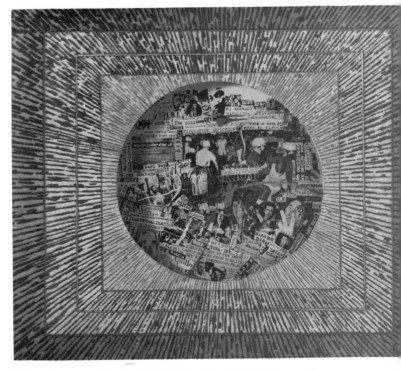

Michael Ponce de León. *Tell It Like It Is*. 1970. Lithograph-intaglio. Shutter contracted. (Photograph by Arthur Swogen; courtesy of the artist)

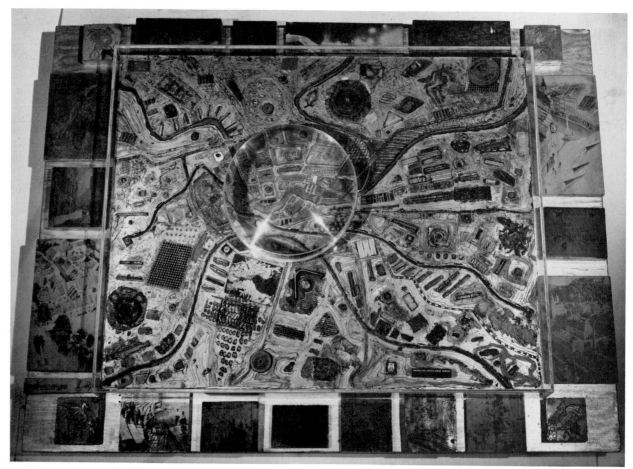

Michael Ponce de León. *Kinetic Construction with Lights and Sounds.* 1965. Metal collage (tapes taken in Ljubljana; metal from the debris of the city of Ljubljana). (Courtesy of the artist)

Although Ponce de León is famous for his techniques, he prefers to think of them as secondary to the importance of his work. "I think tools have a voice, materials have a voice," but they are only the means for the creation of a work of art. The ultimate importance of a work resides in its content and its formulation.

One of the recurring shapes in Ponce de León's work is the circle. In one instance he started out with a specific idea related to the paper he was using. Along with this he began to use the circle. "I began to do things in the circle bigger and bigger until there was nothing left but the circle. Now the circle to me is a force of life. It has no beginning, no end. But then I began to think of the circle as a confinement.

I wanted to get out. So I began to make the circle move out and come in because this comes from the idea found in Zen Buddhism." He then explained how breathing exercises influenced his formulation of the work. Meditation in India, according to Ponce de León, is accomplished by closing the eyes, inhaling all the thoughts of the universe, feeling all the enemies of the universe move through the body, absorbing them, and then exhaling and giving them back to the world. Pointing to the work, he explained further, "This thing goes out because it has to go out. You see, it curls into itself and it goes out and comes back. The same thing happens with the colors. One is in front of the other and so on."

Sometimes Ponce de León feels that he traps him-

self in the complexities of his conceptions. However, he does not formulate an idea for novelty's sake but because he wants to make a very personal statement.

Ponce de León thinks of himself and his work as something that is always changing, developing, and receiving and transmitting signals that are constantly changing. When asked who he is, Ponce de León answers with a question, "At what time and when?" What he was the day before is slightly altered by the following day, and manifestations of this changed state of being are gauged by his pronouncements, "Every day I am somebody else." What he says today will be altered the following day "because one of the things I hate more than anything else is to follow in my own footsteps." There is a constant regeneration and recharging, which is accomplished by changes in environment.

Inspiration for a work may come from film, music, or the theater. The use of photographs in his prints was inspired by the movies as early as 1959. This was in keeping with his work with collage at the time. The photograph was classed along with other found objects as eligible for incorporation into a work of art. A discolored photograph was preferable to just any photograph. Concepts of time and space, evocative of a period, were obviously determinants in the selection of a photograph.

In a work done in 1961 and entitled *Mundigrama*, Ponce de León incorporated a 1914 photograph, an eggcrate, a drawing, a bullfight, people jumping, a boat, and one of his old cartoons.[5] This represents his manner of working in dualities, of constantly opposing forces. From this he turned to using mountains in his work, then abstractions. At all times, however, he thinks in terms of problems and their solutions.

[5]This is probably the first *photo*-lithograph in the United States, according to Ponce de León (correspondence). The print is found in the Library of Congress, the Philadelphia Museum, and the Smithsonian Institution. It is interesting to note that many of Robert Rauschenberg's prints with photographs date from about this time. In fact, Ponce de León showed Rauschenberg how to use photographs in his lithographs, when they worked together for a short time.

[6]Paul Klee, *On Modern Art*, also *Pedagogical Sketchbook* and *The Thinking Eye: The Notebooks of Paul Klee*.

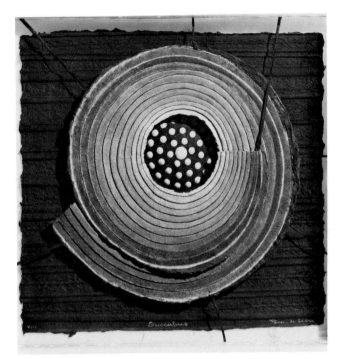

Michael Ponce de León. *Succubus.* 1967. Collage-intaglio. (Photograph by Arthur Swogen; courtesy of Charles Rand Penney Foundation, Olcott, New York)

Artists who have impressed Ponce de León a great deal are Picasso, Matisse, and Klee. Picasso was his idol in school. His involvement with Cubism was in fact so great during this period of his life that he had a difficult time breaking away from it: ". . . not only did I get involved with Cubism, but also I got involved with the personality of Picasso. And this is the important thing. To finally be able to paint something and to make it your own is the most difficult thing in the world. This is what I hope I have been able to do. Something entirely personal."

Although Ponce de León was not attracted to Matisse in the beginning, he later was very impressed with the artist's "cutouts" (cut paper) produced toward the end of his life in the fifties. These cutouts were a great inspiration to Ponce de León. The broad unmodulated color areas and the strong contours are clearly what attracted him to Matisse's work.

Paul Klee's writings[6] were also a strong influence in Ponce de León's work. "I don't mean to say I have

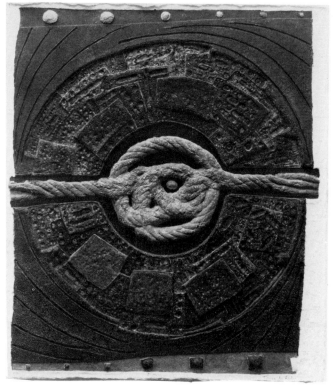

Michael Ponce de León. *Entrapment.* 1965. Collage-intaglio. (Courtesy of International Art Program, National Collection of Fine Arts, Smithsonian Institution)

done things like Paul Klee." The organic, poetic, and musical qualities of Klee's writing made a deep impression upon him.

Ponce de León's interest in Klee's writings can perhaps be linked to his own involvement with words and their meanings, which he sometimes uses in his works. Some of the words he has used for prints are *succubus* and *countertrust.* He explains his approach. "I was trying to find a word that has something to do with suction—suct, suct, suct, suction. I found the word succubus, which I had never heard before. It is the opposite of incubus, which is when a man possesses a girl in a dream, from a demon, and makes her pregnant. And this is the other way around. A man dreams that a woman possesses him, you see. So I thought, this is terrific." The imagery suggested to Ponce de León by this word forms the basis for

this work, which has been much discussed by writers. "Now, it doesn't matter whether people [writers] see it or not. But I am trying to say something. And, if something happens to you in the act of doing, then that is important. I react to this differently than would somebody else. So each thing I do, I believe, is based on something."

In discussing his print entitled *Countertrust,* Ponce de León emphasizes that he purposely spelled it that way. He coined it specifically for the print. He based it on the inscription "In God We Trust" found in the U.S. coin he used (an impression of it) in the center of the print. "To me this is representative of two worlds in conflict." He incorporated the implements of war—the arrows—held in the eagle's claws. These concepts were further amplified in the system of colored arrows that dominate the print and move in opposite directions toward the sides of the print.

On another occasion one of Governor Wallace's statements suggested a possible concept for a print. It was the governor's contention that Negroes were treated better in the South than in the North. Ponce de León then began to build up the imagery in his mind and to actually put it down during the preliminary stages of the work. A rope with a knot suggested the Ku Klux Klan to him. He made it white with a small black shape placed in the center of the knot. Somehow it did not work satisfactorily. When the two ends of the rope placed at the edges of the visual field were pulled the knot would be drawn tighter, thus squeezing the small black shape. But it needed something else, so he added representations of rivets to the print. In the process he decided to make it more universal. The black shape was changed to red. The rope was no longer white. This then began to represent the psychological, physical, and spiritual problems of man. Thus, the red shape became the red cell of life, or people. He entitled the work *Entrapment.* And although the placement of the rivets had been dictated by the necessities of the work, possible meanings were also assigned them at a later date during one of Ponce de León's lectures. "People asked me, well if the red cell of life represents people, what is this thing you have there? Even

though I just drew those to close the picture, I said without hesitation, 'if this is a person, these are people like you and me. We just stand on the sidelines watching what is going on.' "

This anecdote illustrates very well how Ponce de León proceeds with his work. "I don't know what I am doing until I am two-thirds finished."

During one of his visits to Mexico he formulated an idea for another work, even though he had gone there to rest. "I was taking a sunbath in Mexico in the month of August. You know how the clouds are at that time. The clouds came and covered the sun. I couldn't take a sunbath and I wanted to very badly, so finally I was so angry with all those clouds just coming in and out that when I came back I began to do things and this is what came out. I call it *Abduction of the Moon*. So this became one big cloud and this another. And this is almost like taking it away."

He considers himself to be a product of many cultures. Although he was brought up in Mexico, he has traveled in many countries and learned many things. On occasion he is told that his works are Mexican in feeling. Although that makes him very proud, still he has to point out that he was not thinking in those terms when he made the work.

Ponce de León continually emphasizes that, although he may not have a clear idea of what he wants to do in a particular print, he has to determine what it is, sometime during the process of working. He may assign meanings to certain shapes eventually but not during the execution of the work. Yet that shape has to have some meaning even though he may be unable to articulate it at the time it is being used with others in the work.

In emphasizing the use of shapes, lines, and colors in his works, Ponce de León points out that it is no mere formal exercise, of putting things together. There has to be some foundation. Here he lapses into a discussion of the movement of celestial bodies and their relationships. "There has to be a oneness with the universe. For instance, a planet going around the sun. What is happening is that the planet is trying to get closer and closer to the sun from which it was once expelled. It never really gets there, but the idea

of trying to get in—that is what pulls a person. You might fail; you might try to get a perfect shape, a perfect color, but you never get there."

This process of becoming, of doing, for Ponce de León means having something as a basis for the work, some meaning, not just the assumption of a passive role in which you wait to see what happens, what develops. There has to be an involvement. One of his favorite stories deals with the Oriental artist who was commissioned to do a painting of a certain mountain within a period of one year. "He spent the whole year going to the mountain, making sketches, absorbing, sleeping there, breathing the air, feeling the mountain, walking through the mountains. Now, he said, the mountains are in me. So he got a sheet of paper and in one hour he had the whole thing done." That is what Ponce de León means by involvement. This philosophy may have some relationship to his trips to Mexico once a year, where he usually goes to rest. He does not visit any of the galleries. He just looks around, spends one month. "I just go to Mexico City for a few days and then I take off. I walk around the mountains."

These trips to Mexico are efforts to recapture some feeling he has about the place. Yet this does not mean that his work is to be considered Mexican in any way. "I am very proud of Mexico. But I can not say I am what I am because I was raised in Mexico. Who knows. I don't know myself. I am what I am. This is an open question for me. I am exploring it and I don't come right out and ask each artist about this. Because I personally do not feel that it is important. I have to be myself, whatever that is, I don't know. I don't even care. I am not going to find out what it is. I am in the process of finding out, but of course I never will."

How a man develops as an artist is not wholly determined by where he comes from. Ponce de León tried to explain this to his Indian and Pakistani hosts when he visited their countries several years ago. He was having a great deal of difficulty reaching his audience simply because he was from the United States. "I am an artist and art is universal. An artist does not have a particular country. An artist thinks

and feels in universal terms. So it doesn't matter where I come from. Let's get together and see what we can do. I have things to give you and you have things you can give me. This is an exchange of ideas."

This statement expresses best how Ponce de León sees himself and his art.

Rubén González

Rubén González, best described as a construction-assemblage artist from Bayard, New Mexico, incorporates found objects into his works. He also uses oils, acrylics, watercolors, welded steel, carved wood, and wood assemblages with collage.

González, born in Hurley, New Mexico, in 1923, spent part of his childhood in Mexico. When his father died, Rubén was sent back to this country to live with relatives so that he could continue his education. He was about thirteen when he returned to the States and he has never returned to Mexico. He attended elementary school in Santa Rita, New Mexico, and Cobre High School in Grant County. He worked in the mines briefly until his induction into the service during World War II. He served from 1944 to 1946. Upon his return to the States he went back to his employer, the Kennecott Company in Bayard, where he continues to work.

González loved to draw as a child. Some years later, plans were made to study with Diego Rivera, but they had to be abandoned when González's father died. Although he was not able to return to his art studies until very recently, González feels that all along he has been an artist at heart, confident that some day he would be able to concentrate on his art work.

In 1965 González began to study art on a part-time basis at Western New Mexico University in Silver City. Within two years, with the encouragement of his art instructor, he entered his first juried show in Tucson, Arizona. His work was accepted; it received an honorable mention and was purchased by Joseph H. Hirshorn of Greenwich, Connecticut. Since then González has exhibited his works throughout the Southwest.

González has been much impressed with the works of the Mexican muralists, as well as with Picasso and Henry Moore.

Although González starts out with several ideas in mind, he keeps changing these, discarding or adding as he goes along. He considers materials to be extremely important in his work.

In one of his most recent pieces, entitled *Search for Identity*, González used collage and construction. Although the surface, built up with different materials, has definite ridges and depressions, the main concept is pictorial rather than sculptural. And in keeping with this concept, the piece is appropriately framed.

The work is divided into several narrative fields; the left part contains the American scene, while the right contains the Mexican. A highly stylized eagle with jagged edges divides the two sections. The angularity of the eagle in surface and in outline is retained in portions that correspond to the colors of the American and Mexican flags, both of which are given equal importance. Directly above the eagle is a circular field, half of which is within the blue field (with stars) of the American flag and the other within the red of the Mexican flag. The eagle falls equally on the red and white stripes of the American flag and the white stripe of the Mexican flag. Wedged directly beneath both flags within a triangular shape are references to Mexico along the outer band and within two small triangular, or pyramidal, forms at the bottom.

González has used the colors of the flags at their highest intensity. The blue field with white stars is offset by the red of the Mexican flag. Had the red and white stripes been defined in their usual proportions, González would have had a visual problem, so he narrowed them considerably. To have done otherwise would have courted disaster visually with the color red dominating everything. In order to maintain a further hierarchy of parts, he has used black-and-white photos for the bottom and color (primarily yellow or gold) for the circle above. The photographs are of well-known landmarks in Mexico like the library and other buildings at the National

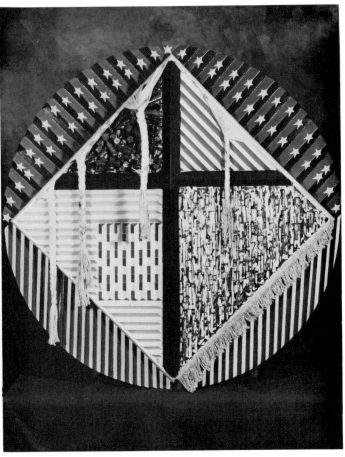

Rubén González. *The Great Society.* 1969. Painted wood relief. (Courtesy of the artist)

University, the Quetzalcóatl pyramid at Teotihuacán, a serpent head from a baluster of a pre-Columbian structure, and pictures of the Mexican people. The American experience appears to be a more volatile mass comprised of signs and photographs. Everything is squeezed into the circular container, each shoving against the other. Some of the words and objects seen are *tortilla, tamale, chili, Cuervo, Falstaff,* a photograph of John Kennedy, a headline, an image of the Virgen de Guadalupe, the American flag, and so on. González has managed to contain the experience of the Mexican American people within this series of images.

In a slightly earlier work González used basically the same materials but a far more specific reference to the United States. In his *Great Society* (wood relief), the American flag forms a backdrop for a square field turned on its side to form a diamond in which a cross is used to divide it into four parts. The diamond is framed by actual fringe and tassels. This time González included all fifty stars within the blue field instead of less than half that number as in his *Search for Identity.* Each of the triangular fields within the negative areas of the cross is treated differently. Upper right and lower left are clean, precisely defined in terms of alternating stripes of grey and white, going diagonally above and horizontally below. The latter stripes are punctuated by vertically placed capsulelike red and blue shapes. The upper left triangle is filled with small cylinders painted, none too carefully, in blue and red. The clusters appear rather menacing. This gives way to a white field on the lower right, which is spattered with blue and red. Calm and violence seem to be incorporated in this work.

Pedro Cervántez

Born in Wilcox, Arizona, in 1915, Pedro Cervántez has lived most of his life in New Mexico. He attended school in Texico and presently lives in Clovis, where he runs his own commercial art business.[7] Exhibitions of his works in Santa Fe and other cities in New Mexico, as well as in other parts of the country, over the last thirty years have brought him renown in his home state. He received national exposure very early in his career when he was included in a show of contemporary American art presented at the Museum of Modern Art in New York. The works of Cervántez and nine other American painters and ten Europeans were included in a book entitled *Masters of Popular Painting.*[8] One of the works included in the exhibition was *Pink Oxalis on Stove,* a meticulously painted still life. Cervántez's works have also been exhibited in the Dallas Museum of Fine Arts, the Colorado Springs Fine Arts Center, the Whitney

[7]Information from the artist.
[8]Holger Cahill et al., *Masters of Popular Painting: Modern Primitives of Europe and America,* pp. 108–110.

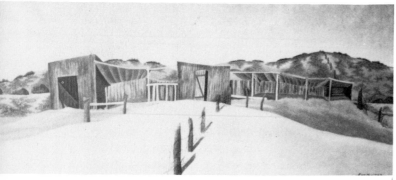

Pedro Cervántez. *Desolation*. 1951. Oil on masonite. (Courtesy of the artist)

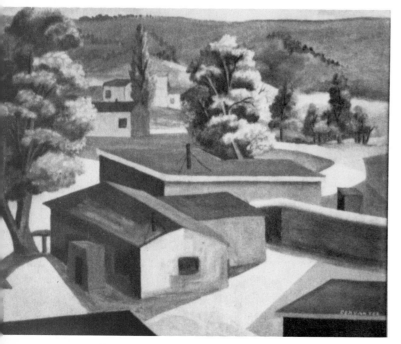

Pedro Cervántez. *Rooftops*. 1960. Oil on canvas board. (Courtesy of the artist)

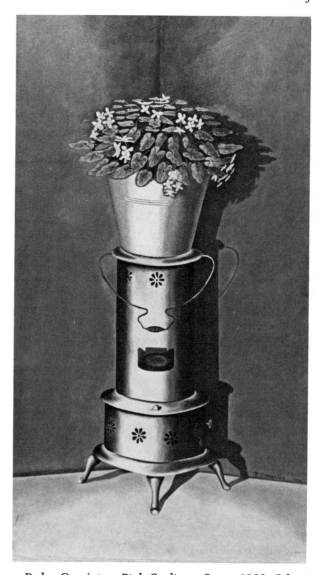

Pedro Cervántez. *Pink Oxalis on Stove*. 1936. Oil on masonite. (Courtesy of University of Texas Library, Austin)

Museum of American Art in New York, the New Mexico State Museum, the Roswell Museum, Eastern New Mexico University, and in Miami, San Antonio, and Clovis.

For two years beginning in 1938, Cervántez studied art in a special course offered at Eastern New Mexico University in Portales. From 1941 to 1945 he served in the armed forces in Europe, where he was able to see and study works in the major museums

of that continent. He returned in 1949 to his art studies, which he continued until 1952, at the Hill and Canyon School of the Arts in Santa Fe.

Landscape plays a very important part in the work of Cervántez. An early example is an oil painting on masonite entitled *Desolation*. A series of apparently abandoned wooden structures with porches is presented in a long horizontal format. A post-and-wire fence leads up to the building complex and continues

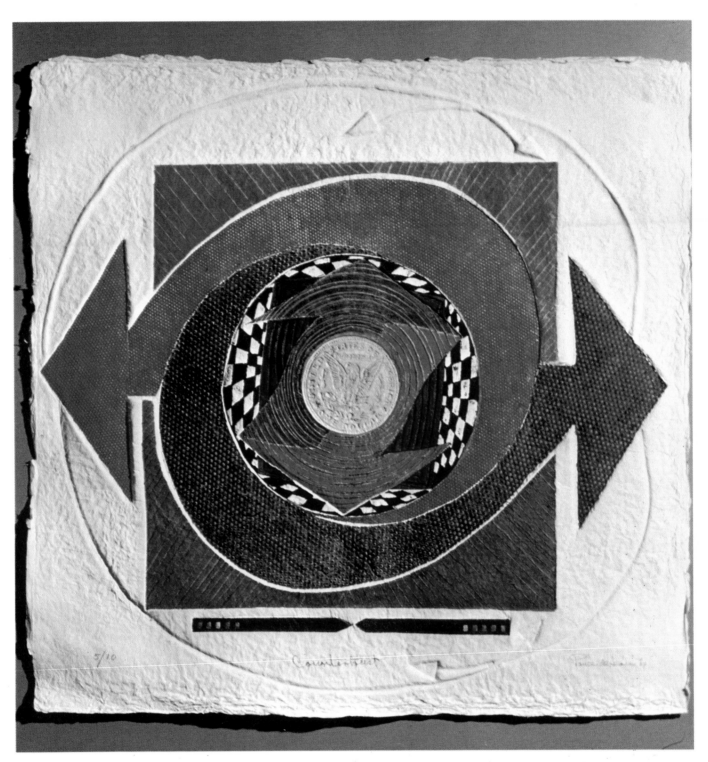

Michael Ponce de León. *Countertrust*. 1967. Intaglio. (Courtesy of the artist)

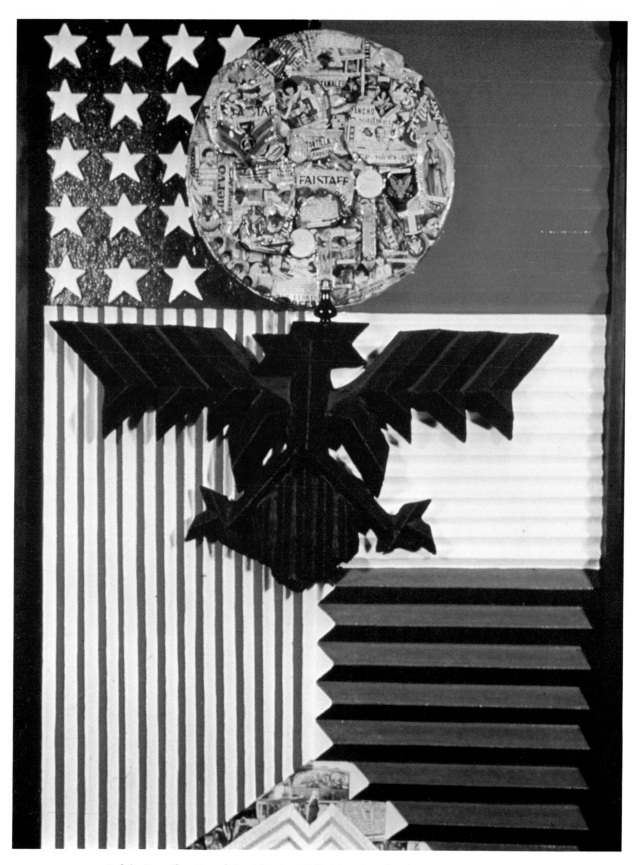

Rubén González. *Search for Identity*. 1969. Mixed media. (Courtesy of the artist)

on the side and over the horizon in the distance. The structures are presented on a slightly rising terrain whose horizontal extension is emphasized by the painting's dimensions, its width being two and a half times the height. The diagonals of the roof lines and the verticals of all supports—walls and porches—are cushioned by the softly rolling hills dotted with scrub brush seen in the background. The effect of the gently rising and falling terrain, running in all directions, is created by the definition of the hills in the background and by the receding post-and-wire fence that appears in the lower center and disappears over the horizon on the upper part of the painting.

A different spatial arrangement is contained in the far more geometric painting of a town, which is entitled *Rooftops*. Here the diagonal of the pitched roofs and the foreshortened presentation of the structures are carefully worked out by the artist, whose elevated position enables him to look down on the segment chosen for the painting. The sharp rectilinearity of the structures is offset by the inclusion of several large trees in various parts of the visual surface.

These works demonstrate Cervántez's very conscious handling of his materials and themes. He always has an idea or concept before he starts painting. He is not interested in working directly from the object or from nature. Numerous preparatory sketches are made so that the composition can be established before the painting is ever started.

Joel Tito Ramírez

A very well known painter of the New Mexico landscape and its people, Joel Tito Ramírez of Albuquerque uses the small villages of northern New Mexico with their unique domestic and religious architecture for his work. The ever-changing colors and light reflected during different times of the year are very important in his paintings. He is also very much involved with the history of New Mexico: ". . . love for the history of our people is so embedded in my work that even [when] I paint the Southwest, and particularly the Albuquerque landscape, there [is] a nostalgic flavor of the past, especially when costumed figures are included. This is part of me."

Ramírez, born in Albuquerque in 1923, is primarily self-taught as a painter, although he did attend the University of New Mexico, first in 1949 and again in 1960. During World War II he was a public relations cartoonist for the flight paper at Morrison Field, West Palm Beach, Florida, and from 1942 to 1946 he served in the Air Force Air Transport Command in China, India, and Burma.

Ramírez has exhibited his works in a number of galleries in Albuquerque, in the New Mexico Institute of Mining Technology, in Florida, and in Washington, D.C. He has also shown his work in China, India, and South America. His works are in a number of private collections in Massachusetts, New York, Kansas, and Maryland. He has won a number of awards for his works at the Santa Fe Museum and the New Mexico State Fair. He is presently the owner of Ramírez Art and Signs, in Albuquerque.

The Old Town Galleries and the homes with art treasures in Albuquerque provided the first experiences with art for Ramírez. He has since been greatly influenced by the work of Diego Velázquez, Francisco Goya, Rufino Tamayo, and Maxfield Parrish. The strong contrasts of light and shade in the works of these artists have interested him. He has been particularly impressed by Rufino Tamayo's use of color.

Although Ramírez has worked outdoors in the past, he now works primarily in his studio. "In the past I made sketches or paintings on canvas on location to capture a mood or an effect with the right light. However, working outside too much can speed up the artist's technique and he becomes trapped into the same brush strokes and habitual tricks."

Ramírez's method of working involves making preparatory sketches and gathering pertinent information related to each work. "I write notes to myself, make small sketches, and constantly gather material. When I return from a location, I have a painting concept in mind. I spend a little more time in the studio with pencil drawings and basic color harmony."

Technical and material considerations also play a very important role in Ramírez's work. He likes to use a variety of brushes, large and small, sables and flats.

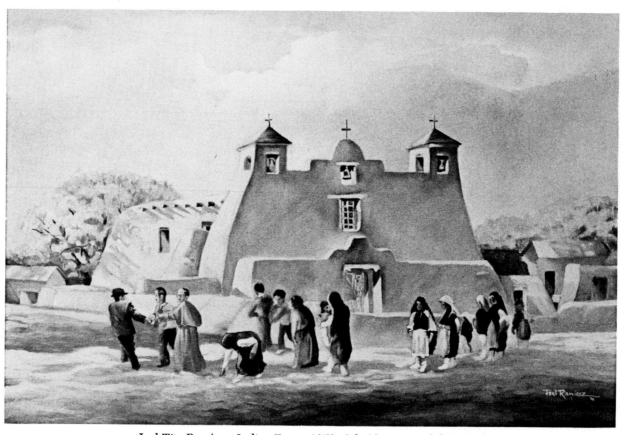

Joel Tito Ramírez. *Indian Force*. 1970. Oil. (Courtesy of the artist)

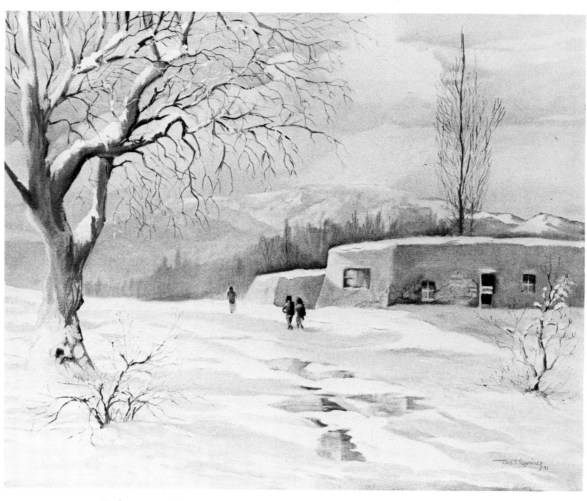

Joel Tito Ramírez. *Winter in Corrales*. 1971. Oil. (Courtesy of the artist)

He also likes to vary the size of the paintings because this gives him the flexibility he needs. Once all the preparatory phases in the creation of a work are completed, he will start on "prepared greyed canvas or gesso panel."

Although Ramírez is usually involved in making specific references to a particular landscape, or using these as backgrounds for historical narratives, he occasionally will paint only clouds. But regardless of the procedure, whether he has a picture in mind or is searching for a subject, he starts each painting with "a background of different clouds." In some cases, he will experiment with this part of the painting until he finds the "proper subject."

Even though Ramírez is very much involved with the light and the effects it has on color and texture in the vast landscapes of New Mexico, he does not follow the varying atmospheric conditions so slavishly that he allows these to dictate the overall color scheme. He still places cool colors above and warm colors below within the visual surface. These arrangements follow in general pattern the reflection of light in the upper (sky) and lower (earth) portions of the painting as a matter of course. Thus, predetermined patterns have as much to do with the use of color as does direct observation.

The exposition of place, and how this is tempered by the seasons—temporal considerations—rather than its articulation in spatial terms, is of major concern to Ramírez. He demonstrates this concern in all his paintings by selecting the same position from which the people, the architecture, and the terrain are to be viewed. This unvarying point of view, slightly to the left of center, is easily discernible. Ramírez is far more interested in defining a place in terms of color and light. Thus, angular rather than frontal views of the architectural units are the rule. In the paintings entitled *Sanctuary* and *Indian Force*, the view of the churches is from the left. In the former, the structure is seen from the back. The façade of Isleta Church is presented in the latter. In *Back Road to Taos* and *Winter in Corrales*, the pueblo dwellings are presented in similar fashion. Thus, Ramírez's position in relation to the scenes appears to be left of

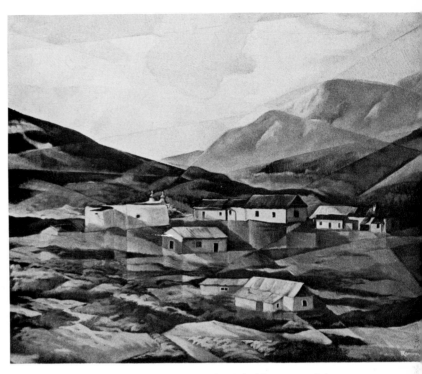

Joel Tito Ramírez. *Las Trampas*. 1971. Oil. (Courtesy of the artist)

center, so that we always see two sides of each structure and other peripheral data related to these.

Even though the sides of the major structures are included in the paintings entitled *Sanctuary* and *Indian Force*, so that the ends—apse and façade—appear to be seen at an angle, Ramírez defines them in such a way that the horizontal directions end up being exactly parallel to the picture plane. The angular displacement of the architectural volumes is defined by the battered profiles (walls) of the structures rather than by the roof line.

In his work entitled *Las Trampas*, painted on location, Ramírez selected a view of the town that conforms to the left-of-center position mentioned above. Since the vertical walls of the houses cannot be suppressed, Ramírez emphasized the diagonals of the peaked roofs by extending the contours of these and the mountains in the background, thus creating a series of overlapping transparent planes. Interestingly enough, the longitudinal axes of the houses in

most cases run parallel to the top and the bottom of the frame.

Thus, Ramírez is interested in defining the position in relation to the selected scenes and relating all visual phenomena to this point of view. He then proceeds to concentrate on the various types of light found in northern New Mexico at different times of the year. How surfaces are transformed by light and how this can be transcribed in terms of color are his major concerns.

6. Third Decade: 1926-1934

THE THIRD GENERATION, which came to maturity in the fifties, represents the traditional approaches as well as the diverse directions that American art was beginning to take at the time.[1] Peter Rodríguez (b. 1926), the San Francisco abstract painter, spans both the second and third generations by having started his artistic career very early. His first exhibitions in New York and San Francisco, in 1940, took place when he was only fourteen years old. Eugenio Quesada (b. 1927), an Arizona painter, studied mural painting with Jean Charlot and lived and worked in Guadalajara, Mexico, for almost six years during the sixties. He has concentrated on easel paintings based on a figurative tradition, although he continues to be interested in murals. In San Antonio, Texas, there is Emilio Aguirre (b. 1929), who uses Pop-like imagery in some of his paintings, and Melesio Casas (b. 1929), who paints large canvases with garishly loud representations of amply endowed females in various settings, usually related to television and the movie screen.[2] Casas

calls these "Humanscapes." These works, with their strong thematic and pictorial tensions, draw us in, ask us to participate and identify with the passive viewer placed in front of the projected images.

In California, Louis Gutiérrez (b. 1933) is noted for his low-keyed collage paintings based on geometric configurations in whites, greys, and off-whites, and, recently, in a richer palette. Esteban Villa (b. 1930), a teacher at Sacramento State College, is a leading member of a group of California artists that is actively seeking recognition of Chicano artists. Not directly allied to any group but still very active

[1]H. H. Arnason, *History of Modern Art: Painting, Sculpture, and Architecture*, pp. 487–520.

[2]Many of the artists included in this chapter were interviewed during the summer and the fall of 1970: Eugenio Quesada, June 28; Manuel Neri, June 19; Louis Gutiérrez, June 17; Ralph Ortiz, June 5. Peter Rodríguez was interviewed on March 3, 1972, in Salado, Texas, and on March 15, 1972, in Austin, Texas. Information on Ernesto Palomino was obtained from the artist through correspondence and by telephone.

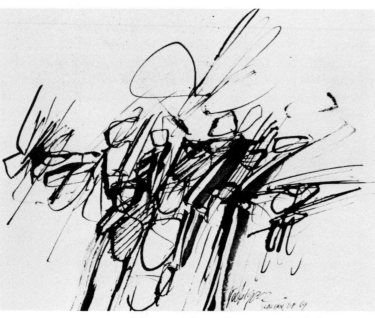

Peter Rodríguez. *Spring Edges.* 1970. Oil on canvas. (Courtesy of the artist)

Peter Rodríguez. *Tlalpan.* 1969. Pen-and-ink drawing. (Collection of Mrs. Guadalupe G. Rodríguez, Stockton, California)

as a Chicano artist is Ernesto Palomino (b. 1933) of Fresno, known for his numerous projects as a painter, a film maker, and, most recently, a muralist.

The works of Manuel Neri (b. 1930) and Ralph Ortiz (b. 1934), both sculptors, reflect the prevailing modes of the fifties and the sixties, respectively. Neri, a San Francisco Bay area artist, has worked in a figurative tradition, using plaster and paint in his relief and full-round pieces. The figural portions are generalized representations, with no attention paid to anecdotal detail, in which the expressive possibilities of the material used play an important role. This effective tension between medium and thematic structure is related to the Abstract Expressionist approach of the fifties. Ortiz, the leading Destructive artist in this country, best exemplifies the artist of the sixties, who has abandoned the concept of the artist as a constructor of objects. He, along with others, has sought to redefine the role of the artist and his work. He is best known for his *Piano Destruction,* which he has performed on national television in London, New York, Vancouver, and elsewhere.

Peter Rodríguez

Peter Rodríguez, a very well known northern California abstract painter, uses natural phenomena as a point of departure for his works. Identifiable elements in nature—celestial bodies, leaves, petals, and blades of grass—crop up imperceptibly in basically nonfigurative works in which process and the path it leaves become important. The brush strokes and colors are prime carriers of the thematic and formal programs. Also important in his work are the circular as well as the rectangular formats.

Rodríguez was born in 1926 in Stockton, California. He resided there for most of his life, but in 1968 he lived in Mexico, where he traveled extensively. He now lives in San Francisco.

Starting in 1940 in New York and San Francisco, Rodríguez has exhibited his work in numerous group shows and since 1956 has had a number of one-man shows in northern California cities and in Mexico. He has exhibited widely in Stockton and other cities in the San Joaquin and Sacramento valleys, and in the San Francisco Bay area. He has also shown his

work in Oregon, Colorado, and Texas. He has had one-man exhibitions in Mexico City, and at the request of José Guadalupe Zuño, the director of the State Museum of Jalisco, he has shown in the city of Guadalajara.

Much of Rodríguez's imagery appears to be floating, weightless, and unanchored within spatial contexts that are similarly defined. There are no clear outlines of shapes. Line often becomes shape and direction rather than a container that establishes boundary or contour. Thus, there is a subtle arrangement of colors defined in linear terms in which the surface is only partially altered. Line and color are rarely used to establish clear positive and negative areas. The negatives and positives flicker throughout the visual surface. Light and space become very important indicators of mood in these works.

The colors Rodríguez uses are evocative of seasonal changes in nature, particularly the spring and the fall. He uses high-value greens, yellows, and oranges. In his circular painting entitled *Spring Edges,* a light-yellow ground is interspersed with tints of yellow and green. These are used to define semicircular and rectangular shapes arranged in several tiers. The vertical and horizontal axes of the dominant noncircular shapes echo not the frame but the wall on which the painting is hung. Thus, what would normally be an arrangement based on a grid pattern is set adrift by its inclusion within a circular format. Although this arrangement is not as pronounced in his painting *Toward Summer,* the effect is similar. A beautiful swaying motion is created by the slanting brush strokes, reinforced by the definition and the arrangement of the shapes themselves.

A slanting from left to right is followed in two drawings, one entitled *Tlalpan,* the other untitled. In the first, Rodríguez has modulated the starkness of the black ink on the white paper by varying the thickness of the line and by leaving traces of a fully loaded brush as well as a dry one. The rapidity of execution is retained in the actual definition and articulation of line. The pencil drawing is also comprised of thick and thin lines alongside shaded areas anchored to a left-to-right movement. The actual markings on the paper of these drawings are such

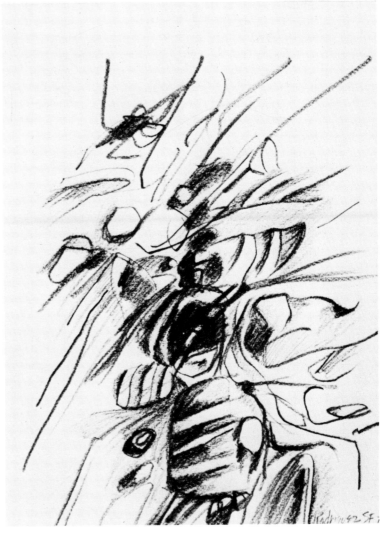

Peter Rodríguez. Untitled. 1970. Pencil drawing. (Collection of Mrs. Alice Tipshus, Rancho Cordova, California)

that the white grounds, or negative areas, are given equal importance in the final configurations. When Rodríguez deals with an actual recognizable subject, such as his drawing of two Mexican women with shawls, entitled *Two Women,* he almost allows the white area to overwhelm the image. Still, the unvarying line encompasses the ground so that the negative areas are activated by a suggestion rather than an exposition of form.

The slanting configurations are reminiscent of

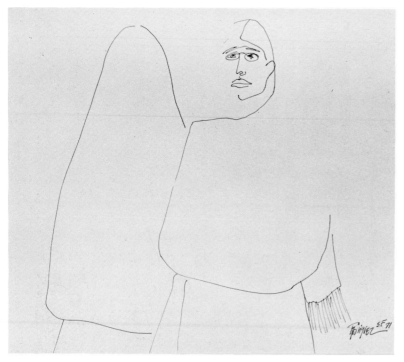

Peter Rodríguez. *Two Women*. 1971. Pen-and-ink drawing. (Courtesy of the artist)

handwriting, which is constantly altered by lightly changing accents and directions. The side-to-side and up-and-down motion, however, is indicative, but not the substantive aspect, of Rodríguez's work. The subtle chromatic and spatial changes that define various degrees of luminosity are the important features in these works.

Eugenio Quesada

Quesada, born in Wickenburg, Arizona, in 1927, was educated in his home state, in California, and in New York. He has had a number of exhibitions of his work in Mexico and Arizona.

Of all the Mexican Americans interviewed, Eugenio Quesada was the only one who had an opportunity to view and study at first hand the murals of Orozco and other Mexican muralists. Much of our discussion centered around the works of these artists and his own experiences in Mexico.

Quesada's comments on the work of Orozco are very pertinent, since so many of the artists inter-

viewed had little or no direct experience with his murals. Luis Jiménez saw some of them but did not study them closely.[3] Manuel Neri saw much of Orozco's portable works (easel paintings and drawings) exhibited at the San Francisco Museum of Art almost twenty years ago, but he also did not relate that work closely to his wall paintings.[4]

Quesada thinks that Orozco "is a tremendous artist, but a very bad muralist. His watercolors are as good as anything that has ever been done.[5] But he went mad with murals. He broke up spaces exactly the wrong way. The most outstanding example is his stairwell painting in the legislature building in Guadalajara, where Hidalgo is painted on the wall and partially on a half dome at the top of the landing.[6] This huge thing is going to fall on top of you. It distorts the architectural spaces that are there. And then when you face in the other direction you look into the light. Above the landing there are other figures that cannot be seen because of the glaring light. Orozco did not take care of these problems. He just painted as if he were dealing with an easel."

Quesada had nothing but praise for Diego Rivera, although he did not have too much opportunity to study his work directly. "I think he's stupendous. As a put-on too. In every way he is stupendous as a technician, as a politician. It's mostly what I have seen in books and then relating it to what I actually saw. You cannot get a good picture of his murals in books. But I was kind of puzzled when I did get a good chance to look. It's like Matisse. It used to puzzle me what there was about Matisse. Many people raved so much. And I am convinced today that he just didn't reproduce well. One day I saw a small retrospective—thirty pieces I think—in Los Angeles. I am his biggest fan now."

In discussing his work, Quesada continued to express his interest in murals. "Several things attract

[3]Luis Jiménez was interviewed on June 2, 1970.
[4]See note 2, above.
[5]These are Orozco's watercolors of schoolgirls and prostitutes, done before his first trip to the United States and exhibited in his first one-man show in September 1916.
[6]This is the center wall of the Government Palace stairway, painted in 1937.

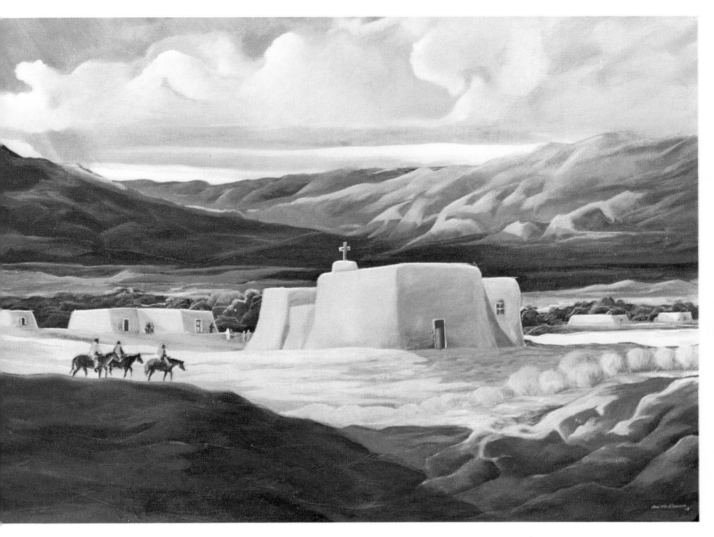

Joel Tito Ramírez. *Sanctuary*. 1969. Oil on canvas. (Courtesy of the artist)

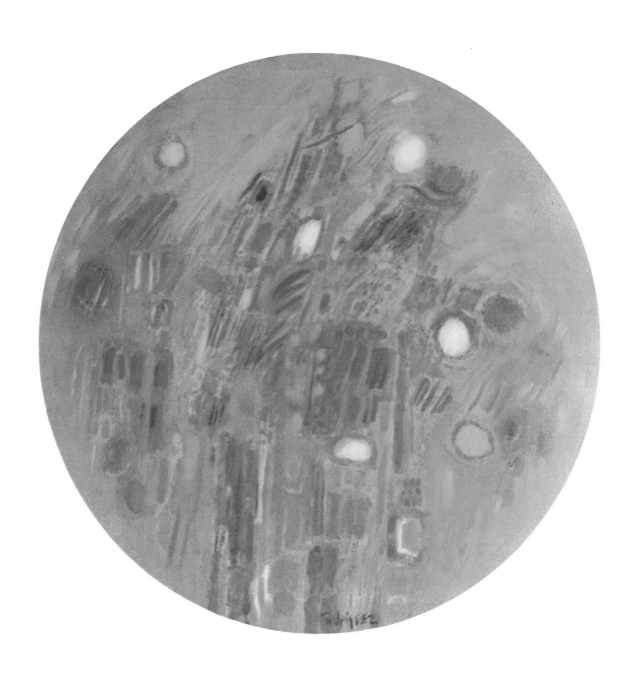

Peter Rodríguez. *Toward Summer*. 1970. Oil on canvas. (Courtesy of the artist)

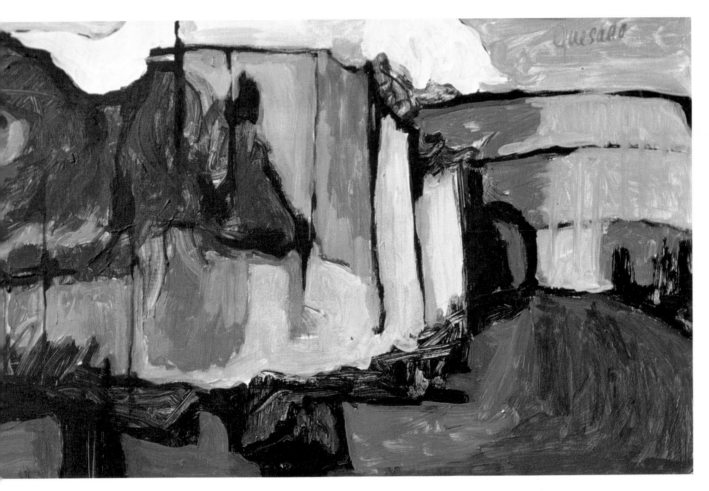

Eugenio Quesada. *Plaza de Toros*. 1969. Oil on canvas. (Courtesy of the artist)

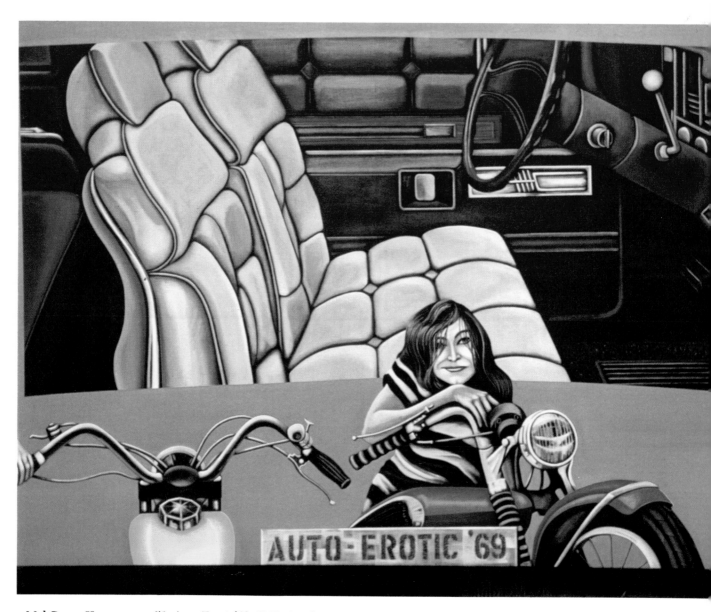

Mel Casas. *Humanscape 51, Auto Erotic '69*. 1969. Acrylic on canvas. (Collection of R. H. Wilson, Jr., Houston, Texas)

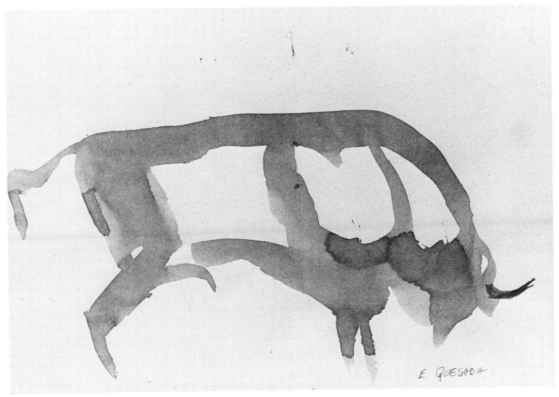

Eugenio Quesada. *Toro*. 1960. Ink drawing. (Collection of Mr. and Mrs. L. H. Hatfield, Phoenix, Arizona)

Eugenio Quesada. *Soñando*. 1964. Charcoal. (Collection of Mr. and Mrs. Stephen H. Harrington, Jr., Ajijic, Jalisco, Mexico)

Eugenio Quesada. *Niña Traviesa*. 1964. Charcoal. (Collection of Mr. and Mrs. Earle Florence, Tempe, Arizona)

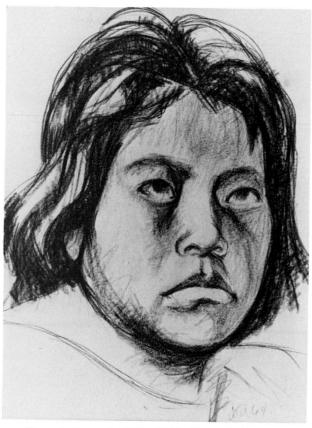

Eugenio Quesada. *Niña.* 1964. Charcoal. (Courtesy of Mesa Community College, Mesa, Arizona)

me to murals. One of them is the size of the space. Physical size. Another one is that I would like to show the world what a mural is after all." And yet it is surprising that Quesada works on very small surfaces. His paintings, whether they are casein, gouache, oil, or drawings, can all be measured in inches. Fairly typical of these in size is his *Plaza de Toros*, which measures 16″ x 12″. There is no semblance of size in Quesada's works when seen in reproduction. They could just as easily be five or ten times that size. He deals with the barest essentials in defining his subjects. The architectural portions, circular forms, are distinguished from the other parts of the cityscape by their contextual setting and their shapes. Quesada ignores the potentials of texture and color as guides in defining specific objects. The street, the architecture, and the sky are treated equally as far

as color and texture are concerned. There is no differentiation between nature and the man-made environment. The use of yellows, oranges, greys, and blues is dictated by the needs of the painting rather than any relationship they might have to objects to which they are assigned. The color is applied in the uniform manner, whether it is the sky, the stadium, or the street. This makes the painting appear to be larger than it is. Each portion is defined in broad brush strokes. Another factor that lends to this impression is the position of the observer in relation to the objects represented. Quesada has placed us somewhere in a middleground but certainly close enough to allow us a mere sliver of sky in the painting. The architecture looms before us, establishing a high skyline in which there is little room to define the clouds and part of the sky. The architecture takes up a major portion of the visual plane, with the street defined on the lower register and moving up on the right as a frame for it.

In another landscape done fourteen years earlier, *Towers and Flowers*, Quesada defines the environment in similar fashion. The sky is relegated to a small portion of the upper part of the picture, while the architecture and the landscape take up most of the space. On a more immediate and direct level are a number of ink drawings of bulls. A few brush strokes of ink wash are enough to suggest the powerful animal's massive bulk and potential aggressiveness. These drawings represent brief but very effective visual statements. More elaborately worked out are a number of drawings of children and their activities. The child's world and his state of being are expressed very directly in these charcoal drawings.

Quesada demonstrates in his drawings and prints of children a kinship with the fine draughtsmanship of such Mexican artists as Raúl Anguiano, Jesús Guerrero Galván, and others. A feeling for the subject and its definition in strong volumetric terms, while at the same time retaining its linear qualities, is admirably presented in these drawings.

Melesio Casas

Melesio Casas was born in El Paso, Texas, in 1929.

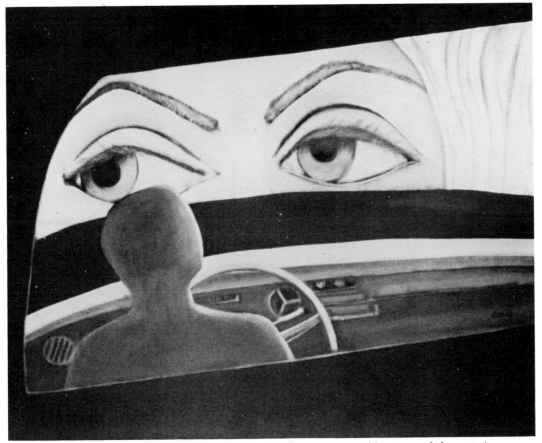

Mel Casas. *Humanscape no. 14.* 1966. Acrylic on canvas. (Courtesy of the artist)

He attended the El Paso public schools and Texas Western College in that city, graduating with a Bachelor of Arts degree in 1956. He received his Master of Arts degree in 1958 from the University of the Americas in Mexico City. He has taught in El Paso and is presently teaching in the Department of Art at San Antonio College.

He has received many awards for his work and has had one-man shows in Mexico City, El Paso, San Antonio, and Seguin, Texas. He has participated in many group shows over the last ten years.

The television and movie screens play a very important role in Casas's work. Several years ago as he was leaving a show of Marc Chagall's works at the San Antonio Jewish Community Center, he was struck by the projected images on a large drive-in screen. "I looked up and saw gigantic heads on the screen above the trees. Cars were passing below on the freeway [the San Pedro drive-in used to be right next to the expressway]. I stopped and I just looked and it looked real, surreal! These were very powerful images. The few moments I sat there, I saw the head of a woman talking to someone hidden by the trees. She actually looked as if she were munching away at the tree tops, and cars were moving away. It was another reality. So I began to play with the idea and I began to refine it."

Movies and television—with its advertising aspects being particularly stressed—were later incorporated by Casas into a number of works which he called "Humanscapes." An excellent example of this series is *Humanscape no. 14.* Casas sees both as mere conveyers of erotic fantasies—thus, their use at all times to establish the context in which all events take place.

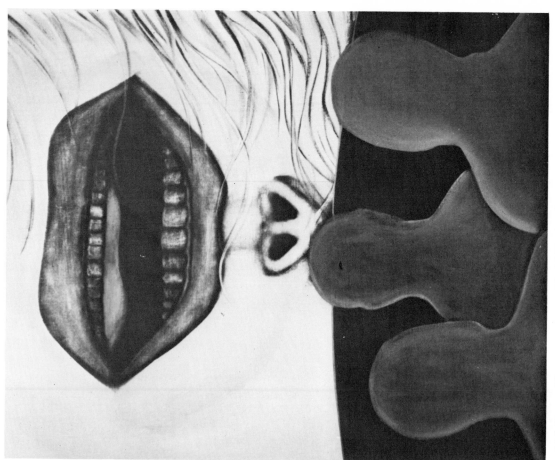

Mel Casas. *Humanscape no. 22.* 1966. Acrylic on canvas. (Courtesy of the artist)

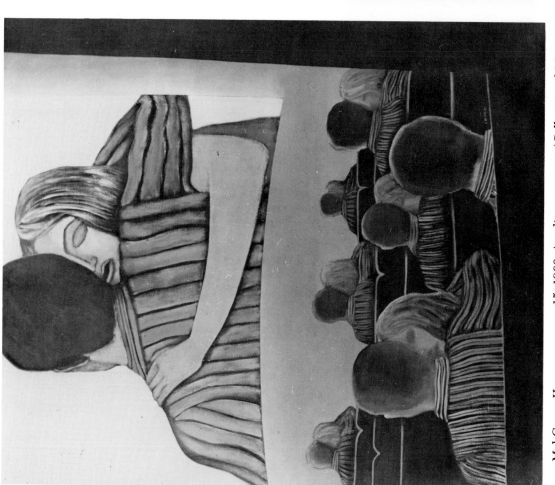

Mel Casas. *Humanscape no. 15.* 1966. Acrylic on canvas. (Collection of Mrs. Ada Anderson, San Antonio, Texas)

The darkness of the movie house (anonymity) and the projected images are at the core of these events. How these affect the viewer, or the voyeur, as Casas sees him, is of the utmost importance in these works. The projected image is the constant, while the variables are the ever-changing configurations. The observer as voyeur was considered essential by Casas at the beginning. The passive observer was later suppressed and only implied in pictures belonging to the same series.

In another early painting (No. 15) in the Humanscape series Casas uses a somber palette. The interior of the movie theater is indeed dark, with all events taking place in a dimly lighted interior. All the colors are shaded so that the overall effect is one of opaque surfaces, including the images seen on the screen. There is distinction, however, of the real and projected images, if not in color or definition, then in context. Casas emphasizes this difference by concentrating on the two realms. He establishes the difference in spatial terms. The audience in the theater is comprised of couples, which are shown in varying distances from the screen. He effectively defines the foreshortening of the theater by presenting the couples in various rows until we see the image projected on the screen taking up half of the painting. The two are given equal treatment on the picture plane. The equivocation comes, however, in the presentation of the same motif used in both—the embracing couple. Which is more real? The projected image or the observers?

Most often during this early period, Casas presented his audience in terms of silhouette, with the projected image given greater and greater prominence. Now the screen takes up more than half of the surface and is defined with greater clarity, while the observers remain in half light. They are painted either in unmodulated grey (No. 22) or in buff (No. 24) with the inclusion of a lighter tone of the same color toward the edges of the forms. Projected on the screen is an extreme closeup of a face with full lips. Only the lower part of the face is retained in this image. But now all the attention is focused on this monstrous apparition, the meticulously defined lips, carefully modeled, and the representation of blonde hair

blowing across the face from one side of the screen. Although these represent extreme definition of forms, the color, the modeling, and the outline are so harsh and hard that they remain totally unreal; and, of course, that is their intention. To be superreal. Their menacing qualities are particularly manifest in these two works, taking up, as they do, the major part of the picture with large gaping mouths. What makes them even more grotesque is the fact that they correspond to the standardized packaged sexual image presented to the public on these screens.

In recent years Casas has used a much richer palette. Colors are presented closer to their maximum intensity rather than modulated, tinted, or shaded. The configurations remain the same as far as the screen is concerned. The same blue field surrounds the slightly curved horizontal screen, which continues to represent the projected image; but, instead of having a passive audience, what is seen on the screen may merely be a portion of a more complete presentation in front of it. There is a clearer amalgamation of the two realities now. With the breakdown of the audience and projection as two distinct entities the narrative is presented within one rather than several planes. Everything now takes place within the foreground.

Casas in a written statement has this to say concerning his paintings: "I so divide the picture plane of my painting so as to force the spectator into the role of 'voyeur,' thus acquiring an identity through participation." He continues: "It is too difficult a task to witness and not react to the transformation of an audience from one world to another subliminally and without critical awareness. That's the reason the audience in my paintings acts as somnabulistic actors in a video space environment that projects sex-anxiety as a protection against nonbeing. Gone is the search for personal reality, and instead there is a collective reality."[7]

Casas's works now appear to be surrounded by impenetrable blacks outlining most of the evenly applied fields of blue. Typical of this kind of painting is his *Auto Erotic '69* (No. 51 in the series), now sig-

[7]Mel Casas, *Mel Casas Paintings.*

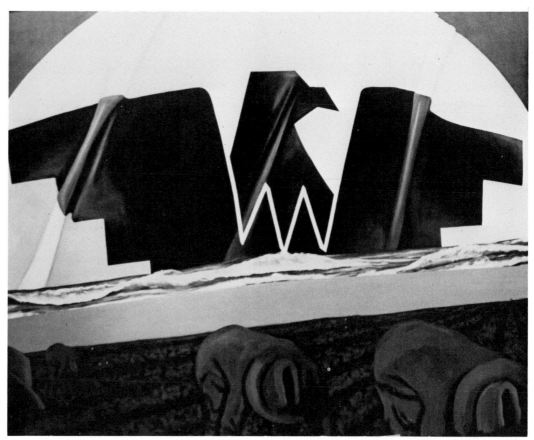

Mel Casas. *Humanscape no. 65.* Unfinished. Acrylic on canvas. (Courtesy of the artist)

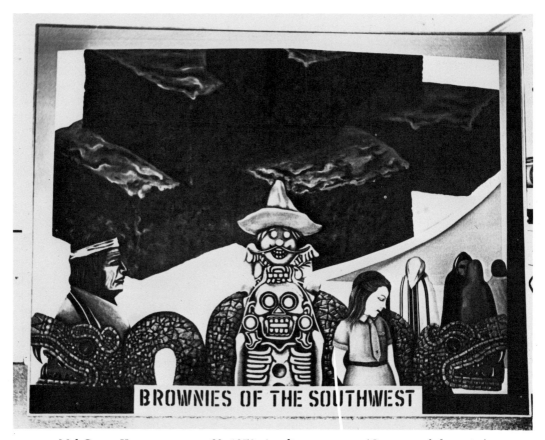

Mel Casas. *Humanscape no. 62.* 1970. Acrylic on canvas. (Courtesy of the artist)

naled by the use of stencil lettering adding to the unreal, machine-produced imagery.

Thematically, then, Casas's paintings deal with the cinema, television, and advertising. It is the power that these have to elevate, to teach rather than destroy or distort, that interests him. And since so much of what comes across is erotic, he concentrates on this aspect. As an example, Casas considers the old automobile commercial, which shows a grey-haired man and a grey-haired woman in separate series, with a young person in each looking hungrily at the man or woman, whichever might be the case, as just plain blatant merchandising and advertising. Toothpaste, perfume, and other countless items are similarly treated—in erotic terms.

When asked about his background and what effect this might have on his work, Casas answered that Mexican Americans are outsiders. He elaborates on what it means to be a Mexican American. "I don't think we should break away from our tradition. We cannot deny it. It will tend to flavor, to color the way we think. I think linguistically and iconographically we will tend to mix the two. I have to my benefit that I can combine English and Spanish to give a more colorful expression than I would if I said it all in English or all in Spanish. The subtlety of the meanings, the syntax, or the pronunciation of the words give it that extra something that is missing."

Casas has become much more involved with sociopolitical and economic problems in his most recent work. He has begun to pay particular attention to the Mexican American, the migrant worker, youth, and other "outsider" groups. In the process his themes have become increasingly elaborate. Casas explains: "The overall title of my painting series is Humanscapes. Each painting has a subtitle which is incorporated into the visual structure of the painting. For example: *Humanscape no. 62* is subtitled *Brownies of the Southwest*. The result is a series of puns, both literal and visual:

Brownies: cookies
Brownies: Girl Scout, junior category
Brownies: American Indian, the nonperson

Portrait of Mel Casas. (Courtesy of the artist)

Brownies: the residual of the Mexican heritage in the Mexican American
Xolotl: Aztec god of rebirth, twins and monsters —the Brownie Monster is the 'Frito Bandido'
Two-Headed Aztec Serpent: represents the schizothymia and dichotomous nature of the Mexican American in the Southwest

Brown as a color is amplified because pigmentation appears to have such vehement social relevance. I use it to give social color to what I consider significant events."[8]

[8]Correspondence with the artist.

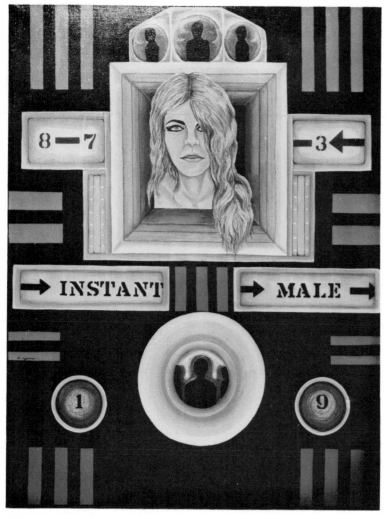

Emilio Aguirre. *Instant Male.* 1969. Acrylic on canvas. (Courtesy of the artist)

Emilio Aguirre

Another notable San Antonio artist is Emilio Aguirre, who was born in Laredo, Texas, in 1929. He moved with his mother to San Antonio to live with his grandparents when he was only three years old. He started elementary school in that city but had to go to work when he was seven years old. He did return to school but had to quit in the tenth grade in order to help with expenses at home. He joined the Marines in 1946 when he was only seventeen years old, eventually serving in Korea from mid-1950 to 1951. He later wrote a book based on his war experiences entitled *We'll Be Home for Christmas,* published in 1959.

Unlike most of the other artists included in this study, Aguirre has not been able to devote full time to his art studies or his art work. He did manage, however, to obtain eighteen hours of basic and intermediate design, drawing, and painting. But due to economic reasons he has only been able to paint on a part-time basis. Recently, he completed a large painting (8′ x 16′) of the astronauts' walk on the moon for the Edward H. White II Memorial Museum in San Antonio. He has exhibited his paintings at the Museum of Modern Art in El Paso and at the Witte Memorial Museum in San Antonio.

Possibly because he has not been able to pay constant, sustained attention to his painting, Aguirre has not developed a consistent style. His works vary from largely narrative paintings based on traditional pictorial conventions to others based on a combination of these with more abstract approaches. Two representative works done recently are included in this study. One, entitled *Instant Male,* demonstrates clearly a debt to the work of Mel Casas. Aguirre used the blonde blue-eyed woman and the male figures silhouetted within the camera lens and the multi-surfaced flash cube, attached to the camera face, which forms the basis for the compartmentalized composition. Stenciled words and numbers are also used. This painting is curiously disquieting, even though it maintains a strict symmetry, a normal indicator of calm and repose.

A more unusual and far more personal statement is made in a painting comprised of precisely defined terrestrial and celestial spheres in which Aguirre has presented a number of strange configurations, based in part on letters. This is entitled *Alpha I.* Anthropomorphic clues are found in a profiled figure comprised of a large *O* for a head, with a small *b* accenting the features, and a striped *G* for the inner side of the polka-dotted body. The composite figure is placed between two large letters—a *Y* and a *T*—whose outer portions go beyond the sides of the frame. Attached to the *Y* are units made up of circular and triangular elements. Flowers are found on the upper part of the *T.*

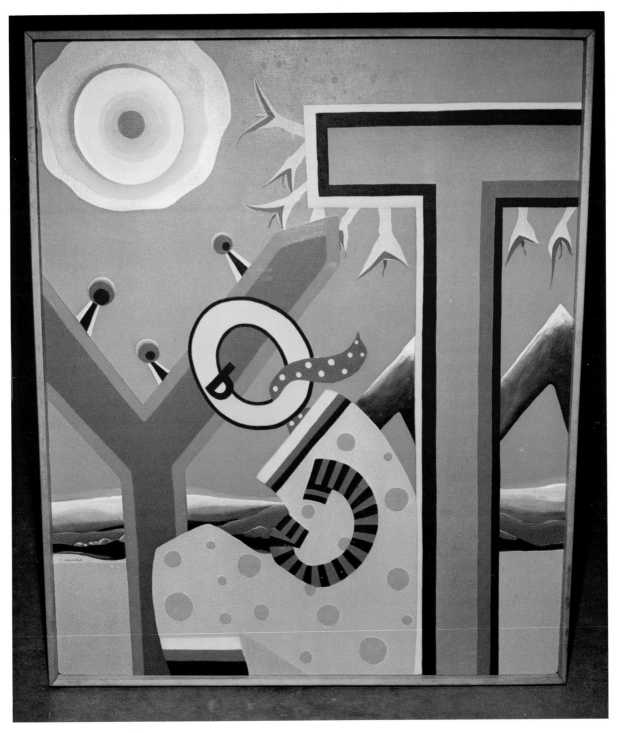

Emilio Aguirre. *Alpha 1*. 1970. Acrylic on canvas. (Courtesy of the artist)

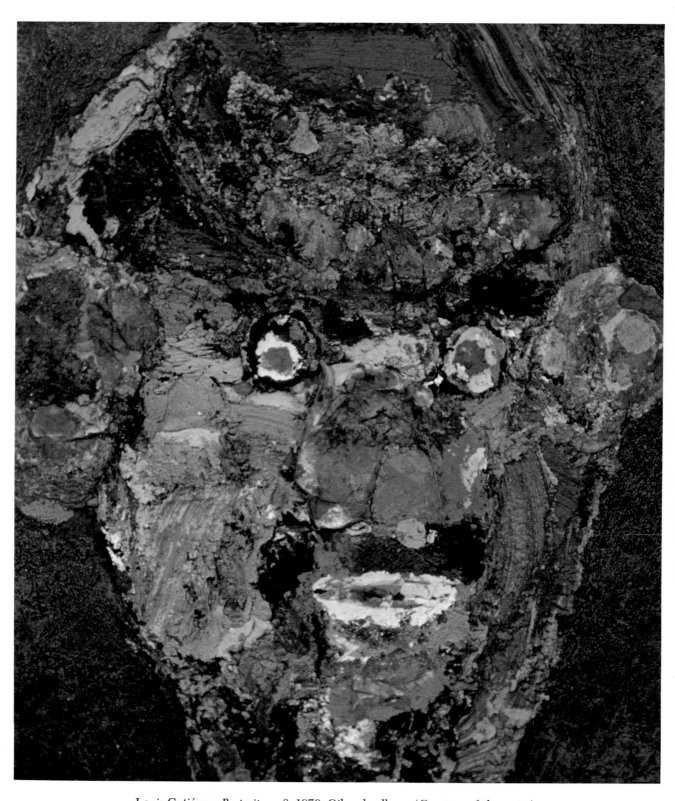

Louis Gutiérrez. *Portrait no. 3.* 1970. Oil and collage. (Courtesy of the artist)

Aguirre has definitely moved away from a prescribed theme with its attendant standard arrangements. There are no predictable spatial intervals in this painting. Events are presented either in clusters within the frontal plane or at a vast distance in the background.

Manuel Neri

Manuel Neri, a well-known California sculptor now living in Benicia in the San Francisco Bay area, was born in Sanger, California, in 1930. He received all his early schooling in Los Angeles but did not take the usual art courses offered in grammar and high school. His involvement with art started in 1949–1950 when he began to study ceramics. He worked in this medium for the next several years until his induction into the service in 1953. He continued to work with clay briefly after his tour of duty in 1955, but soon gave it up.

The immediacy and malleability of the medium, in the preliminary stages of work, did not offset the negative aspects of the later stages. The subsequent physical changes of the clay caused by the drying and firing processes—shrinkage and the resultant shape changes as well as changes in color—were unacceptable to Neri. "I was just too impatient about waiting around for the medium to be ready for me. If there's one thing about clay, it's very demanding that you be there when it's ready to make the change. And I just couldn't wait around."

Neri studied at San Francisco City College from 1950 to 1951, at the University of California in 1952, and at the Bray Foundation in Helena, Montana, in 1953. After his time in the service he returned to the San Francisco Bay area to study at the California College of Arts and Crafts in Oakland from 1955 to 1957 and at the California School of Fine Arts, now the San Francisco Art Institute, from 1957 to 1959.

Neri has had a number of one-man shows in San Francisco galleries since 1957, and since 1953 his work has been included in numerous group shows. Outside of northern California galleries and museums, his works have been exhibited at the Staempfli Gallery, New York (1961 and 1962); Primus Stuart Gallery, Los Angeles (1962 and 1963); the

Contemporary Arts Museum, Houston (1962); the Judd Gallery (1968) and Reed College (1969), both in Portland, Oregon; Bellevue, Washington (1968); and at Louisiana State University (1969). He has received a number of awards for his work and is represented in numerous public and private collections.

Shortly after leaving the service in 1955, Neri had gone to Mexico with thoughts of possibly studying there. He was disappointed in the schools and the "art scene" in Mexico, so decided against carrying out his original plans. He traveled throughout the country instead for three months. Since he had been quite interested in Orozco's work during his student days, he went to Guadalajara to see his murals in that city. When he returned to this country, Neri began his studies at the San Francisco Art Institute and his work in sculpture.

The flexibility, versatility, and low cost of plaster had led Neri to use this material for his sculptures in the mid-fifties. These early plaster works with color added are based on the human figure. "One of the great things about it [plaster] is that you can just chop right back into it and change the form very quickly and that is just impossible in clay—once it's set, it's set."

A number of San Francisco artists, among them Elmer Bischoff and James Weeks, who taught at the San Francisco Art Institute, had an influence on Neri during the late fifties. Their use of the figure and its definition in terms of color impressed him. "I like the way they manipulated the paint—a very sculptural thing." It was not the color as such that interested him, however, but rather its potential as a sculptural element: ". . . the plaster lent itself for the use of color, where I could really manipulate the surface in and out, going back into the surface, chopping back in, painting, covering it, painting again." On another occasion Neri expressed it this way: "I like color because of the destructive quality it has upon sculpture. It really destroys form in a lot of ways, and I like to use it in that way. Not just in the usual accenting or the bringing out of some forms, but kind of this fight that it can create with the forms that you are sculpting."

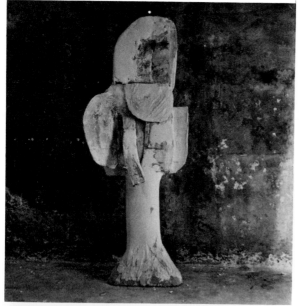

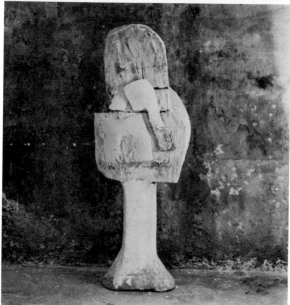

Manuel Neri. Untitled. 1957. Plaster and card-board. (Courtesy of the artist)

Neri has been impressed and interested in a number of artists from the past and the present. During his formative years he liked the work of Max Beckmann and the drawings of Orozco. He has been attracted to the work of Rembrandt, Velázquez, Tintoretto, and "one or two of the Flemish painters." Of

the contemporary artists, he has considered DeKooning a "fine draftsman," has liked the "good earthy feeling" of Peter Voulkos's ceramics, the ideas of Robert Morris and Walter De Maria, the small ceramic things of Kenny Price, and the work of Mark Di Suvero.

Neri is not an unrelenting even-paced sculptor. He works in spurts: ". . . it's a tough thing just to force yourself to go into the studio every day." There are too many distractions, his house, the garden, the countryside, the entire area in which he lives—all very pleasant—so that he finds it hard to work sometimes. Once he does get involved with an idea he works it out. On occasion ideas that he thinks are good end up entirely wrong when put down in sculptural form. He prefers to ease into an idea, work it out slowly in three-dimensional terms.

Neri exhibited with a number of artists grouped under the heading of Funk Art in the late fifties. He contends that, although their work was misinterpreted by art historians, there *was* an official Funk group during the 6 Gallery days. What he and the others meant to do was use the word as local jazz musicians had used it to mean "corny old-time jazz." As Neri sees it, perhaps Funk meant getting down to basic corn and then starting over on their own terms. He and some of the others really distrusted words, particularly reading (art) books. "A lot of us felt like we just wanted to get away from that pile of words that a lot of people [art historians, art critics, museum and gallery directors] think art needs to support or justify it. And it doesn't need it at all." Related to their desire to return to basics in art was their interest in using images that were simple and straightforward—"figures, birds and bees, horses." They were also actively against what materials and their uses had come to mean at that time: ". . . there was the rugged welding that was being done in this country. I was so sick and tired of that. Many of us reacted to that. We wanted to use materials that were flexible and cheap. Like cardboard and plaster were two things that were used."

Some of Neri's early plaster sculptures, done in 1957, are quite large—approximately six or seven feet high. The formal portions are defined and built up

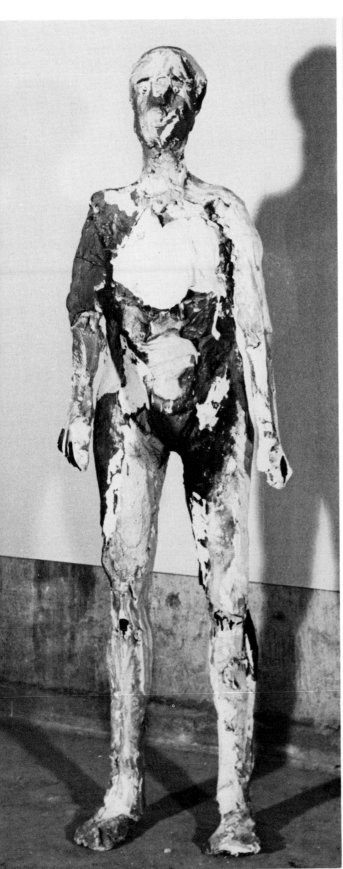 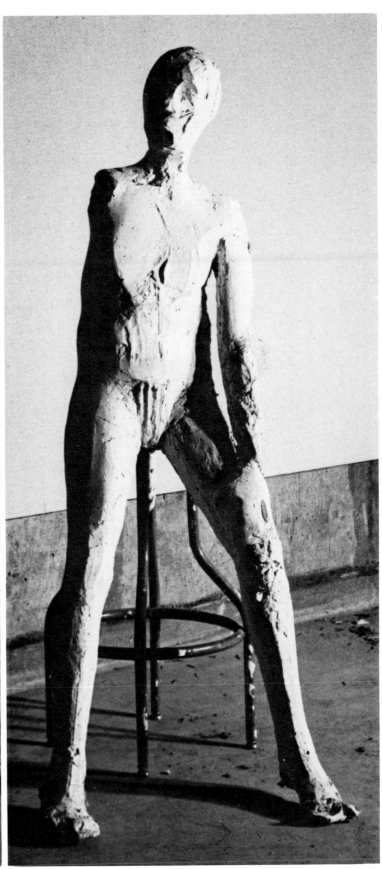

Manuel Neri. *Figure*. 1958. Plaster with polychrome.
(Courtesy of the artist)

Manuel Neri. *Figure*. 1959. Plaster with polychrome.
(Courtesy of the artist)

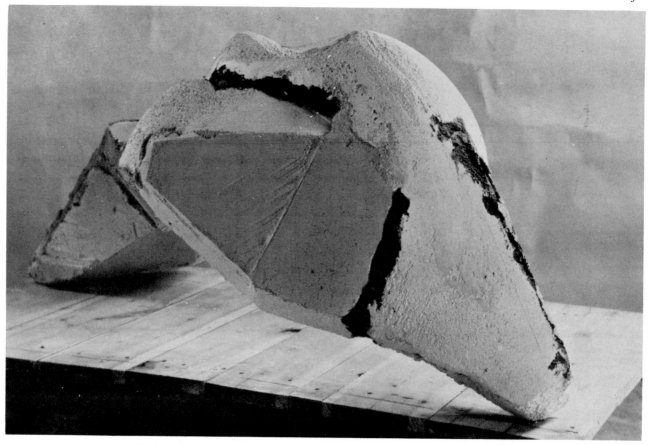

Manuel Neri. *Large Torso.* 1963. Plaster with polychrome. (Courtesy of the artist)

with cardboard. Some of these are placed on a pedestal, while others are constructed on such high stems with talused bases that added elevation is not necessary. Although these are free-standing, three-dimensional pieces, they are broadest in primarily two directions—length and width. This basically two-dimensional format allows Neri front and back fields on which to work. Each side is comprised of a number of partially overlapping planes as in a painting. This strict adherence to the surface plane maintains and emphasizes the two-dimensionality. The shapes, usually comprised of slightly rounded contours, are highly textured, alternately smooth and rough. This creates a very vital surface, a characteristic of Neri's later pieces, as well.

Neri's life-sized polychromed plaster figures, also dating from the late fifties, are presented either in their entirety or headless, and with one or both arms suppressed. The surface—built up, cut away, scraped, cracked, encrusted, and further altered with the addition of color—creates an undeniable force by being more than the mere outer fabric, the container of a battered, mutilated, and sometimes featureless human figure. The inner structural force of these figures is keenly felt even in reproduction.

Around 1960 the figure in Neri's sculptures started to change until it was finally discarded completely, with the basic forms to which Neri had subjected the figure eventually becoming paramount. The figure as such had never actually been very important in his work. He merely felt at ease working with it. Sculptural ideas embodied in the figural pieces were just as readily worked out in other shapes, such as his ceramic loops or the Moon series, which were

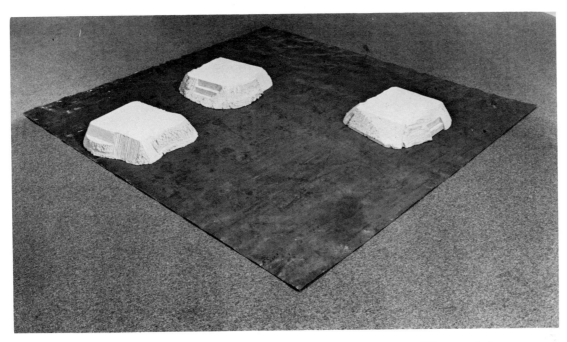

Manuel Neri. *Architectural Forms on Lead Sheet.* 1969. Plaster. (Photograph by Will Milne; courtesy of the artist)

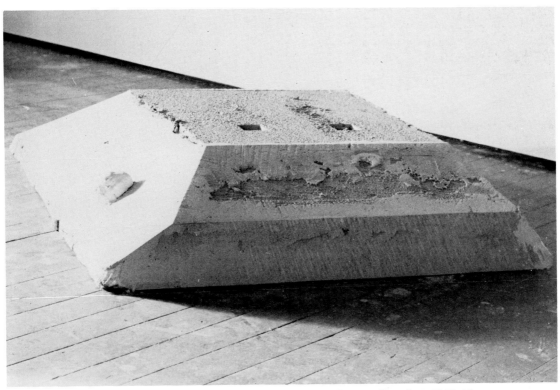

Manuel Neri. Studies for architectural forms, to be done in fiberglass. 1969. Plaster. (Courtesy of the artist)

made as a distraction, to get away from the figure. He eventually did away with color also, so that now only the increasingly geometric forms remained.

By the early sixties, then, Neri had begun to alter the proportions and the definition of the human figure by doing away with many of its identifying features. Added to the highly textured polychromed surfaces were more rigidly geometric shapes. These actually represented subtractions, for they were defined by a number of contiguous geometric planes cut from the usually convex surfaces. This contrast between highly textured rounded surfaces and the angular notches with rectilinear contours deemphasized the figural aspects of the sculptures. These pieces eventually led in the late sixties to the architecturally based truncated pyramidal forms with various staged notches (staircases) subtracted from one or more of the outer profiles of the pieces. These are based on the architectural forms found in the pre-Columbian sites of Mesoamerica (Mexico) and the Andean region (Peru). Several years ago, Neri was quite taken with a number of worked stones he saw throughout the highlands around Cuzco, Peru: ". . . these rocks are all over the place covered with little notches, little platforms. Some of them are very fancy, others are very simple. I really like that." He also became quite interested in the pyramids found in central Mexico, just outside Mexico City (Teotihuacán). He was not interested in the meaning or the use they might have had for their builders but in their physical presence, which is best appreciated in aerial views. This way the entire setting of the pyramidal structures can be seen. When Neri first saw these pyramids he was not particularly impressed: ". . . then I started looking at aerial photographs of them, where it kind of wiped away all the little roadside stalls, and you just saw the setting which they occupied, which they were in. By looking at these aerial photographs you were able to encompass them completely—the setting and the things themselves. I see them as one."

Neri's sculpture *Great Steps of Tula* is based on a view of a partially reconstructed pyramid at that site. Again, it was an aerial photograph of the site showing the reconstructed portion—the steps—that

impressed him. Another work, entitled *National Monument for the Repair of a National Image*, reflects Neri's view that Mexicans have begun to look to their own past in search of their national image after centuries of looking toward Europe. Reconstructions of these structures exemplify this new attitude.

Louis Gutiérrez

Louis Gutiérrez, a well-known northern California painter now teaching at San Jose City College, was born in Pittsburgh, California, in 1933. He started out as a business administration major at Diablo Valley College in 1952 and changed to art at San Jose State College in 1954 after receiving encouragement from his art instructor, Harriet Middleton. He received his Bachelor of Arts degree two years later. With the help of art-minded civic groups of Pittsburgh and Walnut Creek (Valley Art Center members), who sponsored him with a scholarship, Gutiérrez began his studies at the Instituto Allende in 1957. He studied there for twelve months, receiving his Master of Fine Arts degree in 1958.

Exhibitions of Gutiérrez's work have been held since the late fifties in San Miguel Allende, Mexico, and in colleges and galleries in the San Francisco Bay area. He has had one-man shows and has participated in a number of group shows. His most recent one-man show was held at the M. H. de Young Memorial Museum, San Francisco, in October–November 1971. He has received awards from the Tiffany Foundation, the Ford Foundation, and the San Francisco Art Festival. His work was included in the University of Illinois Bicentennial Exhibition of Contemporary Painting in 1965.

In the last fifteen years, Gutiérrez has gone through a number of styles that, on the surface, appear to be totally distinct, one from the other. He has moved from the highly textured surfaces of his collage construction paintings to the equally textured surfaces of his intense color paintings, and from these to the occasionally opaque mat surfaces of his recent figurative works done in ink and in leather dyes.

Gutiérrez has used a number of different materials in his paintings—cardboard, paper, tissue paper, oils,

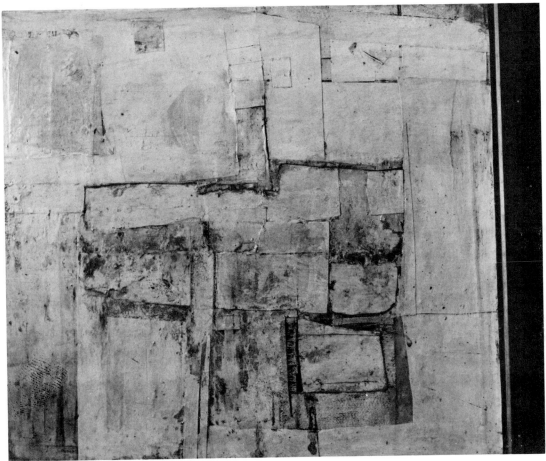

Louis Gutiérrez. Untitled. 1964. Collage. (Collection of Kenneth McElroy, Benicia, California)

leather dyes, and ink. But, regardless of the diversity of materials used, there appears to be a greater interest in process than in the elaboration of any preconceived idea or notion in these works. This approach obviously precludes using any preparatory sketches. "I just develop whatever it is, a construction or a painting. It becomes a natural process. [The works] develop and organize themselves. I end up with something or nothing."

Yet, Gutiérrez does think in terms of concept, no matter how broad that may be, as well as medium. Here concept means the use of a head as a point of departure or merely a geometric shape—a square, a line. But what eventually happens is determined by the medium. "If it is oil painting, I want it to reflect the properties of oil. It can be very thin or very painterly. So I have a definite idea as far as image—which may be a line or a head—then it's the medium and how it reacts—on canvas or on paper—how it moves, how it floats on the page, and the different colors that run into the different shapes and line." There is a constant reaction to materials tempered but not entirely determined by the artist's initial intention.

His use of a two-dimensional spatial grid for much of his work demonstrates his debt, along with most twentieth-century artists, to Picasso, Braque, and Matisse. Other artists considered important by Gutiérrez are Willem DeKooning, Franz Kline, and Robert Rauschenberg. Although he admires the Mexican muralists and singles out Rivera and Orozco,

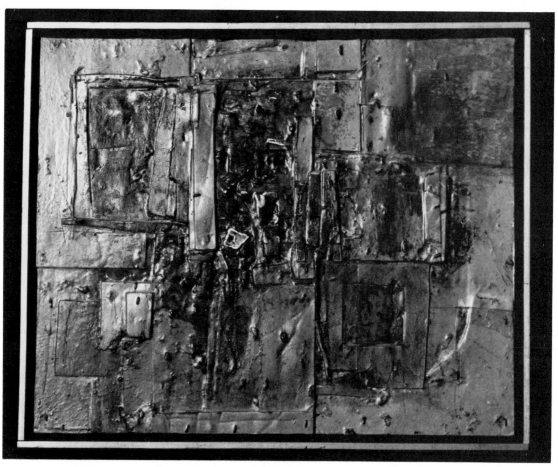

Louis Gutiérrez. *Construction no. 5.* 1964. Construction. (Collection of Mr. and Mrs. Martin E. Rothenberg, Pittsburg, California)

he is still drawn to their easel painting, which he considers more important than their mural paintings. Easel painting is more to his taste. "Because you are there and you can control what you're doing. You can do it over a short period of time."

Even though Rivera is known to most people as a muralist, few realize that he spent over ten years in Europe during his formative years and that he participated in some of the most innovative ventures in painting during that period. Although this experience is usually considered peripheral in importance to his mural career, Gutiérrez thinks otherwise. He, in fact, considered Rivera's return to Mexico and his involvement with murals an unfortunate development. "I

think he would have been a greater artist if he had not gotten involved with the literary thing as far as expressing himself in a mural. If he had spent more time on easel work and stayed in Paris."

Gutiérrez's paintings—collages and constructions—of the early sixties differed primarily in materials used rather than in structure. Both series were based on an intricate web of different-sized rectangular shapes. The constantly changing sizes, with alterations achieved by overlapping, constitute the basic arrangement in which all sides of the shapes run parallel to the visual field. The spatial effect is one of actual projection with the built-up surfaces constantly reinforcing the frame of the painting. Thus, the two-

Louis Gutiérrez. *Oil no. 4.* 1971. Oil. (Courtesy of the artist)

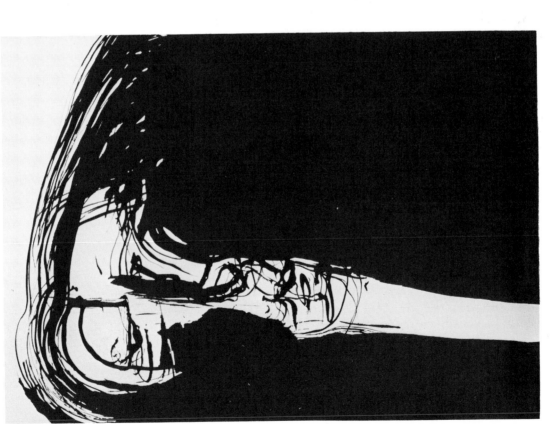

Louis Gutiérrez. *Portrait no. 4.* 1971. Ink. (Courtesy of the artist)

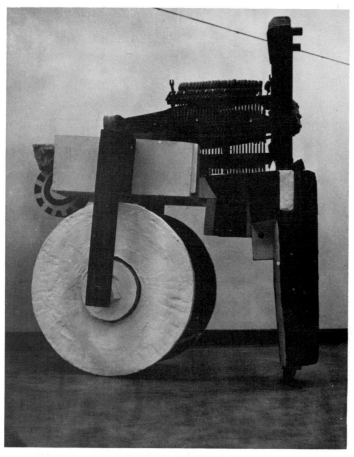

Ernesto Palomino. *George Go.* 1964–1965. Found objects, plaster, painted. (Courtesy of the artist)

dimensional grid is carried all the way to the sides, where it is firmly anchored. Examples are an untitled collage and *Construction no. 5.*

The conscious step-by-step build-up of forms is not as apparent in Gutiérrez's portraits done in ink, leather dyes, oils, and collage. Here there is a breakup of the visual surface into two distinct planes—the positive of the head with the background as negative. A good example is *Portrait no. 3.* The opposite spatial effect is created in one of his recent ink drawings (*Portrait no. 4*), with the face being encased now and surrounded by two large fields of black, which become positive because of their size and configuration rather than negative. Notwithstanding the force of the brush strokes, the conscious effort to incorpo-

rate these into a figural representation is so strong that the violence is brought under complete formal control. And that is the underlying force in his work, regardless of medium, regardless of theme. Gutiérrez demonstrates a strong sense of order and a very sensitive eye for nuance of form, color, and structure. This is apparent even in recent works, such as *Oil no. 4,* that appear to be flying apart. Yet, the flowing lava-like colored surfaces are tightly controlled here, also.

Ernesto Palomino

Ernesto Palomino, born in Fresno, California, in 1933, is a painter, sculptor, film maker, and muralist. His interest in recent years in Chicano points of view has led him to work in collaboration with Luis Valdez of the Teatro Campesino in Fresno. Since the fall semester of 1970, Palomino has taught in the La Raza Studies Department at Fresno State College.

Some of Palomino's very early charcoal drawings and a few oils done between 1947 and 1955 were compiled by Mrs. Elizabeth Daniels Baldwin for a book entitled *in black and white: evolution of an artist.*[9] The work covers the artist's life from the age of fourteen to twenty-two. The artist appropriately dedicated the book to Mrs. Baldwin, his first teacher.

Palomino has studied in several schools in Fresno and San Francisco. He attended the San Francisco Art Institute on a scholarship in 1954, Fresno City College in 1956, and Fresno State College in 1957. He also attended San Francisco State College from 1960 to 1965. He has had one-man shows at the Fresno Arts Center (1954), the California Legion of Honor, San Francisco (1957), the Crocker Art Museum, Sacramento (1957), and Fresno State College (1958). His work was included in a group show held in the Mission Gallery, San Francisco, in 1963.

An indication of Palomino's present attitude toward his work is his characterization of his entire output from 1960 to 1965 as *gabacho* art. This is a reference to his use of diverse materials to create objects or "found-object sculpture" in which there is no specific reference to his experience as a Chicano. Even though the discarded pieces of machinery,

[9]Ernie Palomino, *in black and white: evolution of an artist.*

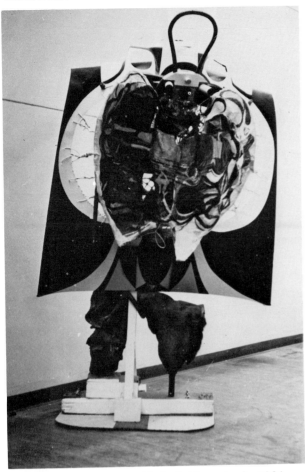

Ernesto Palomino. *Wild Bird* (frontview). 1964–1965. Found objects, plaster, wood, wire, painted. (Courtesy of the artist)

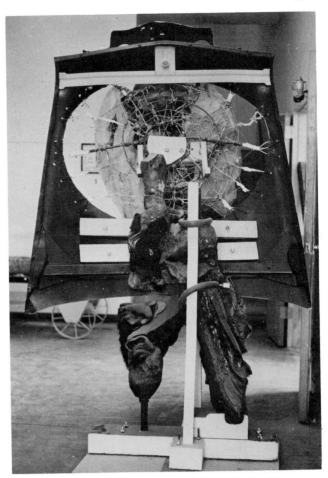

Ernesto Palomino. *Wild Bird* (rearview). 1964–1965. Found objects, plaster, wood, wire, painted. (Courtesy of the artist)

plaster, and other "found objects" in these sculptures are placed in nonutilitarian contexts, the allusions to functional units like automobiles, stoves, chairs, and chests remain very important in the artist's program. Palomino used a number of these sculptural pieces in a forty-five–minute film, entitled *My Trip in a '52 Ford*, for his Master of Arts degree thesis project presented at San Francisco State College. The three-dimensional objects attained extra sculptural identities once they were used as characters in the film. The main protagonist in the film is a 1952 Ford, named *Mary Go*. When *Mary Go* ceases to function as a passenger car, she gives birth to a tractorlike son named *George Go*. Other sculpture-characters in the

film are *Dorothy Dresser*, a prostitute; *Carol Chair*, a housewife; *Steve Stove*, a pothead; and *Wild Bird*, a mythical-religious symbol.

According to Luis Valdez, Palomino has used inanimate sculptures as human characters and symbols of life's basic interchangeability. People, Palomino seems to be saying, define themselves and other things according to their function; they fall into ruts and routines, and are unable to see life in its constant process of change and revolution. Its usefulness spent as an automobile, Palomino's '52 Ford could well have been redefined as a pile of junk, and nobody's imagination would have been strained. For that is how we routinely label broken-down cars. But Palomino the artist shied away from that stultified approach to reality, and took an ap-

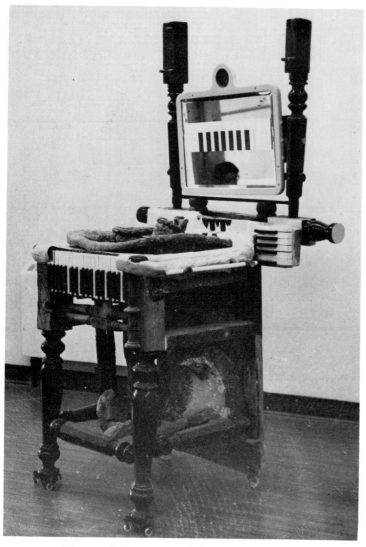

Ernesto Palomino. *Dorothy Dresser*. 1964–1965. Found objects, plaster, painted. (Courtesy of the artist)

proach as fresh and alive as life itself. He not only redefined the '52 Ford as *Mary Go*, he fathered children by her and then made a film about them.[10]

There is a meticulous arrangement of objects in these sculptures that indicates a very orderly mind. Each object retains its identity. The fragments of mass-produced objects are taken out of their original contexts and rearranged in ways that do not destroy

[10]Luis Valdez, "An Interpretation of Ernie Palomino's Film 'My Trip in a '52 Ford,'" p. 2.

the object's original configurations. An object may be transformed into something else, as is the case with the automobile hood used for the wings of the *Wild Bird*, but its identifying features remain intact. Only a part of its surface is violated. A perforation is made to contain references to *Wild Bird's* upper regions, which are held in place with wires. The same is true of *George Go* and *Dorothy Dresser*. Each separate item—turned legs, multiple casters, piano keys, mirror, radiator, and other objects molded of plaster and painted—is carefully prepared and attached to the work. This demonstrates Palomino's interest in the thematic as well as the formal potential of each object. Thus the casters (for hustling), the basin, and the other items that make up the dresser are related to *Dorothy Dresser's* line of work.

More recently Palomino has devoted part of his time to painting murals in Fresno. He has finished one (49' x 16') on Tulare Street and is presently working on another. These murals represent a greater involvement with Chicano themes than in the past. References to pre-Columbian and Mexican American themes are found in the Tulare Street mural. The central part of the horizontal painting contains the main theme: the Mexican American and his relationship to his home, his work, and his economic-political situation. Pre-Columbian antecedents are shown on the sides. An enormous red eagle, first used for the La Huelga (The Strike) activities by César Chávez and the farm workers, takes up the central portion of the space. All other motifs merge and are contained within this part of the symbol. A woman with child is framed by stereotyped representations of the sleeping Mexican with sombrero. The entire motif rests on the flat bed of a truck. Superimposed on the wings of the eagle are larger figures shown in a kneeling position. Directly below each figure and on either side of the large wheels are large bunches of grapes. Pre-Columbian mosaic masks, serpents, and seated personages are seen on extreme left and right sides. Sunlike rays emanate from the eagle's head. This chromatically and thematically rich painting demonstrates the artist's new-found direction in his work. Palomino, like other Chicano artists, is using the Chicano experience in the valleys of California

and in the entire Southwest in general as a point of departure for his work. Palomino would like to "help create the new Chicano culture. I could never be anyone else other than what I am and it looks like it's happening with or without me. What is left from my life is just enough time to resolve what little I have done and what will happen in the future. . . . I am sure [it] is exactly what I've always dreamed of—an enjoyment and understanding of my life from the very beginning until the end, with time being the only valid material, since I have always been a poor Chicano." Palomino is very definitely at the forefront of those who are dealing with the Chicano experience as a point of reference and as an inspiration for their work.

Ralph Ortiz

Extremely active as lecturer, teacher, political activist, and writer, in this country and abroad, is Ralph Ortiz, the Destructive artist. Ortiz, born in New York in 1934, received all his formal schooling in New York. He studied art at the High School of Art and Design, the Art Student League, the N.Y.C. Brooklyn Museum Art School, and the Pratt Institute, where he received a Bachelor of Science degree and a Master of Fine Arts degree. He is a candidate for a Doctorate of Fine Art and Fine Arts Higher Education at Columbia University. He is presently director of the Museo del Barrio in New York City.

Starting in 1960, Ortiz has had numerous sculpture exhibitions, concerts, and theater exhibitions in galleries and museums in New York City, Boston, Montreal, Vancouver, London, Los Angeles, and San Francisco. Among these are the Riverside Museum, the Museum of Modern Art, the Whitney Museum of American Art, the Park Place Gallery, and others in New York; the Boston Museum of Fine Art; and the Oxford Museum of Modern Art, London. Ortiz's work is represented in these and other museum collections and in a number of private collections, including that of Dr. Richard Hulsenbeck, founder of Dada.

Ortiz has also lectured extensively in universities, galleries, museums, and high schools, as well as on radio and television in England and Germany, and

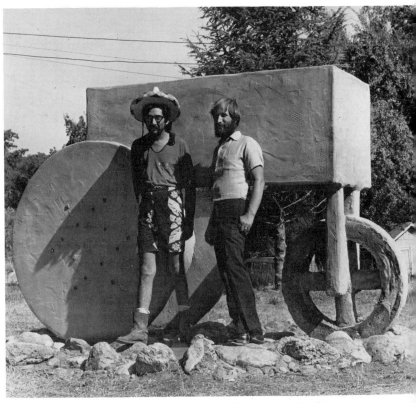

Portrait of Ernesto Palomino (*left*) with friend in front of tractorlike sculpture. (Courtesy of the artist)

in this country in New York, Los Angeles, and San Francisco. He has taught art at Columbia University Teachers College Graduate School and at New York University. His writings on Destructive art have been published in London and New York. His work has been featured and reviewed in major publications here and abroad.

In the mid-sixties Ortiz and other Destructive artists began to receive international attention with their Destruction in Art Symposium (DIAS) held in London, England. Ortiz became particularly well known for his *Piano Destruction Concert* performed on BBC Television in 1966 and later presented on national and local television—ABC and NBC—in this country. His *Piano Concerts* and *Destruction Theatre* were presented in galleries and museums in Europe, in this country, and in Canada.

It is appropriate at this point to quote an excellent

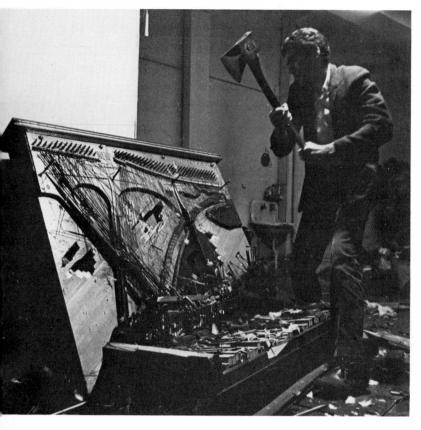

Ralph Ortiz. *Piano Destruction Concert Duncan Terrace*. Destruction in Art Symposium, September 1966, London. (Courtesy of the artist)

description of one of Ortiz's performances held in Vancouver on August 28, 1968, written by Joan Lowndes and published in *The Province*. The *Destruction Theatre* was organized by the Douglas Gallery.

The first was his famous Piano Destruction Concert. Armed with an axe he first chopped up a record player, then deadly serious and dedicated, attacked a green upright piano.

To make the slaying more shocking, plastic bags filled with animal blood suspended inside the piano burst under his efficient strokes, spewing blood-spattered keys and chips of wood onto the floor.

Ortiz himself was splashed with blood as he left the piano flat on the ground, white mice covered with blood crawling out of its guts.

Before the audience had time to recover the second

piece began. In this about 12 shouting men and women cut each others' clothes off with scissors and threw dixie cups full of blood at each other.

. . . The third sequence consisted of a film of the piano attack, which Ortiz has performed at a Destruction in Art Symposium held in London in 1966 as well as in New York.

In its closing sequences a live chicken is beaten to death against the piano wires after which, as in a ritual, Ortiz sprinkles feathers over the spectators. A chicken was hopping about in the Vancouver performance, but to the general relief was not sacrificed.

The three pieces together lasted an hour, leaving the audience dazed.[11]

By the time Ortiz presented this performance in Vancouver, *Destruction Theatre* had become almost institutionalized, having received extremely wide television, radio, film, and magazine coverage. Ortiz had written letters to editors of art magazines expressing his view on destruction in our everyday lives and how it related to art. He had written manifestos in which his position regarding these activities was explained.[12] "To realize our destructions within the framework of art is to finally rescue ourselves and civilization from the havoc reaped by our depersonalized psychologies. Destruction theatre is the symbolic realization of those subtle and extreme destructions which play such a dominant role in our everyday lives, from our headaches and ulcers to our murders and suicides."

One of Ortiz's early works, done in 1963 and entitled *Tlazolteotl*,[13] is actually an upholstered chair that has been literally "destroyed." This piece belongs to a series of works he called "Archaeological Finds." Each was given a Náhuatl proper name. He explains: "I was interested in the particular mythology that had evolved right after the Western con-

[11]Joan Lowndes, "Destruction Theatre: A Shock Spectacle with Moral Motive," *The Province*, August 28, 1968, p. 8.

[12]Written statements by the artist: Ralph Ortiz, *Destructions–Past & Present*; "Destruction Theatre Manifesto," *Studio International* 172, no. 884 (December 1966): 19–24, 51.

[13]Tlazolteotl, the goddess of dirt, earth mother, was worshipped under many synonyms. See George C. Vaillant, *Aztecs of Mexico: Origin, Rise, and Fall of the Aztec Nation*, p. 105.

quest, the European conquest and destruction [of Mexico]. It was in a sense searching into my roots, into the whole visceral relationship that we had originally to nature's processes, into life and death, and the whole creation and procreation—things beginning and things ending, and coming together and coming apart. The idea of taking something that is made or not making it. In a sense, giving back to the forces of that which the forces gave. There is one piece that even went beyond that. I call it 'Montezuma.'[14] It is a piece which I ripped apart and formed a kind of cross, which is older, much older than the Christian cross. It reveals the internal forces of what the Aztec culture was about. Within all that there is a rib cage kind of division, opened up—the heart, the sacrifice —the going inside, pulling things out. That is a very important part of the whole process."

In spite of these specific references to the Aztecs, Ortiz tends to think of the pre-Columbian cultures in very general terms. This attitude does not preclude bringing in other American Indian groups, like the Arawaks, the Caribs, and others. He is primarily interested in getting to the essential "visceral" character of these early cultures. In his view, the life-and-death process was not seen by these peoples as an abstraction. "They were not cerebral, but a very intuitive, body-oriented people." Ortiz's emphasis on this aspect of culture represents a search for his emotional roots. For what is important, after all, is "what we can touch, what we feel, what we know in our bodies to be real, not something written somewhere."

The acts of theater in which objects or even animals are destroyed become equally important in Ortiz's work. However, these and the destructive objects he has exhibited as "Archaeological Finds" are not related to Dada or Surrealism. Ortiz's approach may be superficially similar to what Rauschenberg or even Kurt Schwitters may have done in the past, but he has entirely different ends in mind. "I am convinced that Kurt Schwitters' and the Rauschenberg [objects] are utilizing those processes

[14]The sculpture *Montezuma* is reproduced in Jacinto Quirarte, "The Art of Mexican-America," *The Humble Way* 9, no. 2 (Second Quarter 1970): 6.

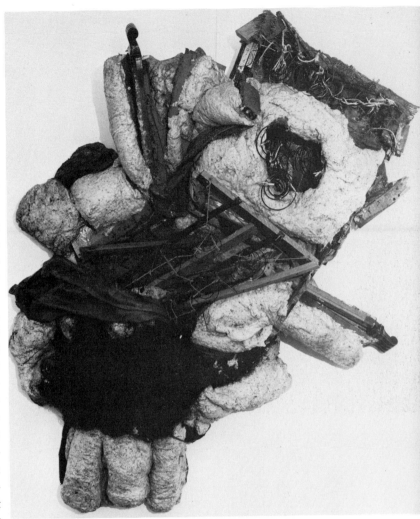

Ralph Ortiz. *Tlazolteotl.* 1963. Destroyed upholstered chair. (Courtesy of the artist)

that are relevant to their roots, because we know that the fetish, the totem, is not something that is specifically South American or African. We know that the Celts also had their totems and human sacrifice and [very basic attitudes toward] life and death, and the procreative process." Ortiz, on the other hand, is merely responding to other sources and is obviously not interested in creating purely formal configurations. The Destructive objects embody these vital processes, just as the *Destruction Theatre* is an actual reenactment of them.

7. Fourth Decade: I, 1937-1940; II, 1943-1946

Aᴿᵀᴵˢᵀˢ ʙᴏʀɴ ʀɪɢʜᴛ ʙᴇꜰᴏʀᴇ and toward the end of World War II were trained in the late fifties and the early sixties and have only recently come into their own as artists. Heirs to the changes in American art postdating the domination of the Abstract Expressionists, these young artists nonetheless work in a number of traditional ways. In almost all cases, there is an emphasis on the figural aspects of a work of art. Extreme precision exists in the depiction of nature and man-made objects in terms of rather harsh line and color by Eduardo Carrillo (b. 1937). Ray Chávez (b. 1938) uses live oaks in lieu of the human figure within otherwise denuded landscapes, with celestial phenomena playing an important role. Joseph A. Chávez (b. 1938) is involved with the expressive powers of the materials he uses in his abstract sculptures. Michael López (b. 1938) is a ceramist who experiments with new as well as old materials and techniques in his works. Luis Jiménez (b. 1940), a sculptor, uses the typical American phenomenon of the Pop sex goddesses and the motorcycle in large, shiny, polychromed sculptures fashioned in fiberglass and epoxy.[1]

Outstanding among the younger artists in the second group is Glynn Gómez (b. 1945), who has concentrated on primarily black-and-white and monochromatic representations of people in Vietnam, done during a five-year tour of duty there in the Marines, and in recent years of the people of New Mexico. In contrast, Amado Peña (b. 1943) uses very rich colors in his paintings, also based on a figural tradition. Rudy Treviño (b. 1945) is the only painter in this group involved with an abstract idiom. Alex Sánchez (b. 1946) concentrates almost exclusively on extremely unusual phenomena—also figural

[1]The information in this chapter was gathered from taped and unrecorded conversations and from extensive correspondence with all artists during the years 1970–1972: Eduardo Carrillo, correspondence; Ray Chávez, September 12, 1971; Joseph A. Chávez, April 1971; Michael López, June 23, 1970; Luis Jiménez, June 2, 1970.

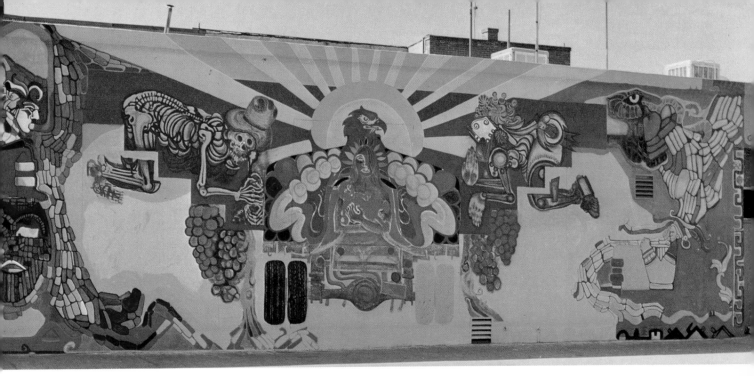

Ernesto Palomino. Untitled. 1971. Mural (outside wall). Tulare Street, Fresno, California. (Courtesy of the artist)

Eduardo Carrillo. *Fisheye*. 1970. Oil on wood. (Courtesy of the artist)

Ray Chávez. *Moonsong*. 1969. Acrylic on canvas. (Private collection)

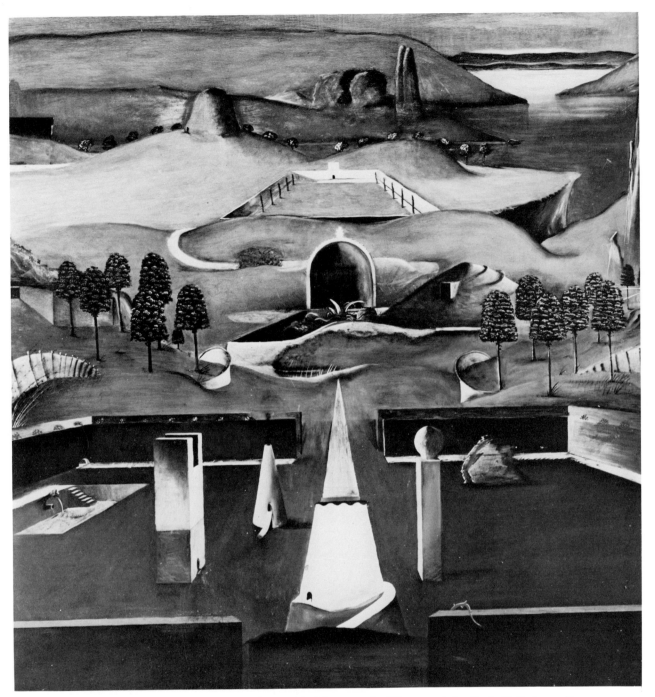

Eduardo Carrillo. *Subterranean Garden*. 1964. Oil on wood. (Photograph by Ceeje Galleries; collection of the late Samuel Booth, Beverly Hills, California)

—which have as a base a highly complicated narrative. He uses a rapidograph to create very fine drawings on glossy paper.[2]

[2]Glynn Gómez was interviewed on June 12, 1970, and at various times during the spring of 1971; Rudy Treviño, August 1, 1970; Alex Sánchez, April 1971.

I, 1937–1940

Eduardo Carrillo

A teacher at Sacramento State College since 1970, Ed Carrillo was actively involved in the Chicano movement in Los Angeles a few years ago. In the

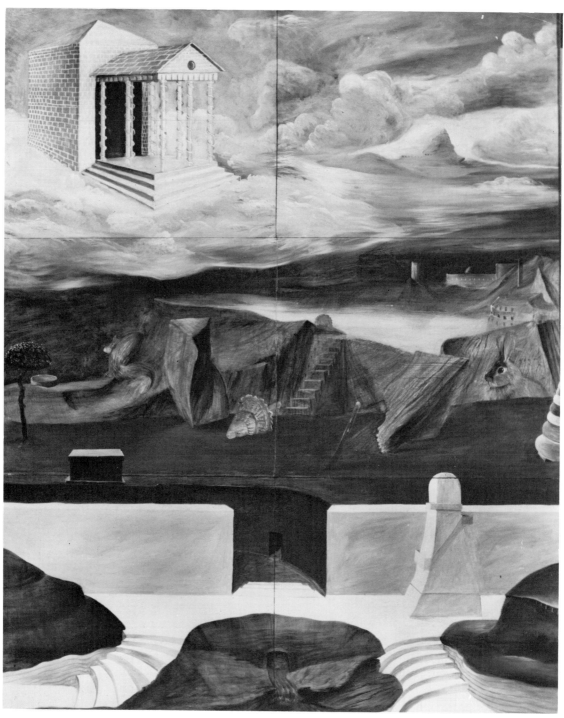

Eduardo Carrillo. *Cabin in the Sky*. 1964. Oil on wood. (Photograph by Ceeje Galleries; collection of Tony Berlant, Santa Monica, California)

summer of 1970 he painted a mural in collaboration with three Chicano artists—Ramsés Noriega, Saul Solache, and Sergio Hernández—in the Chicano library at the University of California, Los Angeles. He later painted another mural in a Sacramento barrio. Now he is more introspective about these things. His recent works reflecting nonpolitical points of view are more related to artistic problems. He is concerned with the appearance of objects, their surface configurations, and their identifying textural qualities.

Carrillo, born in Santa Monica, California, in 1937, attended Catholic grammar and high schools in Los Angeles. He entered Los Angeles City College in 1955 and transferred the following year to the University of California, Los Angeles, where he studied until 1959. He received a Departmental Award at City College, and the Art Council Undergraduate Award at the University of California. From 1960 to 1961 he studied drawing at the Círculo de Bellas Artes in Madrid, Spain. In 1961 he returned to the University of California, Los Angeles, where he received the Bachelor of Arts degree in 1962 and the Master of Arts degree in 1964.

During his last year in school Carrillo was a teaching assistant. He later taught art at the University of California Extension in San Diego from 1964 to 1966. He left the country again in that year and went to La Paz, Baja California, where he founded and directed the Centro de Arte Regional until 1969. He and his wife taught ceramics, weaving, and dressmaking to local teenagers. He returned to the States in 1969 to work as an art instructor at San Fernando State College. Since September of 1970 he has taught at Sacramento State College.

Carrillo has exhibited widely since 1962 at the Ceeje Gallery and other places in Los Angeles, and in other southern California cities. Since 1966 he has exhibited in Hayward and Sacramento, California. Outside of California he was included in a group exhibition, "Painters of the Southwest," held in Houston in 1963, and in a juried show in the Palace of Fine Arts, Mexico City, in 1968. His most recent one-man show was held at the University of California at Santa Cruz in October 1971.

While in Spain in 1960 and 1961, Carrillo became very interested in the works of Hieronymous Bosch, Diego Velázquez, and El Greco. Carrillo's works of that period are in fact quite reminiscent of some of Bosch's paintings, for example, his triptych known as the *Garden of Delights*, now in the Prado Museum. Carrillo's paintings are comprised of imaginary landscapes and figures.

Carrillo stopped painting for several years during his stay in Mexico, preferring to work with ceramics. He returned to painting, however, during his last year in Mexico. These works are all based on observable objects found within his immediate surroundings. "We lived in a one-hundred-year-old house (adobe) that belonged to my grandfather. I did paintings of the different rooms and my wife."

Upon their return to the States in 1969, Carrillo became involved with the Chicano movement at the University of California, Los Angeles. His collaboration with other Chicano artists in painting a mural and his experience with actual violence during the Chicano Moratorium of August 1970 in Los Angeles —beatings, tear gas, and jail—eventually led to his disillusionment with the Movimiento. He has since become very interested in painting the effects of light falling on different materials. "I have moved away in idea from Movimiento concerns recently because I think that racism is the world's number one problem and the Movimiento breeds racism. I want to embrace the world, and La Raza is busy building a medieval fortification."

Carrillo's meticulously painted landscapes of the early sixties—oils on wood panels—are comprised of vast open areas in which are found lakes or seas, architectural and, on occasion, animal forms. These imaginary landscapes are broken down into various spatial fields, with the frontal plane invariably sharply delineated by man-made walls, staircases, and towers, serving as a proscenium, to which objects and terrain within the middle and back planes are related. His *Subterranean Garden* has a thin double-walled precinct in the foreground in which are placed a number of unusual geometric structures. In the center is a conical structure with smoke coming out the top and a rectangular one with notches. On the

Portrait of Eduardo Carrillo. (Courtesy of the artist)

left side is a partially empty rectangular depression (pool?) with a staircase at one end. Within the double walls are evenly spaced trees whose foliage can barely be seen rising slightly above the walls. The foreshortening of the walled precinct, based on a single vanishing point located slightly above the opening in the center, demonstrates the elevated position of the viewer. The tilted middleground is comprised of rolling hills, abutments, roads, and evenly distributed trees (six on each side). There is no variation in the spatial intervals between them. Another walled precinct, found a little beyond this middleground and foreshortened according to another eye level, creates the effect of a ground again falling away into the distance. The orthogonals of the two precincts break the visual surface along diagonals in contrast to the series of planes found in the middleground and the background—the water, hills, and trees.

The juxtaposition of geometric volumes reminiscent of architectural forms and the mute presence of groups of evenly spaced trees, undifferentiated in any way, give this painting a fantasylike atmosphere.

Carrillo's *Cabin in the Sky* is evocative of the same type of feelings. But, now, the placement of totally unrelated objects within a similar spatial ar-

rangement—the large shell in the middleground and the profile representation of the large rabbit to the right of it—gives this work an even more unusual aspect. This is further enhanced by the celestial cabin amid a turbulent sky. The usual grounds—front, middle, and back—are now relegated to the lower half of the painting, with the sky taking a much larger portion of the visual surface. The extreme foreshortening of the temple, which gives a strangely anchored effect, in the gravitational sense, contrasts sharply with the predominantly horizontal directions, or planes, of the terrestrial sphere.

Fortress at Turrey Pines is also based on a series of walled precincts within the frontal plane, whose configurations appear to be dictated by the artist's imagination and the needs of the painting. The middleground gives way almost immediately to a great expanse of the extreme background.

The representation of objects within the landscape in all three paintings demonstrates the use of various eye levels within each. Yet, even with these similarities, the definition of the horizontal in each is dictated by the needs of the theme. In *Subterranean Garden* the sky is a mere sliver, while in *Cabin in the Sky* it takes up half the visual surface. In *Fortress at Turrey Pines* the sky takes up one-third of the painting.

Carrillo's most recent works are equally meticulous in their representation of objects. However, the vast expanses of the imaginary landscapes now give way to close-up views of specific locations, like the exteriors and the interiors of a home—the front and back yards, a kitchen floor, chairs, tabletops. A good example is *Testamento de el Espíritu Santo*. The same spatial habits are retained but more circumscribed to the frontal plane, in which the numerous objects are placed. This is also the case with his *House in Venice* and *Backyard*. Both present a vertical plane of the house—the front and the back—on the left as a limit to the foreshortened extension of the foreground. A narrow section on the right allows the artist to open up the tightly enclosed cubical space of the foreground. This device is also used to show other homes and automobiles on the periphery. There is a strict adherence to horizontals and verticals in *House in Venice*, which is partially retained in

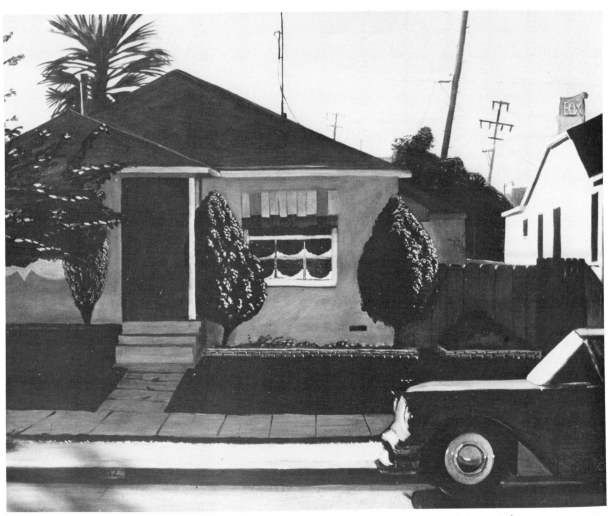

Eduardo Carrillo. *House in Venice*. 1969. Oil on wood. (Courtesy of the artist)

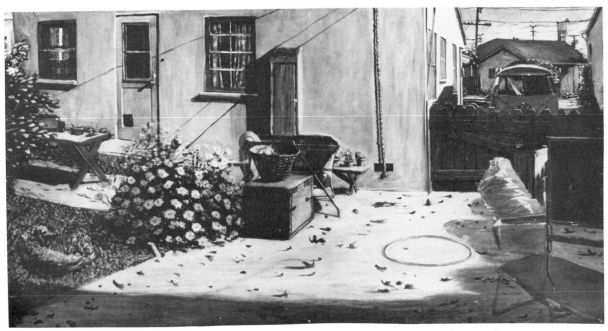

Eduardo Carrillo. *Backyard*. 1970. Oil on wood. (Courtesy of the artist)

Backyard. The tunnellike effect of the carport in which the Volkswagen bus is parked is deemphasized by the inclusion of the gate and the fence leading to the backyard. Although Carrillo studiously restricts his selection of subjects to these almost snapshot types of views of his immediate surroundings, he takes these and presents them in tightly knit compositions that are spatially based on a series of planes that constantly echo the frame, along vertical and horizontal directions.

The habit of relating a foreshortened ground plane to a vertical wall plane, with an opening to the right of the visual surface, is also found in his painting of a chair placed in front of a large chest.

The painting entitled *Fisheye* is a faithful representation of a tiled floor on which are placed three plates, with the center one turned over. The octagonal-shaped tiles and the lines placed perpendicularly to each of the four sides of the tiles that are parallel to the frame are used in a subtle way to define the tilted plane of the floor. The octagonal shapes are foreshortened, as are the vertical lines that represent the orthogonals of the linear perspective used. The overall pattern is beautifully contrasted by the inclusion of the three plates along a diagonal starting on the upper left and extending beyond the lower right.

Carrillo has a keen sense of space—the substantive part, I believe, of his paintings. It is the arrangement of the numerous objects within the controlled spatial frameworks that is evocative of the dreamlike scenes in which human beings are rarely included but whose presence is indicated by the objects. This is as true of his earlier imaginary landscapes as it is of his more recent blown-up details of his immediate surroundings, within the home and its exterior.

Ray Chávez

Ray Chávez, born in San Antonio, Texas, in 1938, attended Catholic schools from the first through the twelfth grades. He studied art at San Antonio College in 1964 and 1965, and at the McNay Art Institute. He has exhibited his works in central Texas cities—primarily in San Antonio and Austin—since 1966 and has won several awards. His most recent one-man

show was held in February 1972 at the Dos Patos Gallery, Corpus Christi.

Chávez has devoted full time to his art work since the middle of 1971. Prior to that, he worked as a technician at Kelly Air Force Base, a position he held for thirteen years. He now lives in Castroville, Texas.

Robert Tiemann, a San Antonio artist and teacher, has been an important influence on Chávez, as has Marc Chagall, whose works he saw on a recent visit to New York. He likes the works of these two artists very much.

The materials Chávez prefers to use are pencil, rapidograph pens, colored pencils, and acrylic paints on paper and canvas. He works out exactly what he has in mind in small sketches, done on paper with a rapidograph pen, which are then colored with pencils. Finally, these sketches, usually one-of-a-kind miniature paintings, are sprayed. Once this entire process is worked out, Chávez puts it down on canvas with acrylic paints.

The one outstanding feature in Chávez's works are the trees he uses in a number of contexts. These realistically portrayed trees, presented singly or in groups of four or five and placed within otherwise very abstract configurations, are a very essential component in these paintings. They convey a variety of meanings. They may represent "a feeling, a mood, or a person," but basically they stand for humanity, or people.

Although the human figure interests him, Chávez prefers to use trees as vehicles for his ideas. He is drawn to them as he is to other formal configurations. The special role assigned to these trees is signaled by the way they are portrayed. He uses modeling to give the illusion of volume in the foliage and the trunk of the tree. The other parts of the picture are painted in flat unmodulated colors. This selective "realism" is carried only as far as it will enable him to put his point across. It is not essential that he work from actual trees in these paintings, for he is interested not in telling us about specific trees but in his own state of mind and emotion in relation to his own past and his everyday experiences.

The trees have been interpreted as mushrooms

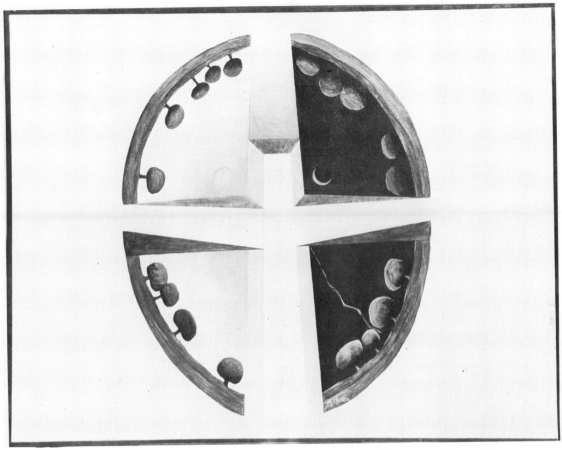

Ray Chávez. *Jesus in the Round.* 1968. Acrylic on canvas. (Courtesy of the artist)

and lollipops! But aside from these unusual interpretations, they have even been considered as just plain intrusive. According to one observer, "The painting would be ok, if it weren't for the trees." To Chávez, the trees are very important. Otherwise, the paintings have no meaning.

Other constantly recurring motifs in Chávez's work are earth, air, sky, and celestial bodies. Their definition in terms of color and shapes, and their placement and displacement to create positive and negative areas, are used to express a feeling, an experience, a point of view, and never as ends in themselves. He may be struck by something he experienced during a specific time of day, a mood, or a feeling he may have had during a particular morning. Efforts to capture that feeling are focused on the type of light—sunny, cloudy, or whatever—that may

have pervaded the atmosphere that day. Or the reference may be much more general. The earth divided into various layers, each represented by a different color, may symbolize life, existence: "blue for sky, green for earth, brown for dirt, red for blood, yellow for sunlight." And orange? "It just fits in visually." Or the reference can be to a specific spectacular event, like the moon walk.

Chávez's painting entitled *Moon Song* is literally a celebration of man's first walk on the moon. Yet, Chávez does not use identifiable images that could be related to this event. The colors, shapes, space, and very personal motifs, like the trees, are used to evoke his own feelings about this historic event. The various levels of experience and existence are symbolized by a few images arranged within horizontal registers. The earthly stratum is evoked by the four

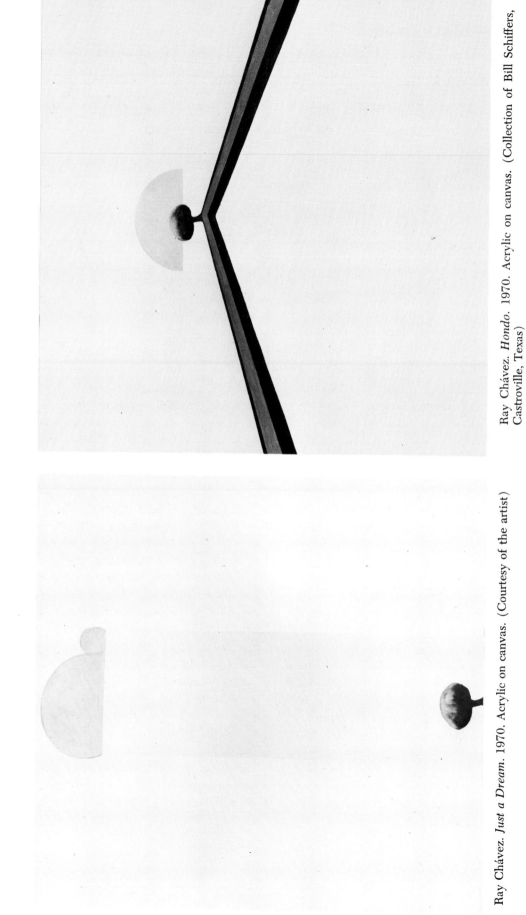

Ray Chávez. *Hondo.* 1970. Acrylic on canvas. (Collection of Bill Schiffers, Castroville, Texas)

Ray Chávez. *Just a Dream.* 1970. Acrylic on canvas. (Courtesy of the artist)

trees. Effects of light from above are used to give the only illusion of volume in the painting. The trees in a green field with a sketchily defined blue sky above are topped by hemispherical shapes painted red-orange and yellow. The total shape of the earth, with sky and sun above, is like an inverted badge, or shield. The entire scene, funneled through the pointed extension of the green level, draws our attention to the smaller stylized representation of a yellow crescent-shaped moon forming part of the orange sphere. The moon is surrounded by various values of blue, which eventually fade toward the edges until the white field on which all images are placed is reached.

The white negative space, very important in Chávez's paintings, provides the kind of open field in which the positive spaces of the various strata are placed.

Chávez's *Jesus in the Round* is a little more complicated visually. Instead of the dominant, centrally placed earth, sky, and celestial bodies, various aspects of these spheres, tempered by the passage of time, are presented in four units. The horizontal registers are now placed in quadrants of a large oval. The green field with trees is slightly curved, and the sides of the register are inclined so as to form the quarters into which the oval is divided. Starting on the upper left and moving counterclockwise, there are representations of (1) the sun, (2) overcast sky, (3) a stormy sky, and (4) the moon. The four manifestations of the earth, sky, and celestial bodies within quadrants are so separated that a Latin cross is defined by the negative spaces between them. Again, the images float within a vast white field.

Chávez's recent paintings are much simpler. One of these is *Just a Dream*, in which a single centrally placed shaft is used to connect a puffy cloud above and a single tree below. Another of these is his painting entitled *Hondo*. Again, a single tree is used but now placed at the apex of a striped ground. The hemispherical shape behind the upper oval of the tree and the ground falling away at two slightly different angles create the same effect already discussed above. The expansive negatives of the white grounds enhance the equally economical use of positive spaces—the ground, tree, and sky.

These very poetic works are based on Chávez's feelings and reflections toward outside events, toward his own experiences and background. Thus, his works are not a direct record of reality but of his own special relationship to it.

Joseph A. Chávez

A sculptor in the traditional sense as far as materials and techniques are concerned, Joseph Chávez of Albuquerque, New Mexico, uses alabaster and stoneware clay in his work. Recently, he has begun to incorporate inlaid plates made of steel and chrome in his sculptures. The veined, variegated surface of the hard stones and the shiny metals are important facets of these works.

Chávez, born in Belén, New Mexico, in 1938, received most of his art training at the University of New Mexico, Albuquerque. He received the Bachelor of Arts degree in 1963, the Master of Arts in Art Education degree in 1967, and the Master of Arts degree in 1971. He has taught arts and crafts in the Albuquerque public schools for eight years. He has exhibited his works in various galleries and at art fairs in Albuquerque, Santa Fe, and Taos.

In keeping with his interest in natural forms, pebbles, sea shells, bones, and plants, Chávez has been impressed with the work of twentieth-century artists whose works have clearly been inspirational points of departure—Constantin Brancusi, Hans Arp, and Henry Moore. Although his work may be reminiscent of the works of these artists as far as materials and techniques are concerned, his intentions and final products differ. They consistently created anthropomorphically based sculptures. Chávez's works are more abstract or, more precisely, nonfigurative. In fact, instead of having a preconceived idea when he begins a work, Chávez allows the shape of the rough stone to partially dictate or suggest the final form of the sculpture.

Whether Chávez uses alabaster stone or clay, there is a consistency in the formulation of these works. The swelling forms, bulges, and indentations

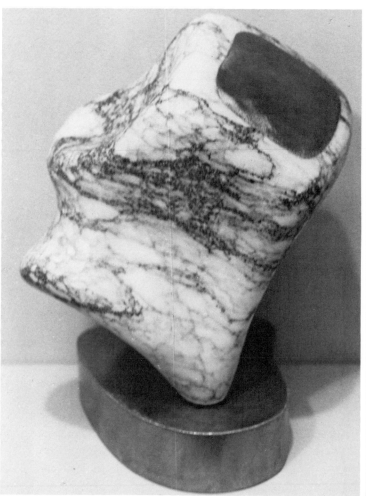

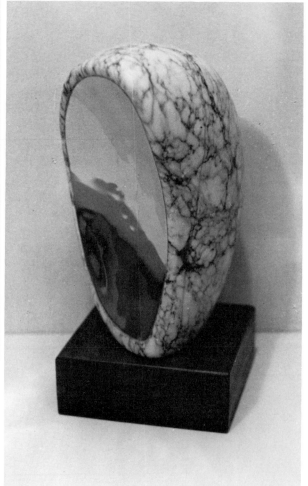

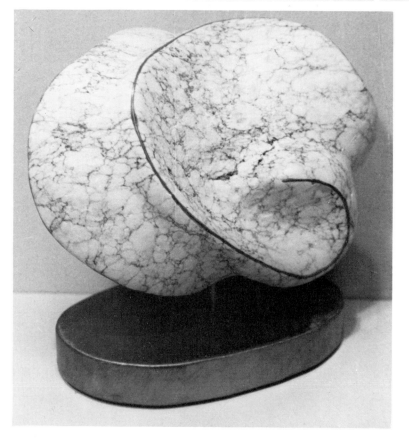

(*Above, left*) Joseph A. Chávez. *Beyond.* 1971. Alabaster with steel sheet inlay. (Collection of Mr. and Mrs. Norman Allen, Albuquerque, New Mexico)

(*Opposite*) Joseph A. Chávez. *Flight* 1969. Alabaster with steel wire inlay. (Collection of Mary Ryan, Albuquerque, New Mexico)

(*Above, right*) Joseph A. Chávez. *La Luna.* 1971. Alabaster with chrome-plated steel inlay. (Collection of Mrs. A. T. Seymour, La Luz, New Mexico)

merely serve to forcefully contain an almost impacted configuration. Certain portions of the surface appear to be struggling to move out from the nucleus of the piece but only manage to add further strength to the core. One is conscious of the weight and mass of these pieces whether they are solid, as is the alabaster sculpture entitled *Unity,* or hollow like the ceramic stoneware entitled *Phallic Form.*

The effect of the sculpture entitled *Beyond* is slightly different from those mentioned above. The inclusion of inlaid steel plate on an alabaster stone adds to the light feeling that this piece is intended to give. Its anchoring on one side, which makes the piece appear tilted, is also designed to give the illusion of weightlessness and, by extension, movement. It appears almost poised in an anthropomorphic sense. Although the piece entitled *Unity* is also balanced on a small portion of its surface that actually touches the pedestal, its main vertical axis is maintained. This arrangement gives it an entirely different effect. The dimensions of the cylindrical shapes are not altered appreciably. The longitudinal configuration of these interlaced cylindrical forms creates the effects of great potential power, a highly charged surface. Only one portion is actually contained by an outer ring. Both represent two axes running perpendicularly to each other. This simple interlace appears to be far more complex formally than it actually is because of the almost bursting effect of the inner and outer cylindrical forms that make up the interlace.

Michael López

The ceramics of Michael López, a northern California artist, combine a variety of highly textured (torn clay), smooth, and brightly polychromed surfaces (spray painting). These pieces are produced by a number of ways, some of which are traditional (high and low firing), while others are the result of the application of new materials (resin).

Michael López, born in Los Angeles in 1938, attended Catholic schools in that city. He studied design and advertising art at Los Angeles City College from 1956 to 1960 and then sculpture at the California College of Arts and Crafts, Oakland, from 1960 to 1963. He received the Bachelor of Fine Arts de-

gree in 1962 and the Master of Fine Arts degree in 1963. He received a number of awards for his work at Los Angeles City College and scholarships to attend Arts and Crafts. He has exhibited his works in California cities since 1961—Los Angeles County Museum, Richmond Art Center, M. H. de Young Memorial Museum in San Francisco, Pasadena Art Museum, and galleries in Sacramento and Marin City; and in other parts of the country since 1962—Denver Art Museum, Museum of Contemporary Crafts in New York, Chicago Festival of Arts, and Everson Museum of Art, Syracuse, New York.

Although López was very interested in drawing as a child, he did not study art until he had been in college for one semester. His father had wanted him "to be an engineer or a doctor or something substantial like that." Since he was not interested in any of these career possibilities, he compromised. His first course of study included mechanical engineering and drafting at Los Angeles City College. His father "thought that mechanical drawing, drafting would be very good. I wanted to go into art. He didn't want me to have anything to do with that." Michael soon became convinced that he wanted to take art after all, when he talked to Jaime Torres, a grammar school and high school friend who was then taking art courses. The only way to convince his father that he was not well suited to his present course of studies was to flunk out that semester. After this he was able to change his studies to art. Yet, he did not study ceramics during these early years. It was only after he had received a scholarship to study at the California College of Arts and Crafts with a major in sculpture in 1960 that he began to work in ceramics. His interest dated from the time he had worked during a summer with a designer who was also a ceramist. After his studies in Oakland he went to Chicago, where he was a department assistant in ceramics at the Chicago Art Institute from the fall of 1963 to the summer of 1964 and an instructor in ceramics during the summers of 1964 and 1965. Finding Chicago too cold, he eventually returned to Oakland, where he still lives and teaches at Arts and Crafts. Even before López began working in ceramics, he was drawn to artists who dealt with highly textured surfaces. While

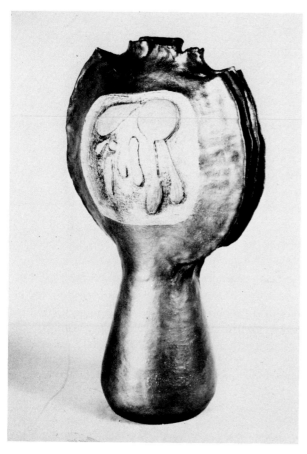

Michael López. *Black Weed Pot.* 1963. Stoneware. (Courtesy of E. B. Crocker Art Gallery, Sacramento, California)

he was still studying sculpture at City College, he became very interested in the sculpture of Theodore Roszak. Another influence has been the work of Peter Voulkos.

During a European trip several years ago, López was drawn to the work of the famed nineteenth-century architect Antonio Gaudí. He was also deeply impressed with the work of Francisco de Goya y Lucientes. Among American artists, Rico Lebrun's work has interested López perhaps more than any other. And, finally, during a Mexican trip he naturally was quite interested in the ceramics produced there. He made a special trip to see Doña Rosa's workshop in Quiotepéc, just outside Oaxaca. She produces

some of the finest black pottery in the Oaxaca area. He also was impressed by the glazed pottery of Tlaquepaque, just outside Guadalajara.

López's early ceramic pieces reflect the concept he had of himself as a craftsman. The final product was the result of certain prescribed approaches in which "highly crafted, very sanded, and smooth and refined, but sort of organic" pieces were created. A good example from this period is his 1963 stoneware piece entitled *Black Weed Pot.* This consists of a large circular form comprised of several flattened-out shapes along its outer limits, set on a conical base. The geometric configurations are, of course, only approximate and do not correctly describe the very organic surface.

The experimentation in ceramics for López has revolved around the technical means that have enabled him to get a variety of textures and colors. His early works, fired at very high temperatures—2,200° F.—to produce high-fire stoneware, have very earthy colors. Other pieces, fired at much lower temperatures, have brighter hues. And still others are spray painted and not fired at all. These are the candy-colored pieces. It is the spray painting and, more recently, the low firing that López has used in much of his work.

López began to experiment with other techniques in order to get a wider range of colors and textures in his work. He began to juxtapose torn clay, whose "rough organic quality [is] contrasted to hard, crisp," very smooth, polychromed surfaces produced by a variety of means, initially with standard glazes and later with spray painting. Some of these pieces are handcrafted, others are thrown on a wheel and then fired. Some of these are the 1968 *Earth Form* stoneware with black and green stripes, and the 1969 *Candy R. B.* earthenware spray-painted ceramic piece.

López's interest in obtaining a wider range of colors led him to use spray painting, but this created additional problems, something he had hoped would not be the case. Not only did he get a limited color range with glazes, but also, as a result of the various processes, many of the effects he was striving for

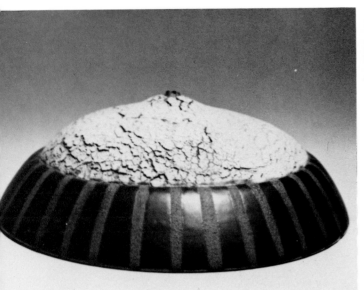

Michael López. *Earth Form.* 1968. Stoneware, black and green stripes. (Courtesy of the artist)

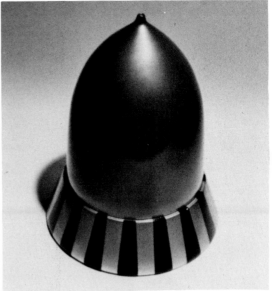

Michael López. *Candy R. B.* 1969. Earthenware spray-painted ceramic. (Courtesy of the artist)

were lost. The color and decoration he was doing with high-fire temperatures bled and ran together, thus distorting what he had in mind. Spray painting would hopefully solve that. Because the clay is so porous and rough when fired, it has to be sanded and primered before it can be sprayed. This turned out to be a laborious process. The sanding and primering had to be repeated numerous times before even a base color could be obtained. He finally resolved that problem by using fiberglass. He put two coats of resin on the ceramic. Sanding created the glasslike surface effect.

More recently López has returned to using low-fire glazes, which have given him the kinds of effects he is striving to create. Some of these pieces are the *Covered Form* earthenware low-fire glaze with a blue under-glaze design, the *Ceramic Object* with blue, orange, and silver, and the *Blue Maltese Cross* with blue, white, orange, and silver. One of his most-ambitious recent works is an earthenware piece comprised of three large square units, entitled *3 Earth Forms.* The rough torn clay has been used exclusively to create a strange landscape effect, which has

a moonlike topography—rises, breaks in the surface, and valleys.

Luis Jiménez

One of the most outstanding of the younger artists is the sculptor Luis Jiménez. His polychromed sculptures made of epoxy and fiberglass are representations of human figures involved in a variety of activities—melting into their immediate surroundings, like a stuffed chair or a motorcycle; emerging from T.V. screens, giving birth to full grown, completely attired figures; and being seduced by automobiles. More recently, he has begun to incorporate neon lights in these full-bodied figural pieces. The combination of intensely volumetric, shiny glasslike polychromed surfaces and neon lights produces an imagery that is at once contradictory, because of such a juxtaposition of dissimilar surfaces, and yet powerful in its insistence that it be assessed along formal and thematic lines.

Jiménez, born in El Paso, Texas, in 1940, studied architecture, then art at the University of Texas at Austin, where he received the Bachelor of Fine Arts

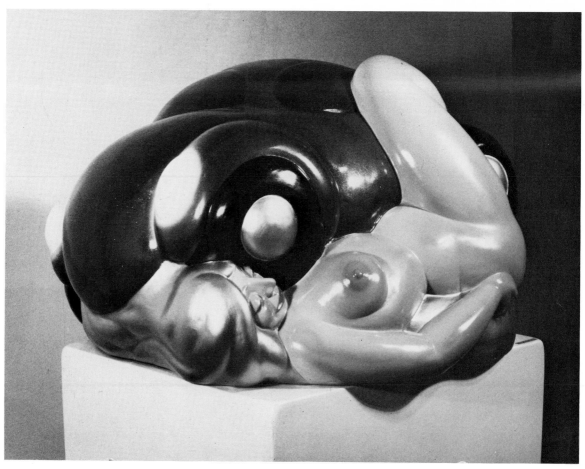

Luis Jiménez. *The American Dream.* 1967–1969. Fiberglass resin epoxy coating. (Collection of Donald Anderson, Roswell, New Mexico)

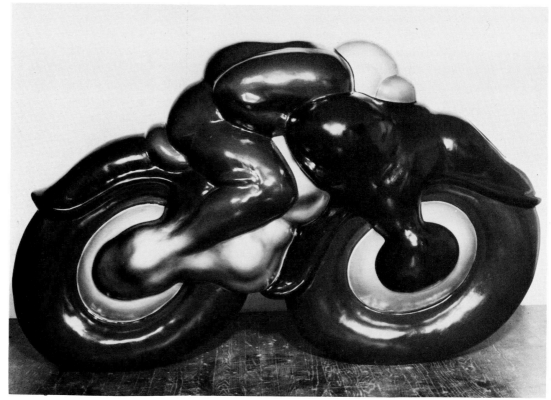

Luis Jiménez. *Cyclist.* 1967–1969. Fiberglass resin epoxy coating. (Private collection)

degree in 1964. A scholarship from the National University of Mexico, awarded that same year, enabled him to travel to various cities in that country over a period of several months. He now lives in New York, where he has had a number of one-man shows at the Graham Gallery. His work has been included in a number of group shows in New York—Whitney Museum and Allan Stone Gallery—in Connecticut at the Stamford Museum, also at the David Stuart Galleries, Los Angeles, and Brandeis University, Washington, D.C. His work is found in a number of private collections.

Although Jiménez's work is completely figurative now, as a student he dealt primarily with nonobjective configurations. It was after he had done some murals that he began to concentrate on the figure in his work. The first of these was a mural he did in 1963 in the Engineering Building at the University of Texas, Austin. He was asked to include a caveman with an ax in a panel that was approximately twenty-five feet long and twelve and one-half feet high. He did two very large hands painted "realistically." The very bright colors he used caused an immediate outcry. The other mural was done for a Pizza Hut in Austin. Here he dealt with university life—faculty and students—on a very satirical level.

Jiménez is very much interested in the machine, particularly the automobile and the motorcycle, and the effect it has had on our lives. Its immediacy and high visibility obviously led Jiménez to consider it as a prime candidate for the thematic structures in his work. He eventually equated the automobile with those symbols that were of major importance in other cultures, other societies of the past. Since many of the symbols of the past, clothed in mythological garb, had to do with the generative and destructive forces in nature, Jiménez sought the equivalent in our society. He hit upon the automobile. The one central theme found in mythological contexts of the past is the coupling of a human female with an ani-

³According to Michael Coe, were-jaguars, "offspring of feline father and human mother [are] deities of thunder, lightning and rain" (*The Jaguar's Children: Pre-Classical Central Mexico*, p. 105). Representations of a woman copulating with a jaguar are found in Gulf Coast sculptures.

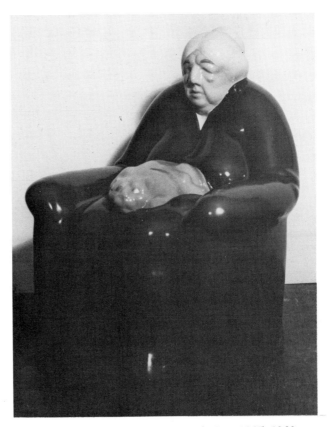

Luis Jiménez. *Old Woman with Cat.* 1967–1969. Fiberglass resin epoxy coating. (Photograph by P. McClanahan; courtesy of the artist)

mal, out of which is created a superbeing. Examples are the *Rape of Europa* and *Leda and the Swan;* their equivalents in pre-Columbian Mexico are the couplings of a "jaguar and human female" to produce the "were-jaguar."³ The theme of a jaguar copulating with a woman led Jiménez to search for its equivalent in our culture. He thought of the machine copulating with the woman. The result would, of course, be a superhuman, a godlike figure. He developed this idea in the piece entitled *The American Dream.*

Related to the coupling theme are drawings Jiménez did of the actual birth of a machine man. Like its counterparts in ancient mythologies the creature is born full grown and fully armed. This is how the Aztec war god Huitzilopochtli appeared, ready to do battle with bolts of lightning. And so he appears

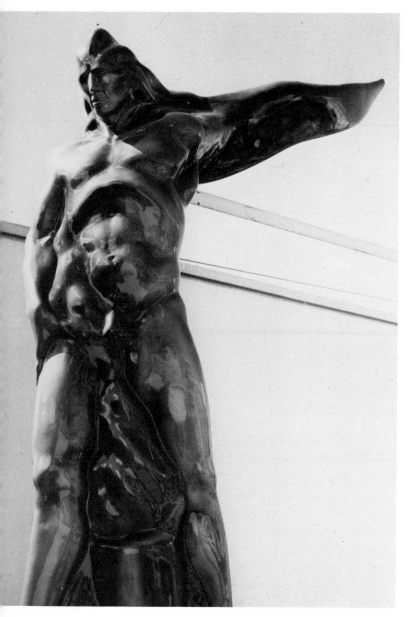

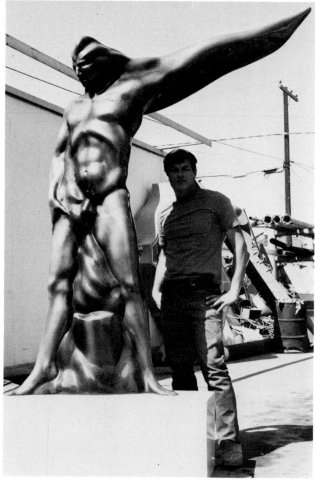

Portrait of Luis Jiménez with *Man on Fire*. (Courtesy of Graham Gallery, New York City)

Luis Jiménez. *Man on Fire*. 1969–1970. Fiberglass resin epoxy coating. (Collection of Monroe R. Myerson, Hewlett Harbor, New York)

in Jiménez's work, complete with a motorcycle helmet and other riding gear. These drawings have now been crystallized into a full-size sculpture showing the actual birth of the machine man.

An earlier related figure is his motorcycle rider. The figure is literally welded to his machine. He becomes part of it. There is no differentiation between man and machine. They are one and the same.

Jiménez is ambivalent and a little self-conscious about his own motivation in creating works of art. He feels that he must somehow make a statement about society in his work. These attitudes were re-

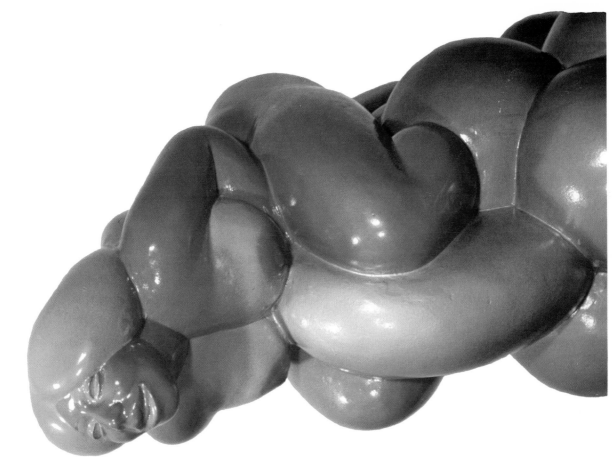

Luis Jiminéz. *California Chick*. 1968. Fiberglass, resin, epoxy coating. (Photograph by P. McClanahan; collection of Robert Grossman, New York City)

Michael López. *Ceramic Object*. 1969. Earthenware and low-fire glaze. (Courtesy of Oakland Museum, Oakland, California)

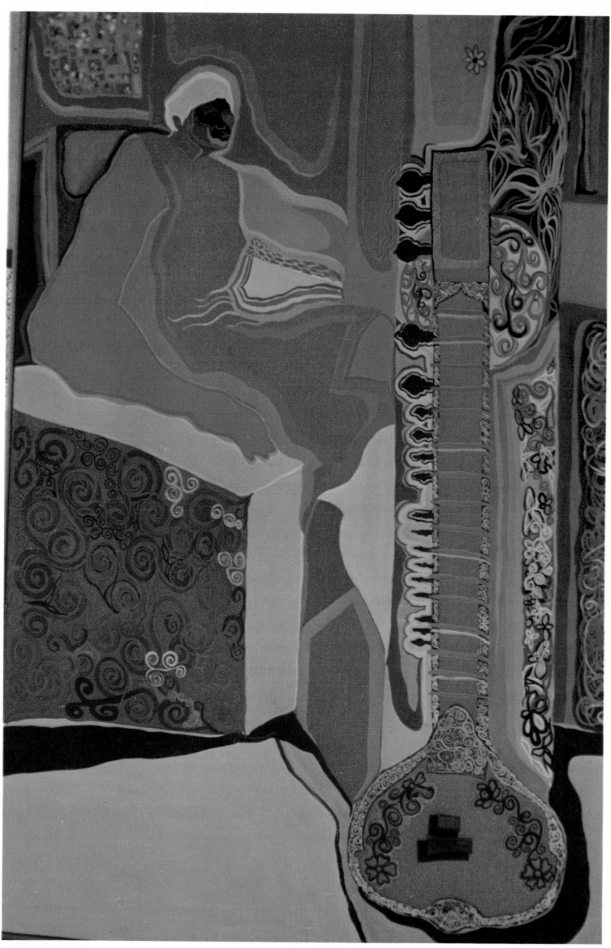

Amado Peña. *Big Faye with Sitar on a Warm August Afternoon*. 1965. Acrylic on masonite. (Courtesy of the artist)

Luis Jiménez. *Indians to Rocket.* 1972. Colored pencils. Cutout model of project comprised of *Indian with Buffalo, Indian and Conquistador, Longhorns and Vaquero, Charro and Stagecoach, Gunfighter,* and *Machines.* The one-hundred-foot sculpture, to be completed within a twelve-month pe- riod, will be financed by a grant from Donald Anderson of Roswell, New Mexico. The model was included in Jiménez's show at the O K Harris Gallery, New York City, March 11 to April 1, 1972. (Courtesy of the artist)

Indian with Buffalo. (Photograph by B. Napolsky; courtesy of the artist)

inforced during one of several trips he made to Mexico a few years ago. "I guess what really impressed me about Mexican art was somehow that it seemed relevant. I thought I had to be relevant to the society."

A commitment to society was eventually formulated into the sensuous, massively endowed female figures placed in a variety of contexts, one of which was the television set. Jiménez, initially concentrating on the television set itself as the primary motif and theme, used it in one of his early New York pieces. Its pervasive presence and the influence it has on American society, largely through sexual imagery used to sell merchandise, led him to single this out for his work. Sex and all its ramifications within programs and commercials were siphoned off and then presented by Jiménez in figural terms.

Other related motifs used by Jiménez in many early works are blonde hair and blue eyes, which he considers to be the personification of the American image. "The Mexican American or anyone who is not blond and blue-eyed is super aware of it, because he does not fit this image. You see this happening in Harlem. I worked there with teenagers when I first arrived in New York. You see black people at some of the teenage dances wearing blonde hair and blue mascara above their eyes. They are desperately trying to fit the American image. And the same is true of the Mexicans. I had a roommate who would walk on the shady side of the street because he didn't want to be darker."

The *Cyclist*, typical of Jiménez's work, expresses great power and force. It has the added dimension of implied motion. The pose of the figure huddled close to the machine and the definition of the wheels as diagonally placed ovals lend credence to this illusion of motion and great power. The rider's legs are tense as they strain every muscle to hug as closely to the sides of the machine as possible. Seen in profile the rider becomes but a slight bulge in a number of protuberances from front to back. A view from the back gives the illusion that the figure and the machine are moving away from us at an incredible clip.

The grandmother in *Old Woman with Cat* also be-

comes part of her surroundings. This time the figure is welded into the stuffed chair. She becomes the chair. Although this is basically a static format with the large square volume of the lower part comprised of the chair, the arms and legs of the sitter, and the cat on her lap, the effect is still one of considerable potential tension. It must have to do with the constantly flowing cylindrical and conical forms, which merge into each other. They literally appear to be throbbing with life. The chair is not a static, inanimate object. It is part of the grandmother. She has not become a piece of furniture. She very definitely retains her identity. The pulsating effects are echoed by the cat on her lap.

A much simpler theme is presented in Jiménez's series of gas masks. These are fragments of a much more complicated theme in which the New York Department of Public Safety appears as a menacing creature in study after study. An officer always wears a gas mask, wields a billy club, and is presented as a looming figure that is never fully encompassed by the pictorial frame. We only see the essentials—the head, the torso, the club coming toward us.

In his most recent show held at the O K Harris Gallery, New York, in March and April 1972, Jiménez showed works comprised of fiberglass, epoxy, resin, and neon lights. As he has done in the past, Jiménez has taken a well-known image for one of his major pieces — A lone Indian on horseback seen against the sky, so popular in the American consciousness. He had done the same with Orozco's *Man on Fire* by using it for a sculpture. The difference in the more recent piece is the inclusion of neon lighting to emphasize the pictorial aspects of the Indian on horseback. The sunset, an important feature in Kitsch images like these, is garishly presented by actual light. This completely transforms the direct transcription of the figural portions into the sculpture.

Jiménez continues to move in directions that enable him to comment on American society by using cherished images of the American past or its present as themes for his fiberglass, epoxy, resin, neon-lighted sculptures.

II, 1943–1946

Amado Peña

Initially attracted to purely visual phenomenon and its transcription in terms of color within figural formats, Amado Peña is now far more involved with "La Causa" as a point of reference for his work. Prior to this commitment, Peña's work was based on figures and objects that were presented in very intense colors. "The color thing has been with me for about two and a half years now. I just couldn't believe it. It was a fantastic thing. Just exploring. I could take one color and stay with it all day long. Just explore that color. But I like my figures big and distorted."[4]

Amado Peña, born in Laredo, Texas, in 1943, attended grammar schools and high school in that city. He then attended a college in Laredo for one year and Texas A&I University, Kingsville, Texas, for two and a half, receiving the Bachelor of Arts degree in 1965, and the Master of Arts degree in 1971. From 1965 to 1968 he taught in high school in Laredo. He now works in Crystal City "as art consultant and teacher and Chicano revolutionist."

Peña's work has been exhibited in the Texas cities of Corpus Christi — University of Corpus Christi, Dos Patos Gallery; Kingsville — Texas A&I University; Austin — Laguna Gloria Art Museum and Elisabet Ney Museum; and Edinburg — Pan American University. His work was also included in a recent show held in October 1971, sponsored by the League of United Latin American Citizens (LULAC). He has received numerous awards for his work in Laredo — The Rio Grande Art Festival (1968 and 1969), the Corpus Christi Art Foundation Award, and the Kingsville Area Show First Award.

Involvement with the Movimiento started for Peña in Kingsville in the late sixties when he began to take graduate courses at A&I University. "We started talking about the Chicano, about [Chicano] art. What are we really doing? Is this what you really are [a Chicano and an artist]? Or is it that you're using art to promote the Chicano movement?" Peña

[4]Amado Peña was interviewed on July 25, 1970.

saw a conflict here between what he considered his own personality as a Chicano artist and its relation to the entire Chicano movement. He has since resolved these problems, so that he has now made a commitment to the Movimiento in Crystal City, Texas.

Peña's earliest experience with drawing, and in effect his first art lesson, took place in the fourth grade. "I'll never forget it. We had a nun come twice a week. What I remember was drawing smoke coming out of a fire. I was drawing smoke going straight up. 'Oh, no! It goes like this.' I still have that drawing." He began to use tempera paints, crayons, and watercolor during these early years in school in which one hour a day was devoted to art classes.

Since 1965, Peña has used acrylic paints on masonite board, and occasionally on canvas. One of the reasons he likes to use masonite is that it provides a smooth surface. "My painting is all flat. There's no gradation of color. The surfaces are really flat, and I find that a lettering brush [all sizes] will give [me] a completely smooth stroke."

Peña follows several procedures in his work. He either uses preparatory sketches or starts out painting with no preconceived idea in mind, and then refers to some of his earlier work for guidance. In most of his early work, he did not work directly, preferring to use preparatory sketches. "I was told [in school] that 'wherever you go be sure you carry a pencil and drawing board.' I used to go on dates with a sketch pad. I'd get bored so I'd start sketching." He continually refers to sketches and his own paintings for the development of his work.

Many of Peña's early preparatory sketches were done with pen and ink. Later he began to use pencils.

Most of Peña's early works are based on the figure presented in static positions within restricted spatial frameworks. These figures are shown seated or standing by a window. *Big Faye with Sitar on a Warm August Afternoon* is a little more complicated in that the foreshortening of the armchair and the figure defines a foreground and middleground. Most of the others, like *Sunday Outing* and *My Favorite*

Glynn Gómez. *Boat Scene, Evacuation.* 1968. Ink wash on brown wrapping paper, mounted on packing crate, shellacked and plexiglassed. (Collection of Mr. and Mrs. Karl T. Tani, Santa Fe, New Mexico)

Glynn Gómez. *Brick Structure, Barbed Wire.* 1968. Ink wash on broken red brick, glued and mounted in wooden box, surrounded with bits of broken and rusted barbed wire, shellacked. (Collection of Philip H. Smith, New York City)

Duet, are basically two dimensional. The emphasis in all of these is on the color. His use of constantly echoing contours — double and triple outlining of all forms — as well as a very bright palette, makes these paintings very luscious. The repetitive scrolls within certain panels, like the side of the chair and the sitar itself in *Big Faye,* adds to the sensuous quality of the painting.

Glynn Gómez

The four years that Glynn Gómez spent in Vietnam as a marine provided the setting for much of his early work done in pen-and-ink wash drawings of the countryside and the Vietnamese people. They are shown crowded into river craft in *Boat Scene, Evacuation,* riding in primitive vehicles in *Ox Carts and Water Buffalo,* and as victims of war in *Brick Structure, Barbed Wire.* During the past several years since his return to his native New Mexico, Gómez has concentrated on autobiographical approaches to his work — remembrances of his childhood, in which children, black-shawled women, and references to the religious life of the people play an important part.

Gómez, born in Cimarron, New Mexico, in 1945, studied art briefly at Los Angeles City College in 1964, before going into the service. One of the things he remembers most vividly of his one semester of study at this school was having to concentrate on techniques in his class. He had an instructor who taught students "how to handle the brush, how to hold it. She never taught anyone how to paint. I thought it would never end. She taught techniques of framing, how to get different gradations in wash.

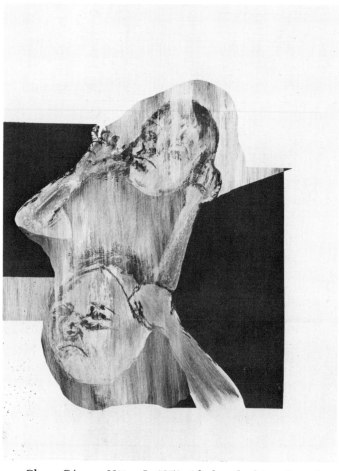

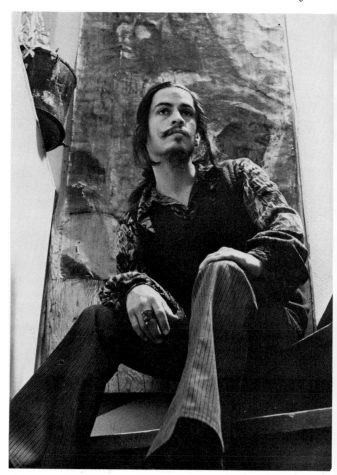

Glynn Gómez. *Niños I.* 1970. Black-and-white oil wash, framed in old wood. (Photograph by Cradoc Bagshaw; courtesy of the artist)

Portrait of Glynn Gómez. (Courtesy of the artist)

I really learned a great deal about wash from her."

Since his return from Vietnam, Gómez has exhibited his work in various galleries and museums in Albuquerque, Santa Fe, and Taos, New Mexico. His "People in Vietnam" exhibition held at Zimmerman Library Gallery of the University of New Mexico, Albuquerque, in 1971 is the most recent comprehensive showing of these works. A large laminated mural on fourteen separate panels (each 10′2″ x 7′), hanging just inside the library's main entrance, was bought by the University of New Mexico. The title is *Three Wheels of Flight.* His New Mexico "Black

and White" paintings and linear constructions, made of "driftwood" and string, have been shown at the Greer Garson Theatre Gallery of the College of Santa Fe and at the La Ventura West Gallery, Santa Fe, and La Placita Gallery, Taos.

The use of brown wrapping paper, broken bricks, and barbed wire as grounds for the Vietnam series, done with stamp-pad ink and sticks rather than brushes, accentuates the effects of violence and destruction suffered by these people. And yet there is a keen sense of visual order in the disquieting scenes. In his *Ox Carts* the slight diagonal displacement of the two vehicles is reinforced by the barely per-

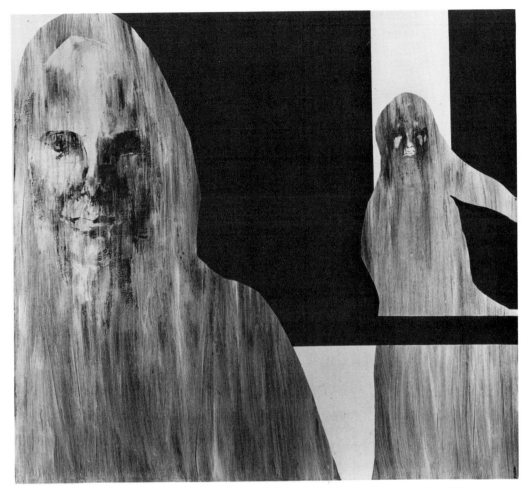

Glynn Gómez. *La Mujer Negra.* 1970. Black-and-white oil wash on muslin. (Courtesy of the artist)

ceptible foliage in the background. Strong horizontals and verticals are sustained in his *Evacuation,* while similar breakdowns are found within vertical and horizontal compartments in his *Brick* painting. The change in scale within each visual unit — the silhouetted armed soldiers on the left, and the faces within adjacent frames — is balanced by the definition of the forms in ways similar to the breaks in the brick. The brutality of the scenes is further accentuated by the frame and the barbed wire.

One of the most beautiful pieces from this period is the blue-ink wash drawing on a brown paper bag entitled *Blue Nude no. 1.* Gómez contrasts the delicately built girl drawn in pen and ink with applications of different values of blue and with the frame made of packing-crate covers.

The New Mexico paintings are stark black-and-white images done on prepared and stretched muslin of a medium weight. The works entitled *Niños I* and *Niños II* demonstrate the use of parts of the figure with quite often an exclusive emphasis on the head. Such is the case with *Niños II,* comprised of numerous heads within a long narrow horizontal band, with a broad black area directly below and a large white area above and below this central scene. The confinement of the heads, demonstrating happy

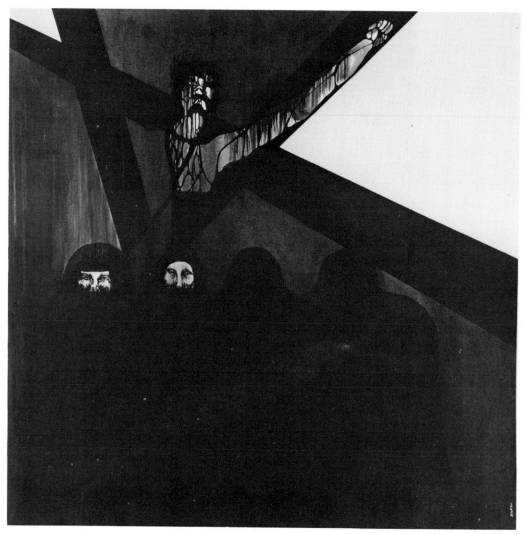

Glynn Gómez. *Pasión I*. 1970. Oil wash on muslin. (Courtesy of the artist)

and unhappy states, is further emphasized by the inclusion of actual weaving on the panel. Anguish is conveyed more graphically in *Niños I* by the expressions of the children and by the fragmented way in which they are presented — stark black sharply defined area contrasted by greyed figural portions adjacent to them. The strict frontality of *La Mujer Negra*, defined within black, white, and grey areas, adds to the stark, direct, eery quality that these personages present to us.

Even more dramatic than the pieces described above is *Pasión I* with its overall black and dark areas in which part of the crucified Christ is shown amid diagonally placed beams. The sharp angularity of this part of the painting is sustained by the four black-shawled women directly below — two facing toward us, two away from us. The two partially seen faces contrast with the clear-cut triangular-shaped white field on the right, which serves to point to the central drama.

These paintings based on figural imagery are very powerful pictorial statements that are always related

to the artist's deeply felt personal experiences in Vietnam and in his home state of New Mexico.

Rudy Treviño

Rudy Treviño, a San Antonio painter, is one of the few artists who uses abstract rather than specifically figural formats in his work. The imagery is comprised of precisely defined shapes, usually undulating and predominantly convex in outline. The visual surface is broken down into a ground line, which usually delineates mountain-size female breasts. White cloudlike forms float above these sexualscapes in the "sky," usually painted dark blue or violet. The contours of the ground line and most of the shapes are comprised of multiple-colored bands. These create the effect of expanding and contracting shapes. Arrows with curved stems are included along with the predominantly curvilinear shapes in a flat visual field. Sometimes this is contrasted by the use of rectangles foreshortened so as to give the illusion of cubical space in which the same motifs are presented — female breasts and other anatomical features, arrows, puffy cloudlike shapes.

Treviño was born in Eagle Pass, Texas, in 1945. His family moved to Crystal City when he was in grammar school and to San Antonio when he was in junior high. He attended the McNay Art Institute during the summer of 1964 and San Antonio Junior College from 1964 to 1966. During the following two years he attended the University of Texas in Austin, and during the summer of 1969 he was at Texas A&M University and again at the University of Texas, Austin, in the summer of 1970.

Treviño's works have been exhibited at the Witte Memorial Museum, the McNay Art Institute, San Antonio College, and the Incarnate Word College, all in San Antonio. Outside Texas, his work has been exhibited in Monterrey, Mexico.

The paintings and prints that Treviño calls "Poetic Sexualscapes" are based on the artist's very personal points of view. The actual states between the conscious and the unconscious, triggered by physical and subsequent emotional and mental activity, are the central themes in these works. He uses a number of motifs and symbols arranged in a variety of visual contexts and configurations. One of these is the arrow with the unusually long, foreshortened stem presented in a standard blocklike fashion to give the illusion of volume. "The sculpturesque modeling of the ever-probing . . . heroic arrows expressively define the shapes to be aggressively masculine. [They] renounce the deep perspective space to form [their] own illusionistic concept of environmental order."

The implied movement, created by the arrows, symbolizes the activity of the mind. The mind's journey from the conscious to the unconscious "may be fragmented by opaque and flat planes that confuse its voyage." The territory through which this takes place is comprised of floating and fixed shapes within cubical and flat spatial frameworks. "The geometric subject matter within my formats are sometimes fused with almost contradictory forms of biomorphism, but it is the fusion that combines the conscious with the unconscious, therefore, [that gives] forth a movement of liberation."

Treviño is also much interested in the way that we respond to visual phenomena, activated either by an object or by words, spoken or written. We perceive the world in fragments. "When you talk nowadays you talk in fragmented-type phrases and I think it carries over into the world of art." Things are not exhaustively described but merely suggested. Thus, his well-thought-out paintings are meant to evoke the types of psychic and emotional events described above, through a series of meaningful fragments rather than through an extensive narration.

Although the dominant formal characteristic in Treviño's paintings appears to be a curvilinearity based on convexities and meandering contours, a severe rectilinearity underlies all the arrangements within the visual frame. This is accomplished by the use of overlapping rectangular shapes, whose contours are always in line with the picture frame. The vertical and horizontal directions are the dominant feature in these works. Even when floating featherlike forms are included in a work like his *Poetic Sexualscape* with a stenciled number 3, they

Rudy Treviño. *Floating*. 1970. Acrylic on canvas. (Courtesy of the artist)

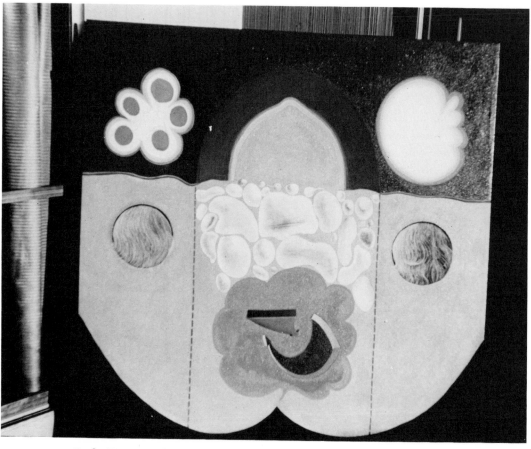

Rudy Treviño. *There*. 1970. Acrylic on canvas. (Courtesy of the artist)

are presented in planear terms. They have height and width but no depth. And, as if to leave absolutely no doubt as to the overall flatness of these shapes, Treviño includes a grid pattern within the red interior. These and the other shapes serve as an essentially flat ground to the centrally located arrow, whose definition gives to the illusion of a penetration of this surface an in-and-out movement.

Treviño relies on the primary hues for his color schemes. Reds and blues are used more often than yellows. The arrows and the "sky" are invariably blue. Large red fields are occasionally used for the lower portions of the painting in which references to the female anatomy are made, usually the breasts.

A landscape effect is created in his work entitled *Floating*. A red field across the bottom of the painting has numerous scrolls painted on it. It forms a stratum for the mountainous breast seen in profile directly above. Three puffy shapes float above the horizon line. The dark blue of the "sky" and the dark brown of the "earth" make the white "clouds" stand out.

Treviño uses a severe symmetrical arrangement in his painting entitled *There*. The ground is divided into two large fields, red below and blue above. A single red breast invades the blue field exactly in the center. Puffy shapes are shown on either side as if seen frontally on the left and in profile on the right. Directly below each of these within the red ground are two perfect circles in which Treviño has meticulously painted, in Mel Casas fashion, a head of blonde hair. The buttockslike configuration of the red field near the bottom of the painting is echoed by the two foreshortened arrows within a darker red field in the center. Directly above these but still within the red area are the cloudlike puffs.

The same constituents within similar contexts are seen in the lithograph entitled *Two Drops*. Here the female figure, placed diagonally, is seen directly behind a cubical space in which the arrows and the "clouds" are seen. A much more abstract configuration is found in the pencil drawing entitled *Detour*.

Alex Sánchez

Some of the most original responses to questions

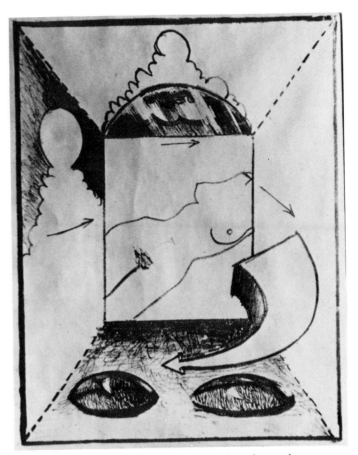

Rudy Treviño. *Two Drops*. 1970. Lithograph. (Courtesy of the artist)

asked in the interviews and to those in the questionnaires came from Alex Sánchez, the youngest artist included in this study. His explanations of his rapidograph drawings done on glossy paper often attained an independent importance of their own. His ability to deal with unorthodox word images carries over into his very unusual, highly original themes.

Alex Sánchez, born in Española, New Mexico, in 1946, attended the University of New Mexico in Albuquerque from 1965 to 1971, where he received the Bachelor of Arts and the Master of Arts degrees. He now lives a few miles south of Albuquerque in Los Lunas, where he teaches art in the local junior high school.

It seems that on occasion Sánchez's drawings are merely used as memory aids for a full narration of

Alex Sánchez. *Drawing no. 4*. 1972. Ink on glossy
paper. (Courtesy of the artist)

Alex Sánchez. *Drawing no. 1*. 1972. Ink on glossy
paper. (Courtesy of the artist)

Alex Sánchez. *Drawing no. 5*. 1972. Ink on glossy
paper. (Courtesy of the artist)

a theme that often reaches outlandish proportions. Ideas evocative of constantly changing images, activities, and movements and a juxtaposition of serious and nonsensical proposals, premises, and concepts are all thrown into a grab bag from which the inventive Sánchez can select, throw out, and fling at his audience — all delivered with a straight face.

When asked what impressed him most during a week-long trip to Mexico, he mentioned the "images of politicians on the sides of mountains." The late Marcel Duchamp, whose works were also based on complicated verbal and visual imagery, also impressed him a great deal. He also likes the "cartoon-like imagery of the pre-Columbian manuscript paintings."

In working, Sánchez maintains that he conceives of a full-color picture of the finished drawing. He is particular about the materials he uses. "Paper has to be smooth enough so that the rapidograph won't jam." Still, he has used typing, layout, ledger, and memo paper for his works.

Sánchez's drawings demonstrate such personal themes that a direct transcription of his own statements related to these works should be made. No other statements beyond these are really necessary.

"This drawing [*No. 1*] is one of a number of drawings for a wind-erosion project. The project 'wind instruments' has to do with wind-erosion templates on a monumental scale. I've constructed two wind tunnels to help in the design of the templates; the idea is to have a shell structure [template] around a more-or-less homogeneous rock mass. The wind will be channeled, by the openings [nozzles] in the membrane, to erode in a predetermined fashion. Also, the nozzles will be designed to whistle and bang with the built-in function of signaling when the work is ready

Alex Sánchez. *Drawing no. 6.* 1972. Ink on glossy paper. (Courtesy of the artist)

(the same way that a teapot signals boiling water). The drawing has to do with a subfantasy concerning the origin of the project. The drawing depicts the imagined accidental origin of the idea. The accidental, see, is shown as a bullet-riddled can which had a plug of limestone inside. The bullet holes are thought to have formed a wind-erosion template resulting in the out-of-focus statuette.

"*Drawing no. 4* [is] a shot from the observations gallery of the Last Supper Truck Stop terminal clinic."

Rather than describe *Drawing no. 5—Fly Crash*, Sánchez made a small drawing of an airplane to explain the theme.

Drawing no. 7, not titled, is Sánchez's favorite drawing. "*Drawing no. 6* [is] T.V. impression of a budget science-fiction movie 'Lee Harvey Oswald is more than just a great gasoline.'"

8. Mexican, Mexican American, Chicano Art
Two Views

SERIOUS STUDENTS of contemporary art would find it difficult to identify an artist by nationality if confronted with his works and no other information. In this respect, American artists of Mexican descent, outside the small towns of northern New Mexico, where artisans have continued to work in the old ways, are indistinguishable from other American artists. They have been affected by the same events that have revolutionized twentieth-century art. Still, antecedents have to be kept in mind. The Mexican American artist straddles several traditions, which at times seem irreconcilable. On the one hand, he is indirectly related to the Spanish colonial and Mexican republican periods of American history and directly involved with American culture of the twentieth century. On the other hand, the ties with Mexico remain strong, and in

certain parts of the Southwest there appears to be a concerted effort to emphasize them more strenuously than ever before.

I

One of the questions asked the artists interviewed during the summer of 1970 had to do with background and the influence that this had on their development as artists. Two representative types of response to these questions are presented here — the first given by Mel Casas, Emilio Aguirre, and Rudy Treviño, all of San Antonio, and the second by Esteban Villa from Sacramento, California. The most extensive treatment is given to Villa's response, since he has not been discussed in the main body of this study, as have the others.

Casas defines a Mexican American as an outsider,

"because once he's not an outsider, he's not a Mexican American any more."

Aguirre was more concerned with the Mexican American label. "Why don't we delete this word Mexican? Why not American of Mexican descent, instead of Mexican American?"

(From here on the speaker's name will be used as identification so as to avoid unnecessary exposition and the use of quotation marks.)

TREVIÑO: I think it all evolves out of search for identity, pride. Therefore, you are going to call attention to this.

CASAS: I think it goes with the times. Because I remember when I was in school in El Paso. Whenever we had to fill out forms for job applications, the teachers made us write down Mexican where it says nationality. We were not Mexicans, but this is what Texas did at that time.

AGUIRRE: Well, I don't think there is any need to say Mexican American really. You are an American first of all. This is the way you should be treated. A Mexican is someone born in Mexico. Like Treviño said, pride. I don't think pride has anything to do with that, because you know what you are and that's it.

TREVIÑO: Socially and politically, I think it could be appropriate, but in the world of art I don't think that it has any relevance. The minute you bring that phase of your kind of struggle into your work — propaganda — then it shouldn't be taken as art. It should be taken as a propaganda movement.

Now, politically and socially, there is a great difference. No one is going to call you an American. You're a Mexican American. That's an accepted thing. Once you accept it then you can take off from there and you can progress.

AGUIRRE: Now, I don't have to say that I am a Mexican. All you have to do is look at me. [Everyone laughs.]

CASAS: You ask whether we paint because we are Mexican Americans. Well, we would paint whether we were Chinese, Anglo, or French, or what have you. Now my work does deal with my relation to the culture, the environment. My painting *is* propa-ganda. But then all painting is propaganda. Whether you paint just squares. You are pushing a formal school.

TREVIÑO: The aesthetic value is more important in my view. Now, the material you deal with would have to do with artistic value. I don't say that your paintings are not artistic [to Casas].

CASAS: You may. Other people have said it. [Laughter.]

TREVIÑO: But it isn't social propaganda, all the time.

CASAS: I can't deal without propaganda, because of the American ideal. The concept of American beauty is not only physical beauty; it's also racial beauty. We are bombarded by this constantly on T.V. This is what I base it on.

TREVIÑO: See, what you're doing is competing with the country or with the world and not a little social thing like the Southwest versus the North or whatever. What you're doing is taking a larger scope. You're not dealing with the Mexican against the Anglo. This is a wider spectrum that has a deeper psychological meaning than just a racial problem. You're dealing more with aesthetic value.

CASAS: I'm dealing with the power of the cinema, the power of advertising, as in T.V.

QUIRARTE: Do the Mexican muralists mean anything to you or are you more in touch with New York–based artists?

CASAS: Much of what I am interested in depended upon my schooling. We seldom went into Mexican art, and when we did it was very superficial. There were names like Orozco, Rivera, Tamayo, Siqueiros, three muralists and an easel painter. The foremost artists of Mexico. That was it. In a sense, their iconography was very different. We were constantly [in school] bombarded with West European concepts. It was difficult to relate to Mexican art. But somehow you were expected to relate to it more. That's like expecting a Chinese to know more about watercolors than you because he's Chinese. It's ridiculous. We did have more contact with Mexican art simply because we were next door to Juárez, Mexico. But the choice was not that. It was more

the American type of imagery. I knew how to read and write in Spanish before I learned English. So when I went to school in Mexico [as an adult] it was like a rediscovery of all this.

I remember distinctly one time asking questions about Mexican art when I was a student. I was put down immediately. Mexican art was propaganda, especially Rivera's work. It was Communist propaganda. Too socially conscious. This was in 1954. Now you find America doing the reverse. American art is very conscious of the environment and Mexican art is very international.

QUIRARTE: Is there a movement or a group of Chicano artists in San Antonio?

CASAS: Efforts have been made in the past to start such movements. When I had a studio downtown I would invariably get involved with people who wanted to talk in those terms. But what bothered me is that we were not talking about art, we were talking about its racial aspects. In other words, we happen to be Mexican Americans, let's form a group that way. But no one questioned the validity of such a position. It meant nothing and it sort of bothered me. Because I am of Mexican descent and I readily admit it. But that doesn't make me an artist. I am not a professional Mexican.

(Casas then related a story that demonstrated his attitude toward this problem as well as clarified local conditions in San Antonio. Each year an artist is selected as "artist of the year" by the Art League. Several years ago he was chosen for this honored position, but only for three days because they had made a mistake. The selection was withdrawn because of ideological and aesthetic conflicts. The following year a less controversial artist was chosen.)

CASAS: To give you an idea of what both mentalities are: During the exhibition of the artist's works at the Witte Museum, one of the ladies from the Art League said, "Isn't it nice to have a Mexican American artist of the year when we're having so much trouble in the Valley" [Rio Grande Valley]. Now, what does that have to do with it? What I'm trying to get at is this. We are truly outsiders. To me being an outsider is the next thing to being an artist. I think we are lucky to be born outsiders. The other

thing. You think because you eat tortillas or you think in Spanish or in the Mexican tradition that this identifies you. I don't think it's quite true. You find us using certain materials in our work, liquitex, canvas, stretcher boards, *no usamos bastidores or manta.* So we are a mixture. So there is no sense in trying to say that we are a pure this or that. We are entirely different. We're neither Mexicans nor Anglos. We are in between.

Esteban Villa and José Montoya have been very active in the Chicano art movement in California for a number of years. Their interest goes back to their student days at the Oakland School of Art and Crafts. Their major manifesto came under the heading of MALAF, the Mexican American Liberation Art Front. This is a group founded in the San Francisco–Oakland Bay area in early 1970. The founders were Esteban Villa, René Yáñez, Manuel Hernández, and Malaquiez Montoya.

VILLA: The main purpose of this group is to use Chicano artists to create new symbols and images for *la nueva raza* [here he reads from a paper]. "It is an effort to present in visual form an artistic account of the Chicano movement. The group also wishes to establish traveling art exhibits to tour the country, to be able to set up training workshops in Oakland or wherever, to publish posters and magazines of Chicano art and artists, and to take exhibits into the working people's areas."

That was the beginning and I would like to take pride in the fact that it was kind of a conscious effort to get the thing going, to establish it as Chicano art. Now there was a lot of negation of the group, of the movement itself, of Chicano art. People would come up and say, "Is there such a thing as Chicano art and if there is where is it?" And also, "Where is the evidence of it? We want to see it." So that was some of the questioning that came out right away. Then, in applying for jobs in colleges, Chicano artists would come up to the art department and say that they do Chicano art. This immediately offended the people who were interviewing the artist. They would say, "We don't want any militant artists." This is really an ironic thing because to me art has always been

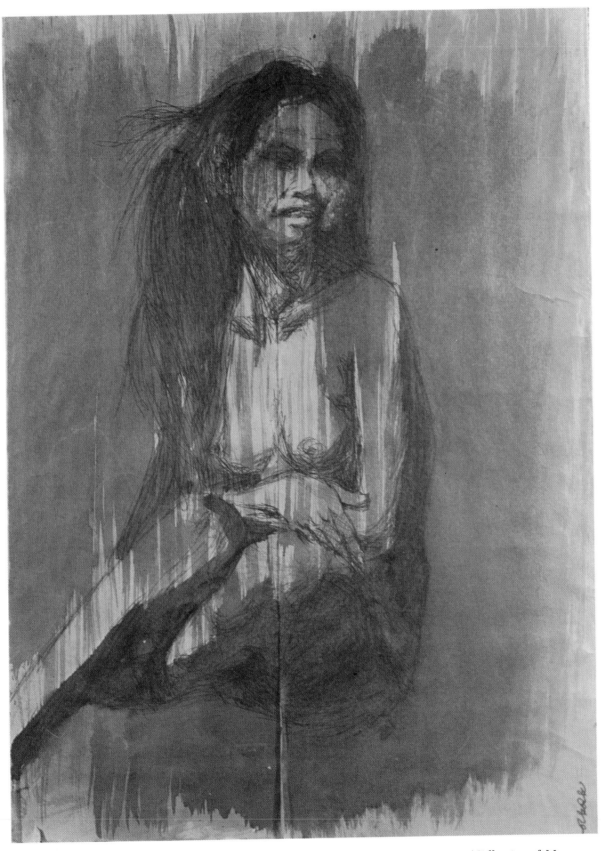

Glynn Gómez. *Blue Nude no. 1*. 1968. Blue-ink wash on brown wrapping paper. (Collection of Mrs. John B. Gomes, Santa Fe, New Mexico)

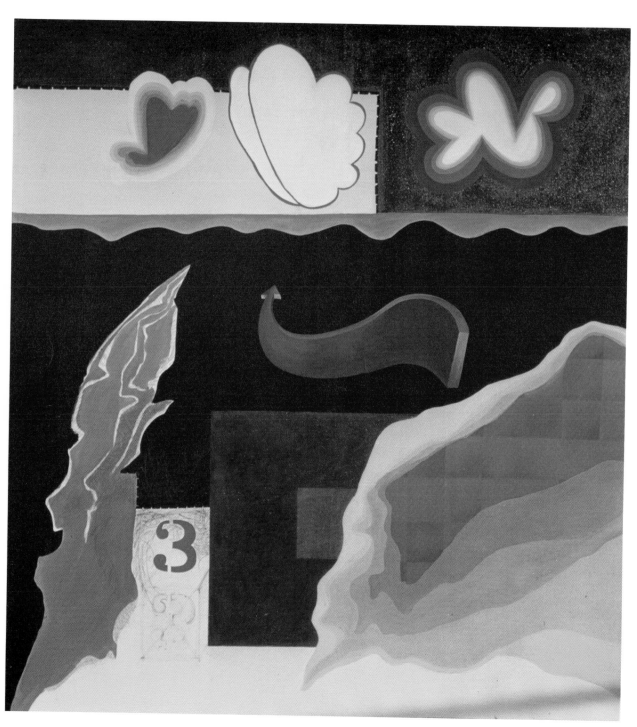

Rudy Treviño. *Poetic Sexualscape*. 1970. Acrylic on canvas. (Courtesy of the artist)

related to ideas and change. So we had a kickback there, a hurdle to overcome. Then the critics that review art shows—exhibitions in the community—also came down on the MALAF group because they felt that we were separatists. "[We're] trying to separate art and break it down into ethnic presentation." They think art is universal so "why try to break it down?"

. . . MALAF, in effect, is a kind of a radical change in the history of art. It's a new concept. It's a new direction and it hasn't been accepted yet.

QUIRARTE: I wanted to ask you whether the reorientation is complete or whether the MALAF people are still ignored.

VILLA: They started out by ignoring us. But recently I was asked to give some accounts of what I consider Chicano art. When I say art I am also including poetry, literature, painting, sculpture, music, and drama. So let's take, for example, the poetry of Montoya. I remember when he first wrote his bilingual poetry; it was an innovation. He submitted his work to the *Atlantic Monthly* magazine and they liked it very much. They wanted to publish it but finally they sent it back. They rejected it, saying it had too many Spanish words in it. It was something that the total population of the States could not pick up on. So it was a detriment to the sales of their magazine. So then *El Grito* came into being. Octavio Romano in Berkeley put this journal together and he thought it was great. "Echale más. Echale más pochismos, palabras Mexicanas." So that was accepted. José [Montoya] also writes short stories.

Then in drama you have the birth of the Teatro Campesino. It's a new Chicano art form which is already being imitated by the San Francisco Mime Troupe, and it's also being viewed and reviewed as far away as France. So that's new. Then you have poster art, which is a Chicano thing coming up now; the idea of posters is not new but Chicano posters are new. There are some other art forms that have been started in sculpture.

Chicano culture, Chicano art, seems to be like a merger of that *que viene de México* and contemporary American society—a kind of marriage of the two. And from this you're going to come out with biculturalism. And this is where Chicano art is right now.

It's just beginning. There are some art forms that are starting to come out. And they are very different from what you would find even in the magazine that you have here [he refers to the *Humble Way* magazine].

QUIRARTE: Within this context, the formal aspects of Chicano art may bear a superficial resemblance to other American art, but I assume that it would be in the thematic area that it would differ.

VILLA: Yes, I think the context, the themes, are important. Let me give you some examples. This is the thing that intrigues people the most: "Well, exactly what is Chicano art? Show me." As far as themes are concerned, I like to get on an idea and then develop a series based on it. I have done a series on the "Gallo," drawings on the *gallo*. Any art media that I can use. Stay with the theme, because the *gallo* is a *machismo* symbol. If you call a Chicano a *gallo*—man, that's a compliment. You feel good. "Yo soy un gallo." It comes out in the *corridos* in the *música Mexicana*. But the Anglo, if you call him a rooster—man, that's an insult. It's too close to being called a chicken. "Nobody calls me a chicken." So that's one thing: the *machismo* symbol. Then I would like to do a series on "La Llorona," that is, Mexican folklore. Everybody's heard of La Llorona, "El Cucuy," "La Lechusa," and "La Húngara." These are symbols that you find in the Mexican families, the Mexican people. But they haven't been brought out. And this is our rebuttal to the people that say that "you're trying to separate art, man. Let's keep it universal." Well, if anything, they don't seem to realize that when we present new symbols and imagery that deal with *machismo* and *chismes*, really what it does is that an Anglo can come and look at it and start asking questions about it. "Well, what's with the rooster? What does that mean? What does the word *chisme* mean? What does *carnalismo* mean?" And he's getting informed. So you hope that when he gets out of there he will have a closer understanding. So, rather than separating us, Chicano art is bringing us together.

QUIRARTE: And in the process the Chicanos themselves are accepting so many of these things that they've only had in the home but not outside.

VILLA: And it's something you don't find in the

schools, the colleges, and art instruction. So that's another thing that we're trying to get Chicano artists to hit on—the ethnic approach—because, so far, the Mexican people are not recognized as an ethnic group in this country.

QUIRARTE: Mexican Americans don't exist.

VILLA: Yes. And the thing that points this out is when you go into the army. You might be as black as I am, but to them I am a Caucasian. I am classified as white. O.K., in school you're told George Washington is the father of your country. Like this poet once said, "Man, if he's the father of my country, how come he's not Chicano." Also in the U.S. census form it says: "Please list your race or nationality." So they list White, Korean, Hawaiian, Oriental, and Black. The word *Mexican* is completely left out. They're implying that we don't exist, like you said. And what we're trying to do, then—through our art—is bring it to their attention, that we do exist, that we are here and not only do we exist but we also have a culture of our own.

II

Not allied to any group at the time that he was interviewed in 1970, Mel Casas has since become a leading member of a group of San Antonio artists who work under the banner C/S (Con Safo).[1] Members of the group are Jesse A. Almazán, Joe Esquivel, Joe Garza, Felipe Reyes, Roberto Ríos, and Jessie Treviño. The artists meet periodically to plan exhibitions and to discuss lecture series, articles, and other activities that will help achieve the aims of the group. During the months of March and April 1972 an exhibition of their works was set up in several cities in Michigan. Tomás Rivera, a writer presently residing in San Antonio, accompanied the show as a representative of the artists. He lectured to various groups about the aims of the artists and their works.[2]

A "Brown Paper Report," formulated by Casas and accepted by the group on December 19, 1971, contains definitions of Chicano, Brown Vision, and Con Safo. Chicano, according to Casas, is a quest "for dignity, self-awareness, survival, humanity, identity." He further states in his definition of Brown Vision: "If Americana was 'sensed' through blue eyes, now brown vision is demanding equal views—polychroma instead of monochroma." He lists more than twenty definitions under Con Safo. Some of these are "Act of defiance, Cry of anguish, A demand for identity, A demand for acknowledgement." Recently Casas circulated another position paper related to the Chicano as artist and his role in society.[3] This paper was discussed with the group in April and distributed in mimeograph form in May 1972. Portions of the paper are included here, for they express the aims of the group very well.

Invariably we are asked: Are you Chicano artists? The question is but the proof of the melting pot fallacy. Thus, how can we be otherwise but Chicanos. Physically, psychologically and philosophically we are viewed as outsiders and programed to consider ourselves as such. ... The C/S (Con Safo) approach is based on the concept of establishing an identity through visual means. The hope is that visual congruity will in turn give us psychic harmony—a statement of our evolving condition and position as Chicanos. ... Chicano artists are duty bound to act as spokesmen and give visual reality to the Chicano vision. We are iconoclasts, not by choice but by circumstances—out to destroy stereotypes and demolish visual clichés. ... Because we are Chicanos we are not anti-Anglo or anti-Mexican. We are very cognizant of how they have failed us. We are pro-human and because of it we are Chicanos.

There is a resistance, from the Chicanos, against assimilation into a "pure" Mexican society and Anglo-American society. Chicanismo is the process of synthesis of these cultures in varying dosages as suits personal and group tastes, with the idea that it never loses its identity as a culture of synthesis of the Americas and Europe.

A process of cultural secession (social internalization process) must be initiated in order to allow ourselves to begin to view ourselves with our eyes and arrive at our own definition about our state of existence and express the nature of our concern for this state.

[1] Mel Casas, "C/S Group," p. 5. The author includes a definition of Con Safo in Spanish: "(Zafarse) Safarme. Safo, fa. adj. —nadie está *safo* de una mala hora." Although Casas has used the word in the last statement to read "no one is free from a bad moment," the usual definition of *zafo, fa* is indeed "free, disentangled; exempt from danger" (*Cassell's Spanish Dictionary*, p. 785).

[2] Tomás Rivera is the author of the book that received the First Quinto Sol National Literary Award. Published in 1972, it is entitled *Y no se lo tragó la tierra* [The earth did not part].

[3] Mel Casas, "Chicano Artists C/S," pp. 1–2.

Conclusion

I T IS MOST DIFFICULT to assess the body of work presented in this study. There are no single styles or visible threads linking the works. What does exist is a common bond based on language and points of view, which have been tempered by direct and indirect experiences with Mexico, either by birth, travel, or temporary residence in that country. There is a feeling for Mexico, which is primarily evident in utterances, if not in the works themselves.

A desire to be relevant, to focus on those aspects of society that most affect the average person, is expressed by a few of the artists. The strident voices of Mel Casas and Luis Jiménez are leveled at those views and attitudes held by the majority that most affect Americans and particularly Mexican Americans. Michael Ponce de León in a more abstract way makes similar if more diverse statements in his work. Chelo González Amézcua, the most enchanted, poetess and artist, deals with all aspects of her background in her work—the Mexican as well as the Texan. Octavio Medellín retains a feeling for the pre-Columbian past of Mexico as well as its present

in powerful works done in wood and stone. Antonio García uses the Virgen de Guadalupe in his mural program at Goliad. Joel Tito Ramírez deals with the history of the Southwest with specific reference to New Mexico. Ralph Ortiz consciously searches for his roots in the pre-Columbian past and signals this by using Náhuatl names of personages and deities for his works. Manuel Neri deals with architectural manifestations dating from the pre-Columbian period in Mexico and Peru in some of his latest sculptures.

Other artists are more directly involved in developing what they consider Chicano art, while the vast majority of those included in this study are more directly involved with their work. Although, in all cases, there was a readiness to claim their Mexican or "Hispanic" antecedents, most felt this was not central to their development as artists. And yet there is a growing consciousness of these antecedents so that they will most certainly play greater importance in the work of these and other Mexican American artists in the future.

Bibliography

Alesio Robles, Vito. *Coahuila y Tejas en la época colonial.* Mexico City: Editorial Cultura, 1938.

Arnason, H. H. *History of Modern Art: Painting, Sculpture, and Architecture.* New York: Abrams, 1968.

Baird, Joseph A., Jr., and Hugo Rudinger. *The Churches of Mexico, 1530–1810.* Berkeley: University of California Press, 1962.

Baldwin, Percy M. "Fray Marcos de Niza's Relación." *New Mexico Historical Review* 1 (April 1926): 192–223.

Bancroft, Hubert H. *History of Arizona and New Mexico, 1530–1888.* San Francisco: History Co., 1889.

———. *History of California.* Santa Barbara: Wallace Hebbard Publishers, 1965.

———. *History of the North Mexican States and Texas.* San Francisco: History Co., 1886–1889.

Bandelier, Adolf F. A. *Historical Documents Relating to New Mexico, Nueva Vizcaya, and the Approaches Thereto, to 1773.* Translated and edited by Charles W. Hackett. 3 vols. Washington, D.C.: Carnegie Institution, 1923–1937.

Bannon, John Francis. *The Spanish Borderlands Frontier, 1513–1821.* New York: Holt, Rinehart & Winston, 1970.

Beck, Warren E. *New Mexico: A History of Four Centuries.* Norman: University of Oklahoma Press, 1962.

Blake, R. B. "Locations of the Early Spanish Missions and Presidios in Nacogdoches County." *Southwestern Historical Quarterly* 41 (January 1938): 212–224.

Bolton, Herbert Eugene. *Bolton and the Spanish Borderlands.* Edited by John Francis Bannon. Norman: University of Oklahoma Press, 1964.

———. *Coronado: Knight of Pueblos and Plains.* New York: Whittlesey House, 1949.

———. "The Jesuits in America: An Opportunity for Historians." *Mid-America* 18 (October 1936): 223–233

———. *Outpost of Empire.* New York: Knopf, 1931.

———. *The Spanish Borderlands: A Chronicle of Old Florida and the Southwest.* New Haven: Yale University Press, 1921.

———, ed. *Spanish Exploration in the Southwest, 1542–1706.* New York: C. Scribner's Sons, 1916.

Boyd, E. *The New Mexico Santero.* Santa Fe: Museum of New Mexico, 1969.

———. *Popular Arts of Colonial New Mexico.* Santa Fe: Museum of New Mexico, 1959.

———. *Saints and Saintmakers of New Mexico.* Santa Fe: Laboratory of Anthropology, 1946.

Burke, James Wakefield. *Missions of Old Texas.* Cranbury, N.J.: A. S. Barnes & Co., 1971.

Cahill, Holger, Maximilian Gauthier, Jean Cassou, Dorothy C. Miller, and others. *Masters of Popular Painting: Modern Primitives of Europe and America.* New York: Museum of Modern Art, 1938.

Carreño, Alberto María. "The Missionary College of Zacatecas." *The Americas* 7 (January 1951): 297–330.

Carroll, Charles D. "Miguel Aragón, a Great Santero." *El Palacio* 50, no. 3 (March 1943): 49–64.

———. "The Talpa Altar Screen." *El Palacio* 68, no. 4 (Winter 1961): 218–222.

Casas, Mel. "C/S Group." Mimeographed. San Antonio, n.d.

———. "Chicano Artists C/S." Mimeographed. San Antonio, n.d.

———. *Mel Casas Paintings.* Exhibition Catalogue, Mexican American Institute of Cultural Exchange, April, 1968. San Antonio: Mexican Art Gallery [Galería de Arte Mexicano], 1968.

Caso, Alfonso. "Calendric Systems of Central Mexico." In *Archaeology of Northern Mesoamerica,* part one, edited by Gordon F. Ekholm and Ignacio Bernal, pp. 333–348, vol. 10 of *Handbook of Middle American*

Indians, edited by Robert Wauchope. Austin: University of Texas Press, 1971.

Cassell's Spanish Dictionary: Spanish-English; English-Spanish. Compiled by Edgar Allison Peers, José V. Barragan, Francisco A. Vinyals, and Jorge Arturo Mora. New York: Funk & Wagnalls, 1968.

Castañeda, Carlos E. *Our Catholic Heritage in Texas, 1519–1936*. 7 vols. Austin: Von Boeckmann-Jones, 1936–1950.

Catlin, Stanton L. "Some Sources and Uses of Pre-Columbian Art in the Cuernavaca Frescoes of Diego Rivera." In *XXXV Congreso Internacional de Americanistas: Actas y memorias*, III, 439–449. Mexico City, 1964.

Chapman, Charles E. *The Founding of Spanish California: The Northwestward Expansion of New Spain, 1687–1783*. New York: Macmillan Co., 1916.

————. *A History of California: The Spanish Period*. New York: Macmillan Co., 1921.

Charlot, Jean. *The Mexican Mural Renaissance, 1920–1925*. New Haven: Yale University Press, 1963.

Códice Chimalpopoca: Anales de Cuauhtitlán y leyenda de los soles. Translated by Primo F. Velázquez. Instituto de Historia, 1st series, no. 1. Mexico City: Universidad Nacional Autónoma de México, 1945.

Coe, Michael D. *The Jaguar's Children: Pre-Classic Central Mexico*. New York: Museum of Primitive Art, 1965.

Dabbs, Autrey J., trans. *The Texas Missions in 1785*. Preliminary Studies, vol. 3. Austin: Texas Catholic Historical Society, 1940.

Domínguez, Fray Francisco Atanasio. *The Missions of New Mexico, 1776*. Translated and annotated by Eleanor B. Adams and Fray Angelico Chávez. Albuquerque: University of New Mexico Press, 1956.

Donohue, Augustin J. "The Unlucky Jesuit Mission of Bac, 1732–1767." *Arizona and the West* 2 (Summer 1960): 127–139.

Duell, Prent. *Mission Architecture as Exemplified in San Xavier del Bac*. Tucson: Arizona Archaeological and Historical Society, 1919.

El Grito: A Journal of Contemporary Mexican American Thought 2, no. 3 (Spring 1969) n.p.

Engelhardt, Zepyrin, O.F.M. *The Missions and Missionaries of California*. 4 vols. San Francisco: James H. Barry Co., 1908–1915.

Espinosa, José E. "The Discovery of the Bulto Maker Ramon Velázquez of Canjilón." *El Palacio* 61, no. 6 (June 1954): 185–191.

————. *Saints in the Valleys*. Albuquerque: University of New Mexico Press, 1960.

Fernández, Justino. *J. C. Orozco: Forma e idea*. 2nd ed. Mexico City: Editorial Porrúa, 1956.

Gante, Pablo C. *La arquitectura de México en el siglo XVI*. Mexico City: Editorial Porrúa, 1954.

Garcés, Francisco. *A Record of Travels in Arizona and California, 1775–1776*. Translated and edited by John Galvin. San Francisco: John Howell Books, 1967.

Geiger, Maynard. "The Arrival of the Franciscans in the Californias, 1768–1769." *The Americas* 8 (October 1951): 209–218.

Goldwater, Robert J. *Rufino Tamayo*. New York: Quadrangle Press, 1947.

Habig, Marion A. "Mission San José y San Miguel de Aguayo." *Southwestern Historical Quarterly* 71 (April 1968): 496–516.

Hallenbeck, Cleve. *Spanish Missions of the Old Southwest*. New York: Doubleday, 1926.

Hammond, George P. *Don Juan de Oñate: Colonizer of New Mexico, 1555–1628*. Albuquerque: University of New Mexico Press, 1953.

————, and Agapito Rey, eds. *Rediscovery of New Mexico, 1580–1594: The Expeditions of Chamuscado, Espejo, Castaño de Sosa, Morlete, Leyva de Bonilla and Humaña*. Coronado Cuarto Centennial Series. Albuquerque: University of New Mexico Press, 1966.

Helm, MacKinley. *Man of Fire: José Clemente Orozco*. New York: Harcourt, Brace & Co., 1953.

Hodge, Frederick W., and Theodore H. Lewis, eds. *Spanish Explorers in the Southern United States, 1528–1543*. New York: Barnes & Noble, 1959.

Hogan, Lawrence, O.F.M. "Mission San Xavier del Bac." *Arizona Highways* 46, no. 3 (March 1970): 8–19.

Horgan, Paul. *Great River: The Río Grande in North American History*. 2 vols. New York: Rinehart & Co., 1954.

James, Daniel. *Mexico and the Americans*. New York: Praeger, 1963.

Klee, Paul. *On Modern Art*. London: Faber and Faber, 1962.

————. *Pedagogical Sketchbook*. New York: Nierendorf Gallery, 1944.

————. *The Thinking Eye: The Notebooks of Paul Klee*. Translated by Ralph Manheim. 2nd rev. ed. New York: G. Wittenborn, 1964.

Kubler, George. *Mexican Architecture of the Sixteenth Century*. 2 vols. New Haven: Yale University Press, 1948.

————. "On the Colonial Extinction of Motifs of Pre-Columbian Art." In *Essays in Pre-Columbian Art and Archaeology*, by Samuel K. Lothrop et al., pp. 14–34. Cambridge: Harvard University Press, 1961.

————. *Religious Architecture of New Mexico*. Colorado Springs: Taylor Museum, 1940.

————. *Santos: The Religious Folk Art of New Mexico*.

Fort Worth: Amon Carter Museum of Western Art, 1964.

León-Portilla, Miguel. *Aztec Thought and Culture: A Study of the Ancient Náhuatl Mind.* Translated by Jack E. Davis. Norman: University of Oklahoma Press, 1963.

———. *La filosofía Náhuatl.* Mexico City: Universidad Nacional Autónoma de México, 1959.

Lowndes, Joan. "Destruction Theatre: A Shock Spectacle with Moral Motive." *The Province,* August 28, 1968, p. 8.

McAndrew, John. *The Open-Air Churches of Sixteenth-Century Mexico: Atrios, Posas, Open Chapels, and Other Studies.* Cambridge: Harvard University Press, 1965.

McCloskey, Michael B. *The Formative Years of the Missionary College of Santa Cruz of Querétaro, 1683–1733.* Washington, D.C.: Catholic University of America Press, 1955.

McGann, Thomas F. "The Ordeal of Cabeza de Vaca." *American Heritage* 12, no. 1 (December 1960): 32–37, 78–82.

Medellín, Octavio. SEE *Xtol: Dance of the Ancient Mayan People.*

Meier, Kurt von. "Violence, Art, & the American Way!" *Arts Canada* 25, no. 1 (April 1968):19–24, 51.

Myers, Bernard S. *Mexican Painting in Our Time.* New York: Oxford University Press, 1956.

O'Connor, Francis V. *Jackson Pollock.* New York: Museum of Modern Art, 1967.

100 Original Woodcuts by Posada. Foreword by Jean Charlot. Colorado Springs: Taylor Museum, 1947.

O'Rourke, Thomas P. *The Franciscan Missions in Texas, 1690–1793.* Studies in American Church History, vol. 5. Washington, D.C.: Catholic University of America, 1927.

Orozco, José Clemente. *José Clemente Orozco: An Autobiography.* Translated by Robert C. Stephenson. Introduction by John Palmer Leeper. Austin: University of Texas Press, 1962.

Ortiz, Ralph. *Destructions—Past & Present.* Exhibition Catalogue, November 10–28, 1967, Fordham University.

———. "Destruction Theatre Manifesto." *Studio International* 172, no. 884 (December 1966): 19–24, 51.

Palomino, Ernie. *in black and white: evolution of an artist.* Fresno: Academy Library Guild, 1956.

Piette, Charles, J.G.M. "The Missions of Colonial New Mexico." *The Americas* 4 (October 1947): 243–254.

Plenn, Virginia, and Jaime Plenn. *A Guide to Modern Mexican Murals.* Mexico City: Ediciones Tolteca, 1963.

Polzer, Charles. *A Kino Guide: A Life of Eusebio Francisco Kino, Arizona's First Pioneer, and a Guide to His Missions and Monuments.* Tucson: Southwestern Research Center, 1968.

Posada, José Guadalupe. SEE *100 Original Woodcuts by Posada.*

Quirarte, Jacinto. "The Art of Mexican-America." *The Humble Way* 9, no. 2 (Second Quarter 1970): 1–9.

———. *Maya Vase and Mural Painting.* Austin: University of Texas Press, forthcoming.

———. "Pintura Mural Maya," Ph.D. Dissertation, Universidad Nacional Autónoma de México, 1964.

Reindorf, Reginald C. "The Founding of Missions at La Junta de Los Ríos." *Mid-America* 20 (April 1938): 107–131.

Robertson, Donald. *Mexican Manuscript Painting of the Early Colonial Period.* New Haven: Yale University Press, 1959.

Rubin, William S. *Dada, Surrealism, and Their Heritage.* New York: Museum of Modern Art, 1968

Saenz, César A. *Quetzalcóatl.* Mexico City: Instituto Nacional de Antropología e Historia, 1962.

Thompson, J. Eric. *Maya Hieroglyphic Writing: An Introduction.* 2nd ed. Norman: University of Oklahoma Press, 1960.

Toussaint, Manuel. *Colonial Art in Mexico.* Translated and edited by Elizabeth Wilder Weismann. Austin: University of Texas Press, 1967.

Vaillant, George C. *Aztecs of Mexico: Origin, Rise, and Fall of the Aztec Nation.* 2nd ed. Garden City: Doubleday, 1962.

Valdez, Luis. "An Interpretation of Ernie Palomino's film 'My Trip in a '52 Ford.'" Mimeographed. Fresno, n.d.

Vedder, Alan C. "Establishing a Retablo-Bulto Connection." *El Palacio* 68, no. 2 (Summer 1961): 82–86.

Weddle, Robert S. "San Juan Bautista: Mother of Texas Missions." *Southwestern Historical Quarterly* 71 (April 1968): 542–563.

———. *San Juan Bautista: Gateway to Spanish Texas.* Austin: University of Texas Press, 1968.

———. *The San Sabá Mission: Spanish Pivot in Texas.* Austin: University of Texas Press, 1964.

Wilder, Mitchell A., and Edgar Breitenbach. *Santos: The Religious Folk Art of New Mexico.* Colorado Springs: Taylor Museum, 1943.

Xtol: Dance of the Ancient Mayan People. Eleven original linoleum block prints by Octavio Medellín. Limited edition of one hundred sets. Descriptive text of the Temple of the Tigers, Chichén Itzá, and Yucatán, by Jerry Bywaters. Mural description by Salvador Toscano. Dallas: Dallas Museum of Fine Arts, 1947.

Index